Investigative Aesthetics

Investigative Aesthetics

*Conflicts and Commons
in the Politics of Truth*

Matthew Fuller
and
Eyal Weizman

VERSO
London • New York

First published by Verso 2021
© Matthew Fuller and Eyal Weizman 2021

1 3 5 7 9 10 8 6 4 2

Verso
UK: 6 Meard Street, London W1F 0EG
US: 20 Jay Street, Suite 1010, Brooklyn, NY 11201
versobooks.com

Verso is the imprint of New Left Books

ISBN-13: 978-1-78873-908-5
ISBN-13: 978-1-78873-910-8 (UK EBK)
ISBN-13: 978-1-78873-909-2 (US EBK)

British Library Cataloguing in Publication Data
A catalogue record for this book is available from the British Library

Library of Congress Cataloging-in-Publication Data
Library of Congress Control Number: 2021930159

Typeset in Sabon by MJ & N Gavan, Truro, Cornwall
Printed and bound by CPI Group (UK) Ltd, Croydon CR0 4YY

Contents

Introduction

Violence lands. Hundreds of troops break into a city. At that moment the city starts recording its pain. Bodies are torn and punctured. Inhabitants memorise the assault in stutters and fragments refracted by trauma. Before the Internet is switched off, thousands of phone cameras light up. People risk their lives to record the hell surrounding them. As they frantically call and text each other, their communication erupts into hundreds of star-shaped networks. Others throw signals into the void of social media and encrypted messaging, hoping they will be picked up by someone. Meanwhile, the environment captures traces. Unpaved ground registers the tracks of long columns of armoured vehicles. Leaves on vegetation receive the soot of their exhaust while the soil absorbs and retains the identifying chemicals released by banned ammunition. The broken concrete of shattered homes records the hammering collision of projectiles. Pillars of smoke and debris are sucked up into the atmosphere, rising until they mix with the clouds, anchoring this strange weather at the places the bombs hit.

Each person, substance, plant, structure, technology and code in this incident records in a different way. Some traces accumulate so fast and haphazardly that they erase previous traces. These records, traces of destruction and pain, are both modes of aesthetic registration and modes of erasure. When they remain, such traces may, given the right techniques, be read for different purposes: some for furthering violence, others for opposing it or simply to stay alive somehow. Those that are obfuscated or repressed are more difficult to access.

Those delivering violence have recourse to higher-resolution sensors: cameras on drones, planes and satellites to record clashes from multiple perspectives. Their overwhelming power relies on weapons, but also on access to information – gathered as floods of images and signals – and the means of working through these streams of data, using AI for interpretation and prediction. While massive collection takes place, such violence also consists of a simultaneous attempt to impose on those experiencing the attack a uniform and impenetrable block of information, one that reads as information from one side and as noise on the other.

That difference between signal and noise will also be used to allow officials of all kinds to lie about what happened, spread disinformation, marshal or manipulate data, and deny the most basic of facts. Later, those experiencing or resisting the violence will testify. Perhaps a soldier will have the guts to reveal what they or their comrades have done – either publicly or by leaking secretly downloaded files. Another might do so accidentally, while bragging on their social network.

However, there can also be a counter-reading, a counter-narrative that gathers all these different kinds of trace, and is attuned to their erasure. Reworking what sometimes are merely weak signals – forming a composite from all of these recordings – can show what happened and what political conditions gave rise to it. Interpreting weak signals and faint traces is complicated as only an act of close reading can be. Weaving these signals in relation to each other is not only a scientific or technical endeavour but a cultural, ethical and political one. It involves wide and varied ways of paying close attention to the accounts of people, matter and code. To those experiencing violence first-hand who lead the struggle for something approximating justice, the question is always how finding the truth about current events may also reveal the shadow of long-term historical processes, and how telling history from the lived perspective of present violence can support their political

struggles. To be effective, contesting official accounts of what has happened is a question of investigation, of history and of solidarity, and such telling is only as good as the political process of which it is part.

———

A bomb is released from a Saudi warplane and blows up in a hospital in Yemen. The bomb is a composite object, its many components arrived from dozens of factories across Europe and the US. These products are themselves assembled from other products drawn from hundreds of subcontractors, and these are supplied by providers of raw materials, which are in turn extracted from mines spread across the world. The bomb's assembled structure is coextensive with the global economy. When it hits a target it sprays its fragments in all directions, tearing bodies and properties and destroying life-worlds. These shards of the bomb do not directly correspond to the assembled components or products but raggedly approximate them in a transformed state.

Survivors of such strikes often make a point of photographing these fragments and uploading the photos online. Other people look, trying to compare and identify those fragments and trace them to the companies that made them. Legal activists use this material to force a moratorium on further export. The process of investigation resembles watching this act of bombing in slow-motion rewind, like the scene in Kurt Vonnegut's novel *Slaughterhouse-Five* where the devastating bombing of Dresden is told in reverse. From the rubble and fragments a bomb is reassembled; it is then shot upwards into one of the wings of a plane, which flies backwards and lands it in an airfield, allowing the bomb to be dismounted and then disassembled, shipped elsewhere, where it is separated into components, each sent further back into the part of the world that gave birth to it; the raw metals are then placed back in deep mines and covered with earth, which is replanted with forests, so that they can't hurt anyone ever again.[1]

In this book, we argue that an anti-hegemonic investigation, drawing out and combining individual recordings until they become collective – a commons – is an intrinsically aesthetic practice. By understanding this capacity for collective sensing and sense-making, we can work towards a renewed, careful, but politically powerful conception of truth practices today. In the pages that follow we want to suggest some considerations on the political stakes of such a formation. This book, which we each came to from different directions, is not a historical overview of the intersection of aesthetics and investigations; it is rather our attempt to think theoretically about our own and some of our colleagues' practices, the terms, components and assumptions that form the source code of what we do, and to reflect upon the contours of our ambitions regarding what we have not achieved but that remains to be done.

—

Among the last projects that film-maker Harun Farocki was working on when he suddenly and tragically passed away in the summer of 2014 was a film on the investigative agency Forensic Architecture. At an initial stage of collecting source material, he wrote to Eyal, who leads the agency, with a mixture of enthusiasm and a subtle reproach: 'Instead of designing a film in the way a building is designed I prefer to build a film in the way birds build a nest.'

The art of urban nest building might involve weaving together twisted twigs with found scraps, bits of string, cigarette butts or torn nylon along with some moss, grass and spider's webs. Harun wrote asking for the found media we were working with, bits of blurry user-generated video and screen grabs of software in action, as well as documentation of physical traces and aerial and satellite images. Harun died before this film was completed, but the mode of work that he pioneered – a weaving together of separate media elements, technologies of vision, imaging, automation and detection, into a series of essay-films that offered deep critical and

investigative interrogation of the intersection of politics and technology – is a possible entry point to describe a mode of practice that we want to call *Investigative Aesthetics*.

Though they were already manifest in his lifetime and piqued his curiosity, several changes in the technological and investigative landscape became more distinctly manifest in the period after Harun's death. In recent years, the rapid expansion of the volume, speed and kind of data being circulated in both technical and social networks meant an increase in availability and kind of what had traditionally been known as open-source investigations, or OSInt. Open-source investigators sieve through material that is publicly available and mostly found online: videos and photos posted by witnesses or perpetrators of violence, commercial satellite images, online databases of scientific data and publications. They look for traces of policies that are invisible, secret or denied and work to produce facts that contest statements and other authorities.

The work of these researchers – to question and dismantle official narratives as much as to build new, alternative ones – begins when each of dozens of videos or other documents shows only a partial detail of a larger incident that was previously occluded or denied. Combining elements that were already in the public domain, potentially visible to all, into powerful statements of fact, seems to follow Stéphane Mallarmé's poetic dictum from the late nineteenth century that 'things already exist, we don't have to create them; we simply have to see their relationships'.[2]

Scraps of information are then compiled into systems, including narrative structures, that allow for their cross-checking and public presentation. One technique developed by Forensic Architecture is to examine the relation between these shards of evidence by synchronising and recomposing them within digital architectural environments. These models become an optical and interpretive device, because within them one can navigate between and compare multiple perspectives

manifested as separate image and video files. These in turn are used to sharpen the model.

In what was probably the last lecture he delivered, Farocki argued that navigational viewing within computer-animated spaces, such as those of games, has replaced the filmic tradition of the montage or edit which produces a linear composition, as the dominant form of filmic practice.[3] When investigating open-source images, the architectural model can provide such a navigational platform; it provides a comparative scaffold to contain all the available videos of an incident in their complete duration. The researcher moves from one video to the next within a 3D environment. The model becomes an operative device, an operative model, both a database and a way of inhabiting an environment of simultaneous media.

Walter Benjamin contrasted the *Bildraum* – image space – the 'small world' of the painting, with the architecturally analytic plan or sectional view.[4] One described an imaginary, the other set out a logical project for the construction in the physical world. But in the context of Forensic Architecture's work the model–video relation constructs an image space that is itself an analytical tool. Within it each incident can be examined from simultaneous multiple camera perspectives, a multiplicity of situated perspectives, rather than from the view from above that characterises the architectural plan. Several, dozens, or even hundreds of elements of source material can thus be brought together in poly-perspectival assemblage. Together, such assemblages echo something of the all-at-onceness of simultaneous perspectives brought together by cubist painting. This way of assembling or weaving together different photographic and video images, in which each becomes a hinge or doorway to another source of information, opens possibilities for political contestation and sense-making activism.

The following are a few examples drawn from our own work. Each involves varied approaches to the production of evidence and different strategies for its public presentation

in courts, citizen tribunals and exhibitions in art and culture venues ranging from museums to academic journals but always aiming to create an effect beyond these. Each investigation brings into being a collective whose efforts are aligned despite including diverse positions and situated experiences.

Forensic Architecture's investigation into the collusion of German state agencies with members of a neo-Nazi group called the National Socialist Underground (NSU). In the early 2000s this group spread terror throughout Germany's migrant communities with a series of ten racially-motivated murders. Forensic Architecture's investigation was undertaken at the request of a 'people's tribunal' organised by activists alongside family and community members of the victims who thought the legal process was limited in its ability to address state and societal responsibility in these murders.[5]

The investigation concentrated on one of the murders, unique for having taken place while a German secret service agent was present at the scene of the crime. On 6 April 2006, 21-year-old Halit Yozgat was murdered in his family-run internet café in Kassel. Attention was concentrated on this case because, within the cafe's seventy-seven square metres, an agent of the state, the killers and the targeted migrants were all present. The investigation was presented at a prominent art exhibition, Documenta, in 2017, only a few hundred metres away from the site of the murder. It was based on a substantial leak of police files with images, videos and the login details of all the computer users at the scene at that time. A re-enactment of the murder within a real-size model of the Internet cafe showed that the agent was giving false testimony when he said he did not see or hear the killing and might have even been colluding with the killers.

Having drawn attention within the context of contemporary art, with groups of German politicians attending to view the evidence, the 'exhibit' was summoned to be presented at a parliamentary commission of enquiry, where lawyers and

politicians used it to confront the agent, who was present, to watch our video. Testifying to the difficulty of crossing disciplinary and institutional borders, art reviews referred to this exhibit as 'evidence, not art', while those accused and threatened by it, including the accused agent and even members of the ruling Christian Democratic Party, (unsuccessfully) tried to disqualify it by calling it 'art, not evidence'.[6]

That art institutions are not only alternative and neutral venues for display, but that they can themselves be implicated in human rights violations, came to the fore when Forensic Architecture was invited to contribute to the 2019 Whitney Biennial. Its response was to investigate human rights violations connected to a product manufactured by the vice chair of the Whitney Museum's board, who was exposed by alternative media and activists as a weapons manufacturer.[7] In coordination with the group of activists leading this struggle,[8] we decided to train computer-vision classifiers to detect all presence of a notorious munition he manufactures – a tear gas canister branded as 'Triple Chaser' – among thousands of videos.

This way we aimed to identify who it is sold to, finding its use against civil society and social movement protests around the world from Palestine, through the Mexico–US border, to metropolitan centres in US cities. The presentation of the film, which was made with Laura Poitras, at the Whitney Biennale, contributed to a collective effort – also involving several artists withdrawing their work from the exhibition – that saw the resignation of this trustee from the board, and his ultimate disinvestment from teargas. At this stage it felt as if presentation in a forum may sometimes help change it, making the museum's white cube or black box not only a critical space, but one that can actually bite.

Other moves travel not from the physical world into the space of the computer, but in the reverse direction. By piecing together and comparing court records, leaked emails from

Sony and other businesses, patent documents and other material in the public domain, and by forensically examining video files, a project led by critical security researcher Nikita Mazurov exposed the mechanisms by which police and corporate labs trace file sharers.[9] Such research helps people involved in information sharing act more securely in the future. Such projects suggest that counter-investigation can also open up spaces for communication.

When a company controlling the largest share of search results in the world switched from delivering 'neutral' results to 'personalising' them, an investigation was established to test what this meant in more precise terms, what indeed 'the personal' could be taken to be and how it might have economic value. Clusters of identities were created to probe the way in which search results were modified according to search history. In a process led by design researcher Martin Feuz, thousands of inputs were mapped and compared to thousands of outputs. Directly acting on the search engine, its algorithms and categories become a means of discovering the ways they shape current culture.[10] The effects of such work are not usually direct, but they build up society's capacity to recognise the way in which its processes, and the means we have of recognising them, are being steered and reordered as much as facilitated by digital platforms.

Taken together, these projects indicate various directions of interest and ways of working in investigative aesthetics. But these are only samples of our points of entry into the debate. Many others are also involved and we will trace some of these as the argument in this book progresses. In order to do so, what we also need to account for is a substantially changing context.

———

Towards the end of the second decade of this century the flood of images from significant incidents turned into a torrent and there were simply too many for human researchers alone to

sieve through. One of the differences between the Hong Kong protests of 2014 and those of 2020, and between two of the major phases of the Black Lives Matter protests (2015 and 2020) in the USA, is that many more hundreds of hours of video were posted online and streamed by participants. Working at the invitation of protest organisations in both places, Forensic Architecture began to use artificial intelligence-based machine-vision to automate the act of seeing.

These programmatic eyes had to be taught to see by being shown thousands of labelled and annotated images. The repetitions of training a neural network on datasets of images so that they could learn to differentiate implied a kindergarten-style reading of images: 'This is a bomb. This is a tank. But this is *not* a police-grade tear gas canister.' Using machine learning tools meant having to account for the ways these technologies come with their own baggage and biases. Recognising and working with and against the quirks of one medium by combining them with those of another is a means of involving the introspection that is necessary.[11] As such technologies increasingly become the medium in which the investigation takes place, introspection – a critical examination of the way a digital tool operates, its own aesthetics – becomes more important. More broadly, though critical and investigative work in software intensified in the last decade of the twentieth century, it has become an increasingly crucial field of investigation as more social and economic processes move online.

For instance, the artist Trevor Paglen worked with critical-AI scholar Kate Crawford on the ImageNet Roulette project to illustrate the ways in which images are labelled and assigned meaning in a database used by many AI systems, often reproducing the biases and racist attitudes of some of those doing the tagging: low-paid and often disenchanted crowd-sourced workers. Images thus processed would be labelled with categories such as 'rage', 'deviance', 'radical' or 'risk' in ways that were culturally, and often racially, inflected.[12]

In 2019, also responding to ImageNet, programmer and artist Nicolas Malevé produced work exposing the curious structure of this database, showing all 14 million photographs at a rate of ninety milliseconds per image over two months, pausing the incomprehensible torrent every now and then to show a randomly selected image and its metadata.[13] Images were often tagged with bizarre connections by ImageNet workers, linking image data to spur-of-the-moment misjudgements. These would be mildly significant glitches were they not embedded in a system used by other software to develop 'solutions to societal problems'.

These examples show that, for investigation, the technological context changed, as did the volume of images, as more and more footage from devices such as smartphones and from streaming services came online. But crucially, the organisational context also changed. It was not only that the field of expertise radically shifted and opened up, but also investigations had become a more collective endeavour. The 'nest building' that Farocki spoke about could no longer be done by one or two birds at a time, but was assembled by extensive networks based on intense collaboration and strong solidarity.

Such networks form commons that might include groups of different nature and standing that could be previously thought of as incompatible: the community who had experienced violence, who recorded their local environment and often led the struggle; the people risking their lives to take and upload such images; citizen and self-taught journalists, bloggers, image and film-makers, artists and architects. These are allied with a remote network of volunteers, activists and human rights lawyers. In turn, open-source researchers scattered around the world pore over images in search of clues. Academics of different kinds, such as archaeologists, oceanographers, historians and scientists, working voluntarily with them also collaborate with film editors, artists and curators to produce and display the cases.

The involvement of cultural producers such as curators and artists also became crucial because such work is presented not only in political, legal and journalistic fora, but in galleries and museums, in citizen assemblies and peoples' tribunals. Such extensive investigative networks can often be based on asymmetrical relations and they must be constructed in ways that recognise and seek to undo the different degrees of privilege and access. Such recomposition of aesthetic fields enables the creation of what later on in this book we'll call 'investigative commons'. Such investigative commons, by merit of their integration of multiple perspectives, pose a challenge to the traditional expert mode of investigation, prevalent equally in science and in human rights research, where specialised arbiters of truth and fact travel to places, impart knowledge and render judgment. This collective and diffused mode of truth production is made necessary by a political situation in which conflicts are waged not only over resources but over interpretation of the real, and identities are formed around the formation and interpretation of facts.

At the same time as these kinds of alliances gave rise to a swell of investigative energy, a new aesthetic dimension is becoming manifest in areas more traditionally understood as investigative in fields such as science, journalism, data analytics, critical computing, law and human rights. Journalists and human rights analysts pore over social media and satellite images or audio recordings, constructing visual or filmic investigations, using visual and other sensory capacities to make their enquiries, without necessarily being explicitly aware of the ways their fields have become aesthetically activated.

In all these emergent practices, aesthetics was crucial, not, of course, as an act of beautification, rather as one of careful attunement and noticing extending to the elaboration of precise means of sensing and sense making.

Investigative aesthetics is, in part, a process of collectively assembling accounts of incidents from media flotsam. It

involves tuning into and interpreting weak signals and noticing unintentional evidence registered in visual, audio or data files or in the material composition of our environment. It also refers to the use of aesthetic sensibilities in assembling cases, in editing material into effective film and videos or installations. In these constructions, each found element is not a piece of evidence in itself but rather an entry point to find connections with others, a part in a heterogeneous assemblage that allows for navigation across and the weaving together of disparate elements – a process of nest-building, perhaps.

———

The investigative paradigm reconstructs incidents around clusters of specific details in order to discern the world of which they are part. Investigations often start from a site or a specific point: a controversy, a local debate, an accident, a detail. From this point of individuation an investigation follows different threads that lead outwards along complex paths of causality. Disentangling these threads needs different forms of knowledge, experience and expertise.

It is in this way that the systemic conditions of a larger political context reveal themselves in incidents. Examples of this can be found in Forensic Architecture's series of works on police violence entitled 'The Long Duration of the Split Second'. Each of these investigates different incidents of police officers shooting innocents in the US, the UK, Greece, Palestine and Turkey. These shootings are defended under the 'split-second argument', where an officer claims the suspect's right to life is suspended because an imminent threat is perceived 'in the heat of the moment'. This defence relies on the notion of natural instinct. But this instinct is culturally and politically produced and can be traced to a long history of the structural violence of colonisation, segregation and domination that dehumanised the colonised and the enslaved and turns them into legitimate prey.

There is a huge epistemological, temporal and geographical space to be traversed from the detail of the incident to larger

historical contexts. The investigative work moves between the scales of the local, politically and culturally entrained, to vast geographies and histories. Combining the detail of the incident with wider forms of understanding requires bringing together different forms of knowledge that can also often test each other. To trace evidentiary threads requires labour and care.

Because it starts from an incident, investigative aesthetics is grounded in experience, and the perspective it brings to bear is openly partial, embedded, activist or militant, rather than a 'disinterested' or neutral view from nowhere. Making sense must also not mean simple conformity to a culture, especially that of a homogeneous mass of variously privileged perspectives which are formed by their perspectival interpretations. Situated experience is varied and subject to different kinds of access, understanding and interpretation.

In such a condition, aesthetics is also about developing sensibilities of extremely careful looking and noticing. As such it is also an ethical position because opening one's ability to sense is opening oneself to the experience of pain, as opposed to the danger of developing an anaesthesia to political injustice which would in turn remove investigation from the proximate relation to the event that it aims to comprehend and to trace. There are constantly aesthetic, political and ethical choices to be made, for example in determining which incidents should be pursued and how wide to open the investigative angle, just as there are to working out which aesthetic impressions can become evidence, and for what.

———

We should be keenly aware of a productive paradox: though they are often understood to be contrary to investigation of facts, the work of aesthetics and the work of imagination are both essential to investigative work. We need imaginaries that can no longer be contained within disciplinary taxonomies but that are also able to work across them.

In making these connections, our propositions may raise some questions. Are we not turning aesthetic practices, indeed art, into a form of expertise, or into a mere utilitarian tool? Are we not, in looking for facts, repeating the long-discarded notion of positivism after decades of careful dismantling and reworking of the mechanisms by which institutional truths are arrived at? How are we to make these practices matter in view of a political culture in which facts are merely one more form of leverage, another kind of spin?

Indeed, in everyday use, 'aesthetics' and 'investigation' do not often sit comfortably together. The terms 'aesthetics' and 'to aestheticise', even the very idea of art itself, seem to be anathema to familiar investigative paradigms because they signal manipulation, emotional or illusionistic trickery, the expression of feelings and the arts of rhetoric rather than the careful protocols of truth. Sometimes they are markers of a lack of earnestness, gravity and sincerity that might divert the quest to find things out. In turn, it is these very qualities that make investigation seem a little too lead-footed for art.

This book seeks to make the encounter between the two terms 'aesthetics' and 'investigation' larger than the sum of its parts. This meeting point is productive because it shifts and expands both constitutive elements. These words, with their many entailments, begin to work into each other and to figure out new potentials in each other. What we mean by aesthetics and what we understand as investigation then changes.

———

Aesthetic investigations have a double aim: they are at the same time investigations of the world and enquiries into the means of knowing it. This means that they seek accountability both for events and for the devices with which we perceive them. They deal with the production of evidence while questioning and interrogating the notion of evidence, and with it the cultures of knowledge production or truth claims that it relies upon. They engage in the presentation of facts while

being aware of the way each presentation, indeed each media form, can distort the very facts they produce. They seek to establish claims to truth while criticising the institutions of power and knowledge with their monopoly over the mechanisms of truth production.

The media technologies of artificial intelligence, satellite images, social media platforms, smart cities or facial recognition cameras are not neutral; they are products of specific political and historical contexts, with inbuilt biases, opacity, partiality and illegibility and have the potential to enhance discrimination and domination. These biases may not only be those that entrench existing social norms, which have to be fought and reworked, but also those that are particular to specific media forms. These might be particular idiosyncrasies or predilections. They might texture or produce information in certain ways. Some of these features might even be useful in some context.

Using the technology at our disposal, we try to do two things. The first is practical: to employ it as an aid and a context in investigations, presentations and dissemination of data and ideas. And the second is critical: to use the occasion of its employment to offer deep introspection into – or critical self-reflection on – the way such technologies are conceived and operate. This could include investigations into the histories of power that gave rise to them, the biases or tendencies internal to them and the present abuse into which they might be incorporated.

The premise here is, however, that critical examination of specific technologies can often best be achieved through employing and reworking them. It is through critical use, and in practice, that contradictions, biases and limitations can be most fully identified, understood and, when possible, exposed. Every investigative use of, say, satellite photography must acknowledge its military history and 'resolution biases' (did you ever notice some parts of the world are available only in

low resolution and wondered what happens there under the veil of blur?) as well as limitations of access (people in some places have no access to these services).

Likewise, a critical employment of machine learning and artificial intelligence can try to achieve the same. Forensic Architecture may be using machine learning to help sieve through and triage an ever-increasing amount of video evidence circulating online, but it also uses the occasion to try to shed some light on the computational processes underpinning them that are otherwise often opaque and unaccountable. In short, 'investigative aesthetics' uses technology, but interrogates the politics of the very technology it uses; it uses multiple platforms to represent things publicly, but queries the limits and politics of these fora of representation; it involves knowledge production while keeping a critical eye on the power–knowledge nexus.

As such, investigative aesthetics has not given up on its roots in critical theory and is not turning to the positivism of old. It remains suspicious of terms such as 'fact', 'evidence', 'truth' and 'knowledge', but seeks to reframe and tease them open rather than abandon them. They are repurposed and reused in a way that yields the productive payload of critical insight. Drawing on work undertaken in recent decades in areas such as media theory, critical environmentalism and science and technology studies, it mobilises both meanings of the term 'fabrication' – making *of*, and making *up*.

Another important aspect here is that every practice seeking knowledge relies on forms of expertise: in the use of this or that technology, in the attainment and transfer of local knowledge or a certain mode of existence, in access to discourses of politics or law, in experience of political activism and so on. Investigative aesthetics does not seek to flatten out expertise and experience, but to network them in a democratic fashion; that is, to recombine their different forms. Recognising polyperspectivity can be a way of bringing together forms of knowledge and experience from multiple sources.

Such work seeks to develop a methodological diagram in which investigations are undertaken through a set of collaborations between those belonging to different fields and practices. It combines people's direct experience of an event with the traces left in inert or active matter as they can be recognised by computational codes and interpreted by technologists. There are substantial ethical questions around the adequate formation of such alliances. A primary principle is that it is essential for them to be led by the people on the front line of struggle – hence an emphasis on learning as a prerequisite of such investigation.

The 'epistemic communities' that come into being through investigative aesthetics include groupings that are not solely human, but also recognise and find ways to work with their ecological co-composition with plants, minerals, animals and multiple technologies.[14] This in turn calls for investigation to be undertaken in and alongside those places designed to be tuned to signals of different kinds: the laboratory, the field and the studio.

Further, truth and aesthetics need to find different modes of coexistence. In doing so, investigative aesthetics expands the sites of truth telling – from the courtroom, the university and the newspaper, to the gallery, street corner and Internet forum. Each such site requires multiple kinds of transversality to reform relations between groups, practices and sensory objects and surfaces, and indeed necessitates conjunctures between different knowledge cultures, some of which need to be treated with caution.

——

The rise of what can be called *anti-epistemology*, often referred to as 'post-truth', makes the work of investigative aesthetics all the more urgent. In recent incarnations anti-epistemology is the stock-in-trade of a digitally oriented, racist and ultranationalist tendency that has made the obscuring, blurring and manipulation of facts their path to power. Investigative

aesthetics is partly necessitated by the bluntness with which the rise of reactionary governments and their online volunteer brigades and proxies rule through the distortion of facts and the promulgation of vivid falsehoods.

Investigative aesthetics seeks to challenge established formations of power over the always complicated questions of truth. This challenge is urgent because it happens at the same time as the rise of political powers that aim to replace the always conditional concept of truth with a thrilling sense of certainty. Such certainty can come in the form of ideological blinkers, both in the sense of fixed ideas and in that of the bundles of norms and routines that accrete as a subject. But it can also come with a snigger or with bombast as the 'free' speech of those who say 'what everybody knows but are too afraid to say', an apparently anti-ideological opportunism that lauds itself as the virile opposition to technocrats and weaklings.

For such figures of certitude the present condition of multiple interlocking crises – ecological, social, political, technical, economic – is one in which truth has become recalcitrant. Science, for them, is both lauded and admonished. The idea of science is upheld when it can provide a source of uncomplicated facts and attacked when its actual practices describe the necessary conditions of doubt.

Individual governments built upon such attitudes may well be phased out, but the methods of aggressive anti-epistemology will survive them. Fact-formation is undermined through means that do not attempt to arrive at truth, but to impart the frisson of rebellion through conformity. By these means, histories of genocide, structures of white supremacy and patriarchy, and systematisations of state or corporate violence, colonisation and dispossession are naturalised and placed beyond question.

Rather than attacking this or that fact separately, 'anti-epistemology' hinges on attacking the very conditions for facts to be created and verified. For power to rest on unverified

claims, the groups and organisations working on the means to arrive at understanding facts, such as civil and human rights groups, universities, scientists or investigative media, become prime targets for attack and undermining. Subjects such as the arts and humanities that critically interrogate the ways in which truth is arrived at and represented, and that equip people to question the formation of meaning, are vilified or demeaned as 'low-value'.[15]

Further, political chancers wishing to prove loyalty to a political base conduct public hazing rituals such as pitching slurs on areas of research like critical race studies. The more fact-free the political rhetoric, and the more it moves into a performance of an ideology for its own sake rather than any even basic attempt to engage with the ostensible topic, the more the base is thrilled. In a slightly different way, scientists are targeted, by smear-merchants in the press, to show that 'like the rest of us' they are merely venal and partisan, a message bearing two intentionally demeaning payloads. The corrosion of means to engage with the facts is productive in both cases because the void can be filled with whatever the authoritarian leader may say is the truth, or with the buzz of sensations such as outrage or resentment.

The issue of post-truth, as exemplified lately in figures such as Donald Trump, Jair Bolsonaro or Viktor Orbán, may or may not be on its way out but such attitudes towards truth are not new and are very familiar to colonised people. The 'boomerang effect' by which processes tested out in the frontier return to haunt the metropole of empire was already mapped by Hannah Arendt and Rosa Luxemburg.[16] What those confronting colonialism for generations – like the Palestinians or Black movements – have always been aware of has merely become more generally visible. Techniques of perception management, obfuscation of violence and dispossession, the destruction of evidence and megalomaniacal evasions have merely recently migrated from the frontier of colonial

conflicts to beach like a carcass onto the shores of mainstream Western politics.

Colonialism and empire may have had science and technology on their side, but were, and are, epistemological wrecking balls destroying a plenitude of different forms of knowledge and perception. Genocide and ecocide, besides being forms of erasure in themselves, were always accompanied by the destruction and denial of the evidence of their very occurence, or naturalised these forms of epistemological devastation as 'progress'. As empires ebb and flow, so do the operating terrains of their rulers and their techniques.

Though it often serves vested interests and originates from well-funded political or corporate power, 'anti-epistemology' portrays itself as an anti-institutional position. In a denial of histories of repression, anti-epistemologists use the scorched earth of the erasure of knowledge – the destruction of facts, their meaning and the due care they require – to build a paranoid, conspiratorial, nationalist, colonising society that happens to fit very snugly with certain familiar economic structures.

The unprecedented epistemological challenge of our era has no source in the critical epistemology of 'postmodernism' or 'post-structuralism' as some commentators suggest. Such tendencies actively questioned institutional forms of truth. These critical currents in cultural theory were significant in opening to, and often being driven and created by, repressed voices that challenged the status quo of power knowledge. The organised roll-out of 'anti-epistemology' does quite the opposite. It is a centralised and strategic attempt to deflect, hide or justify forms of privilege and ever-new forms of state violence, ecological catastrophe and racism, and then smirkingly claim them to be suppressed minoritarian positions.

The volume, reach, speed and targeting of anti-epistemology is magnified by the digital enclosures that have emerged on the Internet. Platforms such as Facebook or Baidu corral control

over information and enhance misinformation, yet camou-
flage themselves as places of diversity and personalisation.
They act as sites of community, but in doing so they inter-
pose their own grammar for the way these come into being.
The centralised power of such platforms allows the feeding of
multiple truth-like substances to different sectors of the Web
or to create bubbles, some of which produce threshold areas
of anti-epistemology.

Indeed, the filter bubble is a very different kind of space to
the idea of the public sphere as which it masquerades. Many
governments have established disinformation and misinfor-
mation units, composed of humans and bots spreading lies
over social media, spreading automated doubt, and seeking
the fissures in existing societies in order to aggravate them.
Information warfare and marketing are increasingly seen as
different shades of the same basic techniques and applied in
many different contexts.

If the attack on mainstream, established, institutional exper-
tise by anti-epistemology is a quest for the destruction of the
old order and the seizure of authoritarian affective power, a
tempting response to it might be to buttress the familiar cus-
todians of factual authority, the academy, journalism, public
administration, the judiciary, the police, perhaps even the FBI
or other intelligence services that seem to be holding together
the 'liberal epistemic order'. To start championing the power
of institutional expertise *as such*, rather than requiring its
passage through critical evaluation, would leave us to simply
believe in the now quaint institutions of state. This would
swap one mechanics of falsehood for another, recursing into a
political–cultural battle of attrition.

Any contestation of the strategies of denial and obfusca-
tion must contend with the reality that there is no longer any
immediately universal standard or norm that we can turn to
and make absolute measurements with. In that respect, an
investigative aesthetics must take on part of the challenge of

post-truthers, while combating others. Investigative aesthetics must go on questioning the mainstream institutions of state-sanctioned authority, but crucially it proposes something else, an alternative, and rigorous, collective and diverse set of truth practices.

To some extent society might have itself to blame for elevating scientific authority over truth, rendering it unquestionable. Nuclear power, racist algorithms, the domination of disciplines such as geology by oil companies, the endless 'accidental' devastations of pollution, the epidemic mayhem of intensive farming and science's too eager siding with whomever offers research funds, all play their part in the slackening of trust. Though the scientific process is conceived to be open and collective, when used as political currency, scientific truth often tends to be presented as too complex to be contributed to or questioned by the 'general public'. This results in the institutions of science sometimes taking on something of the guise of their theological predecessors – inherently true, beyond reproach, with transcendental qualities.[17]

It is thus no wonder that what we today see across widespread locations of many kinds is a sense of inchoate rebelliousness. If the institutions of truth demand belief in the form of simple allegiance, then no doubt opposition will be articulated as heretical. The rebellion against scientific experts and the institutions that buttress facts thus resembles, in some aspects, the Reformation's rebellion against Rome. Indeed, few of the current crop of anti-epistomologists have been slow to cast themselves in the image of insurgent speakers of truth to power. It is a fight for power that deserves a few incredulous giggles, but it has its merits.

Over the presumed ruins of institutional truth, 'anti-epistemologists' present truth as simple and given, ready at hand, its weight coming from mere pronouncement. Rejection of a given authority is simply replaced by affirmation of another. In this struggle perhaps the current push to passive

skepticism towards expertise can be taken as a prompt to look for other ways of producing and disseminating knowledge. Under the bargain bucket cynicism of the anti-epistemologists, a simplified idea of fact, a cartoon positivism, has emerged. Fact and truth might seem like synonyms, but in the regime of the anti-epistemologists, 'truth' is a kind of pronouncement whose authority presents something that cannot be challenged, tested or critically articulated. It is transcendent. By contrast, in the full sense of the word, *fact* is something grounded in the very process of challenging and testing.

A different line would be to embrace the challenge to institutional authorities of power knowledge, while opposing and combating the methods of anti-epistemologists. It is precisely when the value of truth is unstable that we need to question both facts and fact-making: when we cannot rely on the authority of experts and their institutions of knowledge that are debated and decided upon outside the public domain and outside public scrutiny. Then, we must find ways to bring this debate to the public, perhaps meaning in turn to take part in *making* publics, seeing them as active entities that gather around specific issues as sociologist Noortje Marres suggests.[18]

Models are awkward. Calculations come with caveats. For those in power it has often seemed far better to emphasise truth merely as an exercise of power on the one hand (theirs) or as a matter of a point of view in the hands of the other, where it is essentially trivial, rather than something that has to be struggled for and worked at. Investigative aesthetics can act against this tendency by insisting that truth is something with which one is careful. As the philosopher Isabelle Stengers argues in her 'Manifesto for Slow Science', it is necessary to carefully recognise the tensile interrelations of emergent facts, the knowledge and positions that make them credible and the penumbra of possibilities that surround them.[19]

An aesthetic of truth reduced to certainty offers *veritas* a quasi-religious ideal of cognitively affordable simplifications

that rise toweringly above the everyday muddle. Veritas, though by its nature impossible to state, is seen as *that which is simply the case*. Here, fear of the complexity of the world is answered by an elated simplification of it, manifesting as a farcical remake of the defensive corrals of species, gender, race, nation and the pre-eminence of capital.

This is the opposite of the aesthetics that revels in, and struggles with, complexity in the world. In a sense, then, this book bears the traces of a conflict within and between different definitions of aesthetics. It points to an inter-aesthetic conflict – tending, in certain inflections, perhaps, towards an aesthetic civil war. This struggle is as much about what aesthetics might be, what its boundaries are, and how they might expand.

———

The means to arrive at a fact change over time, and achieved facts change as information and sensibility is gained. Furthermore, in the present, 'fact' becomes a term whose meaning increasingly works in relation to verificatory practices of modelling and contestation, prediction and testing. Facts always entail a relation to a hypothesis and to conditions of reflexivity. This is to say that fact, and the means to access it, must be constructed with great rigour as well as with the imagination, the probing of what is possible.

Though sharing aspects of the suspicion of the societal pillars of power knowledge, but instead of the relativism and conspiracy of the post-truthers, investigative aesthetics proposes a more vital and risky form of investigative production. Whereas anti-epistemologists indeed do anything but investigate, investigative aesthetics most often seeks to integrate (but not homogenise) multiple viewpoints, opening up the circles of investigation, establishing new alignments between different sites, styles and institutions of diverse types and standings. These include the science laboratory, the artist's studio, the university, activist organisations, social groups rejecting the

status of victim for that of agency and leadership, national and international legal fora (when they can be effectively used), the media, and cultural institutions. This kind of work seeks to create a poly-perspectival assemblage of open epistemic and aesthetic multiplicity. As such, the process of investigation might itself establish a social contract that includes all the participants in this assemblage of truth production and dissemination that Forensic Architecture calls 'open verification'.[20] Facts bearing upon public decisions will have to be produced, presented and verified in the public domain. Sometimes when the fora for such contestation do not exist, when, as is the case now in many places, the communicative situation resembles a civil war as much as a public sphere, the production of facts can catalyse social production. Here, we find communities taking on the means of production: the production of the most precious meta-political condition, that of the reality around them and in which they are formed.

And facts are indeed produced in conjunction with powers, those of capacities of sensing and sense-making, but also of politics. Nietzsche's attack on the overconfidence of the imperial positivism of the nineteenth century, where he stated, 'there are no facts, only interpretations',[21] can be a guiding maxim here. For Nietzsche, there are no facts in and of themselves.[22] Everything that stabilises out as facts are composites of many things: the capacity of a language or other such system to describe a phenomenon, the political interests running through the institutions and devices that seek to sense or describe an event or a formation of matter that composes the narrow reading of the fact, the recursive calculation of a probability. Facts form at the convergence of multiple perspectives.

Nietzsche's oft-abused phrase has been badly interpreted as an attack on facts themselves rather than on the naturalised and transcendent decidedness that they were taken to embody. This is not simply a matter of relativism, where all statements are equally valid. Critics of Nietzsche's insight miss the way

in which he was writing in a post-human sense. If we take the condition of knowledge about climate damage, for instance, it is not simply a little game of truth arising between scientists, corporations and their politicians, with an agitated penumbra of consultants, PR merchants and activists of various kinds. Rather, it is a condition in which the facts – embodied in water, weather, climate and species – are forcefully making themselves known as their own manifestation of power. A question posed to our societies is that of their adequacy of knowledge and of response.

In this book, we want to lay emphasis on creating a new diagram, a new set of relations between established institutions, organisations and practices of different standing that can also work alongside developing forms such as the assembly – a form emerging in political movements of this century to try to place the formation of knowledge at the centre of decision making.

In this way, the investigative mode is also a challenge to systems such as the university's arrangement of forms of knowledge. Pursuing investigation as an intellectual form of engagement requires different forms of pedagogy. The university is, of course, not only an authority-giving framework, but also based on the disciplinary logic of the division of knowledge and the budgetary silos, citation wells and rivalries that go with it.[23] Such a structure is itself a legacy of modernisation with its entanglement with empire and colonisation.[24] As new kinds of enquiry are pursued, adequate forms of pedagogy will become necessary.

One tendency in this mix can be seen in the classrooms in which we teach where immediate online access to factual debates around every term that we might propose is a welcome turn. It is one that both undoes and conversely ramifies the tendency of the humanities to slow, to become scholastic, as details and interpretations are teased out. This leads to a gentle levelling of those hierarchies based on knowledge understood

as mere information recall alone. Pedagogy must thus become a form of navigation between existing debates, frameworks, sources and techniques.

———

In order to bring aesthetics and investigation together we want to develop a set of considerations about each of these terms. Part 1 of this book is about aesthetics, Part 2 is about investigation, and Part 3 is a proposition for further work.

Part 1 starts us thinking through the multiple layers of the notion of aesthetics. It argues that aesthetics is a mode of perception, a combination of sensing and sense-making, one scaffolded by assembling multiple perspectives and situated registers.[25] As sensing combines with sense-making, interpretation becomes crucial: what of, and in, the sensory flow should be foregrounded? What attended to? What does it mean to be aestheticised? These questions may appear quite abstract, but, when brought together with those of politics, and an analysis of how power flows through and is shaped by aesthetics, these definitional grounds are necessary to provide working foundations. These foundations are distinct from absolute ones, in that the conditions from which a statement is made also need to be drawn into the work of the investigation.

As we have outlined above, sensing relates not only to human sensing but also to that of matter more broadly. Our insistence that aesthetics is active beyond the human, and that sensing is also prevalent in complex technical assemblages, in ecosystems, and in the multiple relations between them, draws on the fading of the antagonistic division of disciplines between the sciences and humanities. It is also the result of a more general sense that it is necessary to mark a further shift in the way in which human understanding ceases to be locked in geostationary orbit onto a particularly gilded fraction of the human population. The West, and the global North, are provincial; their epistemic cultures can learn a little reticence.

After these opening formulations, Part 1 then proceeds to describe interactions and tensions between different kinds of aesthetic formation. We go on to propose two other terms derived from it: *hyper-aesthetics*, which takes into account how aesthetics enters into relations of power in various ways, becoming a ramified sensitivity to the formation of sensing and sense-making; and *hyperaesthesia*, a condition in which sensual overload 'crashes' sensation, when sensing and making sense part ways.

Part 2 takes on the other term that makes up the title – *investigation*. It distinguishes what we call 'the investigative mode' from other kinds of inquiry. In particular, it aims to show how investigations call for supplements as well as drawing on the critical inquiry we have been accustomed to in the fields of arts and humanities.

The practical tools and the aims of investigations present an intensely diverse field. Since engagement is a way to attain knowledge, they also involve intervention, not only reflection, and are transdisciplinary and grounded in practices. So besides nest-making birds, the book introduces other investigative figures: cats, angels, private eyes and ears, coders, the office (state investigations) and the open-source investigator scouring through a seemingly endless flotsam of image and code. These characters are 'aesthetic practitioners' of sorts alongside those commonly understood as belonging to this category: artists, architects, film- and image-makers, curators: our students, fellow travellers and colleagues.[26] All engage in new kinds of investigative work mixing journalistic, scientific, technological and artistic sensibilities in constructing and assembling evidence about the world.

These figures render investigation visible in different ways, move backwards and forwards between figure and ground, perception and field, model and reality, articulating the components of these things as they trace their interaction. But this is not simply a map of the progress of the means of discovery

as they proliferate, it is also one of the ways in which epistemic operations, speaking in certain tones, drawing with a particular set of shades, constitute the capacities of sensing and sense-making that are mobilised in investigation.

Crucially, investigation also involves mediation. Incidents require different kinds of attunement and sensitisation. The historical development of investigation has necessarily been one of a proliferating variety of forms of media, understood as systems for the production, storage, circulation and analysis of information. Media, in turn, increasingly constitute the grounds in which investigations must take place. We try to track, or at least to provide initial pointers towards, this changing condition of investigation. We also note how the different epistemic formations that emerge around the problem of investigation are simultaneously reworkings of the aesthetic, technical and political.

In the last part we try to make our propositions more explicit. We show how aesthetic practices can build new diagrams of critical investigations. As a formation arranged via knowledge, articulated as precisely as possible around specific occurrences and broader problems, investigation necessarily becomes a form of collectivity building.

This potential sets up the possibility for thinking about new forms of organisation and the reworking of older ones, such as that of the lab and the studio. These changes to specific organisations of investigation and aesthetic experiment in turn suggest a wider set of opportunities to rethink the nature of aesthetics and investigation as a form of commons. Given that the sensory occupies such a big part of our thinking, perhaps it could even offer a new figure of 'common sense', different from its meaning as the naturalised epistemological status quo. Commons are not necessarily a site of harmonious sustenance and eternal agreement, of course, but of negotiation, and even of struggle. At the same time, the establishment of such sites as something in common also sets them in motion.

Part 1 Aesthetics

1

Aesthetics beyond Perception

What is *aesthetics*? The notion of aesthetics that we invoke is distinct from its colloquial or specialist use. To aestheticise something is not to prettify or to decorate it, but to render it more attuned to sensing. As such it is also different from the way it is often used by practitioners of art and culture. Rather, we employ a variation on the classic meaning of the term.

The ancient Greeks used the word *aisthesis* to describe that which pertains to the senses.[1] *Aesthetics* thus concerns the experience of the world. It involves *sensing* – the capacity to register or to be affected, and sense-*making* – the capacity for such sensing to become knowledge of some kind. The finding or invention of means to achieve such effects is to aestheticise.

Defining aesthetics in this way allows us to derive two other terms: *hyper-aesthetics*, which we consider to be the augmentation and elaboration of such experience, and *hyperaesthesia*, which we consider to be the state in which experience overloads or collapses, and, as a result, sensation stops making sense.

In this expanded meaning, as a way of sensing the world, aesthetics does not exclusively refer to a property or capacity of humans. It equally refers to other sensing organisms, such as animals and plants, which themselves apprehend their environment. Further, we argue that sensing is also found in material surfaces and substances, on which traces of impact or slower processes of change are registered, including in digital and computational sensors, which themselves detect, register and predict in multiple novel ways.

But aesthetics is not only about sensation or receiving information understood as a passive act; it is also about perception, the making sense of what is sensed. This entails modes of knowledge production, of figuring things out. Sensing is thus only a part of the more complex question of sense-making. The former is the result of the receptive action of a sensory organ, a material or a system. The latter involves experience and understanding of what is being sensed, a perception and conception, or a world view, if you like.

Making sense involves constructing means of sensing. This can take place through the design and development of technologies and techniques – literally making senses – or of reflections and enquiries into sensing, making sense as reasoning of different kinds. The sense-making aspect of material aesthetics is more complex and always involves relations between substances and organisms. We should also keep an open mind as to whether artificial forms of sense-making might arise.

The two meanings of aesthetics – sensing and sense-making – are not reducible to each other. In fact, they are sometimes not even conducive to each other. One can, for instance, be deceived by one's senses, by an ideology or turn of thought, by a perception of accuracy in an instrument. Both sensing and sense-making, then, each necessarily involve a tension with the other. They may even sometimes seek to undo each other.

Each sensing event has a particular mix of contributing elements that distinguish it. In the unfolding of each sensing entity and process of sense-making, aesthetics is situated and perspectival. Each particular form of experience has inherently unique aspects that not only shape it but constitute it. This given, aesthetics can also be a collective practice which assembles the multiple varied and sometimes seemingly incompatible situated experiences – of different individuals and groups, of matter and code – into a poly-perspectival rendering of a situation, combining multiple views from within. Unlike other entry points into fields of knowledge, aesthetics, conceived in

this way, does not appeal to a universal a priori knowledge. There is no privileged or external position from which to make aesthetic judgement. It is, rather, both collective and additive. The experience of different people, for instance, varies depending on their location, privilege and cultural history. Human experience is substantially different from that of non-humans – bats, pangolins, apes, plants, clouds, digital cameras, thermometers or rocks. Indeed, we are not just talking about the sensing capacities of immediately identifiable entities, but also those of more diffuse systems such as economies that can be seen as a complex and varied aesthetic field in which a huge number of sensing points – many more than simply price, such as interest rates, parameters of leverage, volatility of rates of profit and others as well as their complex relations to desire, knowledge and social processes, are present and active. So aesthetics is an approach that is fundamentally about assembling, and finding the means to recognise, a multiplicity of different forms of sensation.

Further, aesthetics does not solely pertain to or spring from an individual thing, such as a person, an object or a plant. In fact, we argue that aesthetics is always relational. Relationality always means that something is always also occurring beneath and beyond individuating entities and dynamics.[2] Indeed, as the expanding academic field of the posthumanities emphasises, computational systems, new biomedical forms and the urgency of ecological understanding compel us to go beyond the frame of what is understood to be individual human perception.[3]

Aestheticisation, the process or act of becoming or making sensitive, is dialogic and collective, just like an emotion is relational and justice is assembled. There is a process to take part in it, but it is also necessary to recognise how the sensing self is an occurrence. The conscious subject is built up through the interaction of numerous entities, systems and experiences. Each of these may have quite distinct aesthetic capacities. The

event of an aesthetic relation between processes manifests in dynamic transformation.

Aesthetics is, crucially, a question of the material relation within and between entities and the ecologies of which they are part. Given this, we must note that materials are aestheticised to each other without the need for human perception and intervention as a convenor. Communication is not simply about sending signals, but it is about transformative interconnection. Examples of such basic sensing might be the way the electron is in thick communication with the nucleus, or the way molecules key into or repel each other, or the moon dances with the tide. A crucial question for aesthetics is to develop capacities of sense-making adequate to such pluralities of sensation.

The obverse of aestheticisation is anaesthetisation, to make the senses numb. Crucially, aesthetics also pertains to the intellect. It implies the ability to perceive. This can include the ability to recognise pain (in more than its physical sense) and even to sense this in the political sphere. For example, a sense of injustice can be aestheticised or anaesthetised, in fact may be primarily so as a feeling before it becomes a thought. And this can create a link between what one may tacitly perceive, see or hear; what one may feel about what one sees and hears; and how that affects one's sense of right and wrong. In this sense, to be politicised is to increase one's ability to be aestheticised to the world.

Sometimes self-anaesthetisation can be necessary to slip out of a sphere of influence, to cauterise a wound. But complimentarily to the anaesthetic, one can also learn to tune into the sensorial dimension of phenomena. Such aestheticisation is not only perceptual, but also may involve creating existential or conceptual dispositions through experience, attention, even by studying. Creating dispositions and devices that dilate perception to illuminate affinities and insights, the work of magnifying and expanding aestheticisation is that of hyper-aesthetics.

Hyper-aesthetics is an expanded state of aesthetic alertness. At one level it can involve tuning in to the sensorial nature of matter and biological substance in a way that is akin to cosmic reverie: a state often referred to by poets and artists wherein the world is experienced in a way that dissolves the self into a feeling of a common unfolding of the world. It is also found in a different way in the development of new technologies of sensing, for instance in the expanded understanding of physics worked through at particle colliders, such as CERN. Here, collisions between accelerated particles are sensed for a fraction of a millisecond by massive arrays of measuring devices. Their sensings are probed in turn by calculations of the possible momentary states of matter produced by these collisions in order to discern what may or may not be present.

But hyper-aesthetic states are not simply to be affirmed: for those with access privileges allowing synoptic oversight via control screens and dashboards, a certain kind of hyper-aesthetic frisson can be garnered from what philosopher Bernard Stiegler calls the planetary-scale *grammatisation* of culture – the installing of a certain limited pattern of operations – taking place through social media.[4] For those with lower-level access, systems that under different political and economic imperatives might be more fully novel experiential and analytic assemblages show different facets. On the one hand social media become infinitely scrollable production lines, and on the other they are sites where fleeting and partial patchworks of affinity can be constructed.

Crucially, hyper-aesthetics also emerges in devising forms of integration between different forms of sensation. First, hyper-aesthetics becomes particularly palpable through the incorporation of human sensing with a network of devices that monitor, count and measure. The unprecedented number and quality of mediating sensors has a politics. What are they tuned to sense and what are they designed to miss? What lies under their threshold of detectability? How are they assembled?

Biometric surveillance, of faces, of genes, of gaits, would be one branch of the 'family tree' of such technologies. Another could be found in the tools and regimes of testing in times of pandemic. Finding the tests that can be aestheticised to the virus is a privilege to those, or those states, with connections, wealth or power. The uneven distribution and accessibility of technological sensors ramifies and produces the sensorium of some. This puts into motion a differential regime of aesthetics that defines emerging geometries of domination. Hyper-aesthetics is saturated with new formations of power.

Second, hyper-aesthetics also emerges in the recognition of an ecology of sensing and sense-making. In such an expanded aesthetics, entities laterally relate to each other as matter to matter, plant to plant, code to code and among and between these, increasingly in novel configurations, such as plant to code, and plant to plant to code, in proliferating cascades of hyper-aesthetic processes that may not go through human consciousness. A simple example would be a greenhouse whose ventilation is automatically adjusted by consulting a moisture sensor: a decision to open or to close windows is made if humidity goes over a specified threshold. There is no inherent need for a human 'in the loop' once the initial programme is set. A more complex one, requiring multiple levels and kinds of sensing and sense-making, is the chains of sensing – from ground, air and orbit – of the mappings of respiration, growth and despoilation involved in the recognition of climate damage.

Such an account might be reducible to a functionalism were it not for the significant matter described well by the novelist Ronald Sukenick when he writes, 'one cannot have control "over" that of which one is part, or even formulate it completely, one can only participate more deeply in it.'[5] Hyper-aesthetics is partly to be found in this deepening of participation, and the recognition of the way in which a 'one' might emerge in such a condition.

An example of the deepening of knowledge that involves sensing and the making of senses through both reasoning and augmentation is the Transborder Immigrant Tool, a collaboration by the art groups Electronic Disturbance Theater 2.0 and b.a.n.g. lab.[6] Begun in 2007, in the shape of an app within a wider campaign, this project brought together a number of capacities. First, as a GPS-based mapping tool it was designed to enable migrants to cross the US–Mexico border northwards and to find resources, such as water, placed in helpful locations by activist groups. Secondarily, the app also delivered poetry that was specifically written for the project. This had the aim of dissolving the border as an experience simply of danger, making it also one of reflection. The project brought together and reworked a military infrastructure, that of GPS, by combining it with a means of political and material empowerment as well as sensual reflection. The exceptionally pragmatic – a means of crossing a border – is combined with the poetry's 'luxury' of thought and experience not trained at any necessary ends, but responding to what some scholars and activists call the 'autonomy of migration'[7] – the ever prevalent turbulence of self-instigated migrant mobilities as the prevalent condition of humanity. The project provides a public service and in doing so asks questions about the design of technologies. It questions whose practices and experiences are augmented and amplified and whose are rendered mute, designated to be lost. In this sense, the experience of migration is a hyper-aesthetic process, tuned to perception, and engaged in counter-surveillance and camouflage.

An important factor in hyper-aesthetics is the way in which different substances – from the most abstract to the most concrete – communicate and share, or competitively and collaboratively, or indeed indifferently, coexist, in sensation. This is the foundation for what we will propose to be an *investigative commons*, or even a common sense. Hyper-aesthetics is thus both an expanded mode of sensation and a condition in

which facts may be assembled out of the coming together of multiple and different modes of sensing.

Sometimes, however, sensing bypasses sense-making, blows it open, and forces it to reorganise in ways that may be sometimes creative even if they are not always very pleasant. The state of *hyperaesthesia* occurs when the senses stop making sense, when information overload short-circuits the logic of reason or the capacity for reflection, sometimes leading to psychic disintegration. It is an aesthetic form of madness, not in the solely clinical sense, but perhaps more in the way that psychoanalyst Félix Guattari saw madness as a disjointed means of figuring out the world that breaks its bounds.[8]

Hyperaesthesia, furthermore, is an informational spasm or fit that is experienced in numerous different registers. It is something that can happen at the level of the nervous system of an individual organism. Hyperaesthesia is often the result of trauma, which could be experienced as a sensory shock which amplifies, distorts or blanks sensation, existing as a filter between sensing and sense-making. Because most of the incidents we discuss are saturated in different ways with ongoing conflicts, hyperaesthesia in individual or collective trauma is an integral component of aesthetic investigations.

This is the reason why hyperaesthesia can also be used as a form of torture, or 'enhanced interrogation', using intervals of intense sounds, lights or smell often alternating with long stretches of sensory deprivation. At another scale, it provides an ideal for a certain form of military strategy which aims to induce it in an opponent at a systemic level, to blind their ability to see and understand what is happening to them by making sure that too many signals arrive at the same time. Hyperaesthesia is among those strategies of overload and of brinksmanship at the edge of entropy that frame the present. This latter aspect of hyperaesthesia is especially found in the strategic rumblings of military-informational dominance and the disinformation campaigns that characterise the sheer

density of contemporary politics, the projection of informational overload to force a sense as much as to render it insensible. In such conditions we can understand that, for certain actors and formations, cyber-warfare becomes the baseline paradigm for understanding communication in all spheres.

2

Aesthetics

The use of 'aesthetics' in this book is distinct from certain other historical uses of the word. In its modern framing, the word 'aesthetics' was established by the eighteenth-century philosopher Alexander Baumgarten. One of his aims was to initiate a basis for art history, and more broadly to establish a training mechanism for good taste.[1] Baumgarten's work later provided some of the source for philosopher Immanuel Kant's formation of the proper activity of aesthetics as the work of disinterested contemplation. This, Kant partly saw as a way of refining the intellect on something that mattered less than those pressing affairs of everyday life and that perhaps had a different significance than mundane affairs. This understanding of aesthetics' capacity to germinate other kinds of experience outside of social routines gave it a potentially subversive power.

One rich strand of aesthetic thinking that followed was developed in poetry by Romantic writers such as Wordsworth and Byron. It aimed to be a counterpoint to the weight of science and industry: to work a seam of ideas outside the domain of the solely rational, related rather to the cultivation of a sensibility and meditation on experience. Their work took in the question of the socially marginalised, or the powers of nature, leaving lasting legacies that remain unfinished.

Elsewhere in the work of Kant, aesthetics was claimed to be partly grounded in a subjective experience of pleasure that was thought to offer up the possibility for a universal understanding of phenomena such as beauty.[2] Yet, as theorists including

philosopher and poet Fred Moten have argued, such ideas of universals have been mobilised to establish, and have been predicated upon, implicit and explicit exclusions based on what counts as culture and who counts as human.[3] The rolling out of the universal in the guise of an invitation to coexist on certain terms established a norm to which that universal pertained. Those to whom the norm was to be extended were assumed to be 'ultimately' the same, or bore the germ of the capacity to obediently become so given the right conditions. Of those who remain uninvited, it was better not to speak.[4]

For these reasons, aesthetics has been fundamentally revised in recent decades, by such fields as cultural studies, visual cultures and postcolonial studies, but it needs to be further reworked in the present. The capacity to sense is not confined to humans, let alone a certain class of them. It is not even confined to intelligent organisms, be they minimally so like algae or complexly so like elephants, but is present in highly differentiated and variegated manners in all matter. This expanded notion of aesthetics does not seek to silence human sensibility but rather augment, play with and test it, to expand and open the conversation to other forms of sensing and sense-making.

Consequently, sensing, or being a sensor, is not only a quality inherent to a specific kind of instrument. Rather, it is a name for the activity of all manner of material things that elaborate sensitivities to the things they come in contact with.

For example, a brick set among others in a wall may not attend to much. But first, in its internal composition, in the ageing of its aggregate components, it records its presence, the kind of earth it has been baked with, the time in which it was laid, the kind of pressure it is subjected to and thus the weight of the structure above it, and in the case of the brick receiving an impact, how exactly the spread of kinetic forces running through the structure of the building are registered. These shift continuously, even if microscopically, in relation to load, vibration, air temperature, humidity, pollution and so on.

What mediates these influences is the brick's material composition; the quality of the clay or other materials; the way in which it was fired; what error, cracks, points of weakness or singularity may exist within it. A brick, one can say, has little to do with sensing a gnat that alights upon it, but it may respond to changes in humidity levels that come through exposure to the elements and certainly to the tread of a bulldozer, the impact of a sniper bullet, or the blast of a bomb or hand grenade. It can environmentally respond, and thus sense, temperature radiation or levels of humidity, salinisation or pollution in the atmosphere. The sensing it makes of the world is inseparable from its composition, which is relatively simple. More complex entities sense in more complex manners. And there are other kinds of sensitisation that involve longer chains of association. For instance, a patch of ground may be able to register, by being transformed, the presence of an organism or a chemical.[5] Each of these in turn may be the trace of an incident resulting from a military or economic policy.

At a more abstract level, something that seems 'immaterial' such as a theoretical axiom can be said to have an aesthetic capacity. This may be expressed by its ability to, say, account for a proposition or to be influenced/affected by others. Even such an abstract thing as an axiom is involved and embedded in a language, which will have its particular capacities for expressing, creating or grasping ideas, and it would also have to pass through a cognitive system of some sort, each stage involving aesthetic translations and reworkings.

Everything senses, therefore, in different ways. But not everything is engaged in sense-making. As such, we are certainly not advocating panpsychism, the belief that everything in the world is sentient in some way. Nor does sense-making always consist of the same substance or processes. Accordingly, a crucial threshold of differentiation is the movement between sensing and sense-making.

Sensing may pass through several thresholds of differentiation and abstraction. What is meant by abstraction here? It is the capacity to recognise patterns whether or not they are related to an observable phenomena. Abstraction allows us to move from one immediate situation to another and see connections and to predict the occurrence of such patterns beyond immediate observation. To abstract is to interpret an observable or unfolding event, even an event that is purely conceptual. This theoretical or mathematical interpretation beyond immediate sensory evidence is necessary for what we call sense-making.

Abstraction can work as a form of transformation and translation that also implies differentiation. A touch between humans is not sensed as merely material contact – it has meaning. Through cultural translations and particular relational configurations it may be understood as, say, a tap or caress, a nudge or a punch. This does not imply a flattening form of understanding that makes everything equivalent. On the contrary, it is precisely in differentiation that sensing becomes significant. Sensing is transformation, and patterns of transformation can also be sensed.

Sometimes different forces interfere with each other so that the sensed trace is not linear but bears the residue of complex interferences. Indeed, no material recording is ever quite pure: it is always an interaction of different forms of recording each partially erasing prior states. So the transformations that are fundamentally part of aesthetics are also about losing what might be read as data as much as inscribing it. Information should be understood as 'matter in-formation'. But the process involves information gain, information distortion and information loss. What constitutes information here depends on the aesthetic process involved, on the mode of sensorial capture and processing, on making or not making sense, on the specific conjuncture and what it conjures.

———

Plumbers are aware of a curious phenomenon to do with the roots of certain plants. They tend to travel through dark earth towards the water pipes running through gardens and then wrap themselves around the pipes searching for a point of entry. How do these roots sense that the pipe contains water? Theories about this range from suggesting a capacity to trace moisture gradients in the ground to an ability to somehow 'hear' the flow of water inside such tubes. Sensitivity to movement and to vibration is also known in some species of plants.[6] Such inquisitive roots are aestheticised to vibrations rather like a heliotropic plant such as a sunflower is aestheticised to light.

Ecologies involve myriad such processes of sensing and response, and of sensing of numerous kinds and capacities. Many of these are so minimal that they are conventionally hard to recognise as more than simple mechanical relations between cause and effect.

One of our colleagues at Forensic Architecture, Paulo Tavares, has shown how, after a complete genocide of Waimiri-Atroari, an indigenous people in the Amazon, the trees of the forest were sometimes the only media to bear the traces of the fact that people lived in the area, and of their way of life, the forest being their life-world. The traces these people left on the environment were gentle and minimal, and when they were destroyed the forest digested whatever material their buildings were made of. What is left to be observed are parts of the forest with a higher density of certain kinds of trees, often fruiting and medicinal trees, in the midst of otherwise wild-seeming forest. When walking through these forests and encountering a higher frequency of a certain tree one can assume that these places were inhabited, and cared for in a form of liminal cultivation that is neither orchard nor untouched wilderness, but something in between.

Removing a few centimetres of earth one reaches the soil between the trees. If the earth is relatively blackened this

may be further evidence that it was in contact with fire. Such ground-level study is referred to as 'ground truth', a process that allows for calibration of the colour variation in a satellite image, or the predictive capacity of mathematical models. The area of a village might be no larger than a single pixel on such an image, so the specific terms of the translation from one to the other are important. Looking at the same forest via aerial or satellite images, it seems like an endless sea of green. But by filtering these wavelengths through algorithms calibrated to the level of photosynthesis or carbon sequestration, a visual pattern becomes apparent: areas of the forest that are less efficient at performing photosynthesis appear as geometrical, circular shapes connected by thin threads. It is almost as though the faint contours of a formal logic appear inscribed on the forest. When the Waimiri-Atroari inhabited the area they cleared small patches of forest to build their villages and then opened routes between them. Fifty years after the genocide and the destruction of the villages, these areas are long overgrown. However, as the trees there are younger than the surrounding ones and still do not photosynthesise at the same rate as other parts of the forest they can be detected by such means.

Photosynthesis can be an aesthetic form of registration, as Hannah Meszaros Martin has shown in her study of the evidence of aerial fumigation in the US-led 'war on drugs' in Columbia.[7] Leaves respond to the sun, drawing chlorophyll in their cells, documenting their changing state as they respire. These leaves are in turn interpreted as biological sensors, a 'compound image-surface' translated by other, technical, sensors on satellites.[8] The data from this translation are classified and parsed out by the sensing of machine vision systems that register variation in a forest's canopy. Using a combination of sensors and interpreting algorithms to parse them, researchers can thus see the circles, ellipses, networks and patterns of movement and thus the relation between places, the

network of villages, routes and waterways that existed on this terrain and the way of life that wove them together with the complexly articulated biomass of the forest.[9] The genocide in this area thus challenges us to recognise it via a combination of ecological, computational and media sensors, that extend from the 'ground truth' of on-site excavation of black earth to algorithms interpreting patterns on satellite images.

To trace patterns in a complex dynamic ecology one must learn to pay attention to its own aesthetic refrains and variations. To do so in this case, one must recognise the active shaping of the world by plants. Trees not only sense the actions of humans, but also sense each other and the elements. Many forest trees have evolved to live in sophisticated and interdependent relationships as well as in competition.[10] Such organisms develop communication networks through symbiotic relations between fungi and plants, and through the air, for instance using phytohormones released by leaves.[11]

The experimental construction of hybrid sensorial communities in social and material terms has a vast wealth of histories to draw upon. As the anthropologist Eduardo Kuhn has shown in the book *How Forests Think*, drawing on the life of indigenous Amazonian societies such as the Runa, various species make up a society held together by various forms of communication and interpretation.[12] This 'ecology of selves' involves myriad processes of vital speculation on the semiotics and logics of the others in the forest. It implies forms of reason working in and through minds, dogs, spirits and tools, among other things, and we can learn from these in order to attend to the multiple logics by which things come into being.

The question of how environmental conditions are brought into relation with the internal organisation of an individuated entity is not just a question of direct communication, but always one of transformation. In the sky, the cloud of water vapour arranges in relation to the hillsides it passes over and the pressure of the atmosphere in which it hangs. It thus

indirectly maps them in its own form, abstracting information by direct incorporation. The cloud responds, within its capacity, and in mediation with the air, to the forceful substance of the rock, perhaps by dressing it with rain or ice. These, over millennia, shape the mountain. To sense, therefore, is to transform, to change shape or properties. Indeed, one might not primarily sense rock or water but rather the repeated and interrupted form of this dance.

In a state of growing ecological catastrophe such an understanding of relational and distributed sensing over time is crucial. Icebergs melt to reveal the traces of air from thousands of years past, sometimes releasing deadly viruses lying dormant for millennia. Trees are felled to reveal the logs of climatic damage in their rings. Over possibly hundreds of years such an organism can gradually accrete a history of interactions with its environment. This makes not only the individual tree, but the forest and the soil, into something that may, with the right kind of attention, be read as an archive with a specific residue of events.

———

These examples demonstrate the function of aesthetics beyond perception. It is easy to observe that a sentient being, such as a tuna or a chicken, senses its environment and itself in numerous complex ways, but like a human or a tulip it may also act as a sensor for other events at levels other than sentience. Living organic cells respond differently to radiation, for instance; their complex body may be read as reacting like 'dull matter', their sensing reduced to solely being acted on. This is simply to make an argument drawn from forensics where 'every contact leaves a trace'.

Being acted upon is translated, mediated, reworked, by the structure of the material that receives the force or contamination and so on from another body or process. Take, for example, the shingle on a beach. In collaboration with waves that cyclically wash up on and over it, the beach figures out

its composition as the waves gradually sift the stones and the stones interact and jostle with their near neighbours.[13]

Aesthetics is understood here as the sensing capacity of entities, which are themselves momentary concretions emerging out of relational forces inherent to matter in various forms, via the remote, proximate or overlapping presence or action of other entities and forces. Sensing is the internalisation, and hence mediation, of environmental conditions into the organisation of an entity. That entity, like most matter and all organisms, is quite likely a composite one, and as something that emerges from and through relations, it is traversed by other entities.

To take another example, in a famous botanical experiment it was found that one species of wild tobacco plant (*Nicotiana attenuata*) adjusts both the chemicals it releases and the shape of its flower to attract and enable two different kinds of pollinators – nocturnal hawkmoths (who may lay eggs bearing leaf-gnawing caterpillars on leaves and are thus to be avoided if possible) or hummingbirds who are active by day (and who don't predate the plant).[14] Such plants interact with and produce complexes of evolved predilections and capacities. Alongside those of their pollinators they also interact with the communications of their conspecifics – as their leaves are chewed, for instance, they release chemicals called jasmonates that trigger defensive changes in nearby plants.

All of these terms describe an entity in relation to others, and constitute those entities as a set of interacting relations of different kinds. These elements are mediatic because they contain and express information about their environment.

We are culturally accustomed to talking about 'things' or 'objects'. These are sometimes handy concepts, but they come with a payload. In some readings they may inherit the Newtonian mechanical idea of life as full of sets of separate things that bump into and whirl around each other. In others they may be hedged about by the capitalist ideal of every fragment

of reality being predicated on fungibility. Still others may be based upon the liberal idea of individual choice, or the Cartesian idea of subject and object which experimentally attempts to split thinking from experience.

As such, we need to understand when we are dealing with entities that have been produced to conform to such a mechanics, or whether there is some kind of conceptual version of an optical illusion in effect. When dealing with what are manifest as objects, aesthetics needs also to register the ways in which different understandings of the composition of the world come into play.

This is why the culture of sensing is of fundamental importance: what makes sense to sense. Indeed, the sensing of formations of sensing (in the way that one senses a way in which one is being sized up, by an institution, perhaps, or by a crocodile) implies that sensing also becomes multi-layered, contradictory, pushing in different and sometimes opposite directions.

Aestheticisation is often less about being alert to a specific object on its own (although exceptions would be heavily monitored things such as a component in a nuclear power station), and more concerned with observing and adjudicating relations between things. Aestheticisation may, for instance, be to a chain of relations between a person, a car, a computer and another person, and from this to another network, a relation between people and data, between a territory and money, citizenship status, a racial category. All of these may come stacked amid myriad historical, legal and other layers, between people or machines and the surface of the earth (car tracks, mines, toxic waste). These form multiple simultaneous narratives that often cannot be described linearly, but where each bifurcating thread – of past or predictive relation – needs to be followed attentively and allocated perceptual or calculative capacities.

———

There are two fundamental and partially interwoven changes in the world today that have particular consequences here. One is the ongoing ecological catastrophe driven by capitalism's present incapacity to take more than a few variables (such as price, cost, profit and so on) into account, which therefore treats nature as something to be dumped and spilled into. The other is the increase in computational forms of agency. Computing has a complex set of roots, filiations and affinities that offer many interesting capacities, even if they are presently predominantly entrained to rather mediocre uses (such as the calculation of prices, values and control).

The shift towards computational sensing and sense-making characterised by systems of translation of the world into data and the production of novel terrains in computing, alongside the increasing rates and denser textures of computational processing and recursive machinic means of understanding, opens up other modes of sensing and perception.[15] Some of these are to be found in the intricacies and particular capacities of expression of code, for example. Others, manifesting perhaps in a neural network, occur in the calculation of whether a sensed entity belongs inside a certain cluster of results arranged by a matrix of parameters. Still further, the aesthetics of viral contagion in networks has been crucial to the political landscape of the last decade. The specific grammars of exposure and relay that each platform adopts and shapes form facets of such a development. For instance, when Facebook switched from being a social networking site to being a social media company, a substantial shift in its underlying ontology came about: it became the largest surveillance apparatus ever conceived

Whenever such sensing and sense-making is involved – in, for instance, detecting and connecting patterns, phases and trends and calculating their meaning – a manifestation of aesthetics is inevitably in operation. Producing and sieving through multidimensional data is an aesthetic act, as are

the various formatting, ordering and filtering transforma-
tions involved in datafication – the process of establishing
digital versions of things or actions in the world. Aesthetics,
conceived from this aspect, can involve means and modes
of gathering, filtering, storing and arranging connections
between information-yielding entities. As such, what is taken
to constitute information becomes ever more significant. And
here, the connection to ecologies is of crucial current impor-
tance. Making connections between computational modes of
enquiry, with all their capacities of analysis and modelling,
and physical systems, with all their liveness and heterogeneity,
requires attention to the way meaning is translated from one
domain to another.

For instance, it may be crucial to know how the presence of
a chemical, or the direction and rate of movement in a current
of air in a terrain reduced to a battlescape, can be read. With
what degree of reliable calibration can such a phenomenon be
sensed? In turn, how the data are handled and what, among
the signals gathered, is considered to be extraneous and to be
filtered out, by operatives or software formats and structures,
can be decisive in determining the ways in which sense-making
can occur.

In information and communication science, there is a
traditional hierarchy of complexity that runs from data to
information to knowledge. At each layer, a greater degree of
structural complexity is arrived at. There are many assump-
tions built into this pyramid, one of which is that entities in
the world can workably, if not precisely, be transcribed as data
to begin with.

In relation to such a formulation, aesthetics is an epistemo-
logical and procedural operation that crosses the thresholds
of these distinctions by looking at the way in which such for-
mations of knowledge come to shape the phenomena they
enquire into. In some cases aesthetics may act to merely orga-
nise and to ratify such things, but it may also become reflexive

and recursive by working on the ways things are known. The particular form or style taken by a mode of knowledge can be treated as a datum, for instance. The way in which a mode of knowledge, even one embedded in a technology, comes into play may work at one level as something that arranges data, but at another level of enquiry it may become a tell-tale sign, a small piece of evidence.

An example of this is the way in which the techniques of digital forensics, or the skilled eye of the artist and video editor, allow for ways to recognise 'deep-fake' videos. Particular patterns and disjunctions become evident when careful attention is paid. This attention could be computational, in identifying pixel arrangements that fall out of pattern or that observe it too regularly. It can also occur in intuitive human attention to uncanny gestures, fakes not yet good enough to fool the brain. In turn, the 'too-good-to-be-true' absence of such clues, when a video has been carefully doctored to hide its manufacture, may also sometimes be a sign of the ecology of mediations in operation.

3

Hyper-aesthetics

Hyper-aesthetics is an expanded and ramified aesthetics, in which both sensing and sense-making are intensified. Hyper-aesthetics increases sensation in three different ways.

First, it amplifies the sensitivity of an entity to detecting the environment around it. The capacity for such attunement is increased in conceptual and material ways. To hyper-aestheticise is to exacerbate the capacity of bodies, technologies or other states of matter to sense, sometimes to record what is sensed, and thus to increase the growth of sense-making experience.

Second, it multiplies and varies the number of ways in which entities act as sensors. This multiplication might entail translation within vertical chains of sensation, for example digital sensors reading and interpreting physical ones.

Third, it generates and builds assemblies that synthesise multiple sensations horizontally. While all matter can potentially be read as sensors, the reorganisation of relations between organic and inorganic sensorial matter, people and computers, can increase non-hierarchical sensorial assemblages and even seek to harvest or 'rescue' traces from beneath layers of erasure. Hyper-aesthetics is an elaboration of this general condition of aesthetics – its interlinkedness – to a point where it mutates and becomes reflexive.

Thus the three articulations of hyper-aesthetics are amplification, multiplication/variation/translation, and synthesis.

—

In order for sensing techniques to accumulate to such a degree that they turn all material things into interlocutors and informants, it is necessary to do two things: to heighten the sensorial capacity of matter – including developing the means of recognising such attunement – and to align sensorial surfaces and systems with different natures in a way that elicits communication between them.

The sharpening of sensory devices – for instance the endless monitoring of sensors placed in environments such as a city – no longer involves a prosthetic extension per se, but a new sensing body that may emerge from the interactions of organic material, including organisms such as humans, mites or trees, image-based data such as CCTV images, the machine learning to decipher them, and other material surfaces. The assembly of a distributed sensing body becomes a technology in itself. In such a context, an important part of that is counter- or anti-aesthetic strategies, means of escape, evasion and camouflage that may numb hyper-aesthetic capture by dominant powers.

To hyper-aestheticise then is to heighten, elicit or exacerbate the capacity of bodies, technologies or other states of matter to sense and increase perceptual experience; it entails an increase in sensitivity and can perhaps augment a capacity to care. This is because, from the point of view of the description of relations as informational, to hyper-aestheticise is to work with and to intensify, and render differentially sensible, the entry of information into the internal organisation of entities and relations. Hyper-aesthetics occurs at such moments of transformation and in the residues created by them. Here, 'information' is never disembodied, but always manifest in and as stuff – ideas, chemicals, media, organisms, photographs and so on – all of which transform and translate these transitions. In turn, information is only ever accessible as information through a means of accessing and filtering it. These means will always have their own perspectivalism. These may be incongruous and asymmetrical to the sources of what is treated as information. This

difference creates further information through the very way in which it is translated or incorporated.

Take, for example, the stalling of the atmospheric condition known as the jet stream over Europe in the summer of 2018. As one amid many aspects of active climate damage this is clearly not a solely informational event. But it is one that has multiple forms of composition informing myriad registers of sensing and aestheticisation. It is also a coefficient of the criminal action of powerful forces in maintaining dependency on fossil fuels. The wind, a corridor of cool air that has historically flowed across Europe from the Atlantic, went awry.

The cooler air and moisture that it usually brought went elsewhere or dissipated. It was experienced and undergone by human and non-human inhabitants, as well as being mapped by meteorological techniques and technologies. The event involved the sensory capacities of satellites and water and weather stations, and finally the sweat on our skins. It was experienced in the south of the continent by the fires that melted cars, took lives and burned buildings. Further north, it produced a rare sweetness in kinds of wild berries evolved to grow in colder climes as more sugars were generated in the heat. Further north still, temperatures of above thirty degrees centigrade were recorded well into the Arctic Circle, even causing fires. This is an example of what we call a hyper-aesthetic event.

Sensing this event requires that multiple experiences and kinds of sensing are taken into account. The politics of such sensory events tie together and cut across existing political formations – namely states and cities – and create new ones in which different elements such as trees in southern Europe, ice in the north and satellites in space create a new formation.

These transformations can be interpreted as an informational change that makes hyper-aesthetics valuable for investigation. Hyper-aesthetics multiplies dimensions of sensing and thus provides routes to its intensification. New

channels and gateways articulate and transform the more generalised sensing of aesthetics. Hyper-aesthetics is 'that moment when' sensing crosses a threshold to amplify its range of registers and when sensing is ramified by a further relation to what is outside its normal learned and evolutionarily optimised range. We mean this in the sense 'that moment when' memes typically show: images of peoples' faces when they recognise that their speech or actions have a double meaning of which they had not been aware.

To make sense of this multiplication of meaning, hyper-aesthetic intensification sometimes demands a synthesis and amplification or networking of sensorial bodies. At other times it demands parsing out and separating the sensorium (for instance into vision, audition, olfaction and so on in the human, or other senses such as gravity-sensing electromagnetic sensitivity in others.) This making discrete can be done in order to slow down time and amplify a single 'channel' to harvest more information from it.

Hyper-aesthetics thus designates a condition that is highly multidimensional in the way in which it brings things together. It can be both regularly and irregularly ordered. It may have aspects and manifestations that are strongly determined, as in the layering of sediments in a geological formation or the triggering of a simple mechanical effect by the lifting of a lever. But it can also be significantly contingent, such as the layering of memories in a person. As such, the modes of transformation involved in a hyper-aesthetic event are themselves subject to differential transformation. That they are differential is significant.

A designed sensor, such as a thermometer, if it is made well, often has a more linear causal coupling with what it senses than do other things that might have a looser or longer chain of translation. Designed sensors often have a display, to allow data to be clearly read. In the case of a traditional thermometer, what is read is 'interval data', measurement along a scale

set out in Celsius or Fahrenheit. Hyper-aesthetics, by contrast, names a state that may involve such things, but captures them in other arrangements of activity and interpretation. Indeed, hyper-aesthetics involves and requires not so much reading off a display as active interpretation of material, organic or computational sensors as fundamentally part of a situation, rather than being idealised as external to it.

By being internal in this way, hyper-aesthetics infuses a differential: focusing or expanding aesthetics. Such relations may be probed for their probable or actual capacity to express and register information. The differential quality marks and engenders relations among changes between changes.

Humans are, of course, exposed to a myriad of different phenomena often without ever becoming cognitively aware of or perceiving them: the complex transformation of skin in exposure to light, mutations of other tissues under exposure to certain chemicals, the normal operations of the organs, and so on. The hyper-aesthetic condition may occur as a state of increased awareness, perhaps in an uncanny way, of such insensible actions and transformations. The strangeness of such a condition derives from sensing an impression of something that one does not have the capacity to recognise as such but which is nevertheless sensually manifest – and which constitutes the self, in so far as that might be relevant. This can be the ground of an aesthetic disposition coming into being.

Another valuable guide here is the environmental sociologist and designer Jennifer Gabrys. In her book *Program Earth* she expands the ontology of sensors and sensing. To sense can also be a networked operation that is composed of a multiplicity of different proximate and remote sensors in the air, ground and space. Here, aesthetic sensing is always a part of a massive composition that requires ways of registering and processing phenomena ranging from networks of weather stations to forms of machine sensing, processing vast amounts of data.

Gabrys looks at the urban environment as offering 'new sites,

assemblages and practices of sensation'. She describes Citizen Sense,[1] her project on environmental detectors placed and managed by communities concerned about pollution, where 'clusters of sensors are situated to detect minute changes in the environment, communicating and processing this information locally and transmitting significant data for human detection'.[2] Such sensors can be organic as well as electro-chemical, mechanical and so on.[3] For example, living organisms, such as a moss, can be watched by a camera attached to a computer that watches it for changes in density or colouration in order to keep a recording eye on certain environmental conditions signified by such changes.

Elsewhere, artist and engineer Natalie Jeremijenko has networked communities of mussels with electronic sensors and computers to sense and show the way in which environmental pollution in the Hudson river and Melbourne Bay are experienced by these creatures.[4] When the water is filthy, they close their shells and seal themselves up. When it is cleaner and more palatable they open and start to sift matter flowing through it. Attaching sensors that register this movement, and linking these further to lighting and sound-generation devices that produce effects at the surface, is a way of attuning a human audience to the experience of life underwater.

Evolving or designing new sensors and capacities of sensation, perhaps in such chains of technologies and organisms, implies constructing new figurations of reality and points of passage from one system of sensing into another. Scientific work then becomes an active collaborator in the sensing of the world as a set of resources for interlocution and further sensing. But the sensors that science might employ on such flora and fauna are secondary sensors in the sense that they sense sensors, the multiple systems of the sensing organism.[5] In fact they could be tertiary, or sensors to an nth degree. To sense in each of these stages is to sense a sensor. Recognising the nature of the translations involved is crucial.

Even humans can sometimes act like Jeremijenko's mussels. In their audiovisual essay *Medium Earth*, artists The Otolith Group start from the way some people – whom they name earth sensitives – understand themselves to be acting as a medium for the earth. These people are said to develop embodied cognition of low-frequency electromagnetic signals relating to minor geological ruptures stressing the earth's crust, frequencies that are otherwise sensed by highly attuned instruments. From this human form of hyper-aesthetic attunement The Otolith Group – Kodwo Eshun and Anjalika Sagar – move to describe the way in which other elements across the face of the earth – such as rocks, infrastructural systems and the cast concrete floors of parking lots in California – act as tectonic sensors. 'Medium Earth attunes itself to the seismic psyche of the state of California,' they write, 'It listens to its deserts, translates the writing of its stones, and deciphers the calligraphies of its expansion cracks.'[6]

All bodies of matter and all surfaces are exposed to the environment around them; some impressions linger and register, others are erased and get lost. Some technologies such as sensors and chemical tests are arranged to increase the ratio of what gets registered to what is lost and to offer such registration with a certain range of clarity or precision. Heat, humidity, kinetic impact, gravity or electromagnetic radiation – emanating from proximity to forces in their environment – are only some of the things that may impact material bodies.

There are several levels or degrees of sensorial translation. In these examples, the formations of matter, regardless of whether this matter is classed as a sensor or not, act as a first-degree sensor. To these can be added an engineered second-degree sensor. All the second-degree sensor does is increase the perceptibility and measurability of the first-degree sensor that undergoes or records its analogue material transformation. To take the example of a thermometer again, the glass tube and the measure of expansion are the second-degree

sensor to the first-degree sensor of the quicksilver that expands or contracts within it.

Another such example is a device for measuring the number of threads in a piece of fabric. Invented in the 1920s, and still in use, it is known as a Lunometer after its inventor, later a pioneering computer scientist at IBM, Hans Peter Luhn. The sensor is not much more than an acrylic strip with a line pattern printed on it with an exceptionally high degree of precision. But when a Lunometer is pressed against a fabric it produces a unique moiré effect derived from the number of threads of which the fabric is made. The gauge of the moiré pattern clearly centres next to the appropriate number printed on the acrylic – indicating the thread count of the fabric. Here, an ingenious system applies an optical effect to produce the second-degree sensation.[7]

Necessarily, to go back to the thermometer, there is a process of standardisation and stabilisation required in the purity of the mercury, the behaviour of the glass, the pressure inside the tube, the accuracy of the numerical markings and so on. These are processes of aesthetic refinement. From there, the reading of a number value itself may act as an event, with no reference necessary to the occurrence of a temperature. Equally, there are sensual systems that yield number values that are far more complex than a thermometer. Here, there may be third, fourth, fifth and so-on orders of sensation, each entailing a form of translation. These may be non-linearly ordered, and with degrees of contingency of variation within the numbers assigned to reading them.[8]

For instance, compare the single thermometer with a global weather monitoring system we previously mentioned: millions of thermometers with myriad interpretive layers operating above them that following certain precise queries can be integrated to create a single complex image.[9] Such hyper-aesthetic images can be seen in the exhibitions of research group Territorial Agency, founded by architects Ann-Sofi Rönnskog and

John Palmesino, where composite renderings made of the overlaying of sensorial representations of different natures – from water, ground air, outer space – map the complexity of human-induced transformation of ocean space. The ocean as a concept and reality emerges in their hands as a product of the multiple modes by which it is sensed.[10]

Hyper-aesthetics is a ramification of a first-order sensation into a wider concatenation of sense.[11] The design and refinement of such first- and second-order sensing, but also their implications for further layers of sensing and interpretation, are a crucial domain that occupies much of the history of medicine, war, science and other fields. The composition of such material processes of abstraction is key to investigative aesthetics too – what are the means by which what is supposed to be secret can be discovered when access to it is inherently mediated and blocked?[12] What are the conditions that can be established in each case that yield a sequence of sensings from an event, and how in turn do these register as orderings and disorderings of matter, into images, spatial dispositions, sounds? Further, what are the means of their measurement, evaluation, and description that can yield something significant to an enquiry?

As with aesthetics, hyper-aesthetics is also formed in composition with fields of power. What is attended to, who is listened to, who is counted as having significance, what calculus of indifference is operative, which structures simply cannot perceive certain things due to their very nature. Measures must be taken to open up what is recognised as the political to the sensing and sense-making of people, beings and entities that have been excluded from them, to reshape the political in so doing.

—

With a method she calls documentary architecture, Ines Weizman has introduced a materialist–sensorial dimension to architectural history, one in which the building itself

is considered as a document whose material layers – paint, plaster, concrete, moisture, black mould and dust – are foregrounded as records of the building's own existence in a changing environment. At the same time, other more traditional modes of recording – photography, films, tracing paper and letters – drift into the background as second order sensors, sensors of sensors, or are alternatively seen as other material objects in the world. She thus focuses her attention on the ink, on the razorblade's cuts and scratches on the surface of the drawing, on the material erasures of data, on little stains of coffee or wine, on ink blots left on paper.

This approach is set against the tradition of architectural history that is too often focused on the biography of great architects, almost exclusively men, on grand periods, on the evolution of techniques and styles or on internal disciplinary or international debates, and this at the expense of the way architectural materiality records history. Reading a building as a recording device that registers the actions of its users and the transformation of its environment can help one arrive at unique insights.

For example, behind layers of paint and plaster in the modernist buildings in Tel Aviv – refered to as 'the White City' and understood as part of a Zionist purity and regeneration myth – she finds the traces of systems of infrastructure – as banal as the details of long dysfunctional plumbing systems – manufactured in Nazi Germany. These testify to the effectiveness of an agreement between the perpetrators and their victims, Jewish refugees. In 1933 Nazi Germany, German Jewish organisations and the Jewish settlement in Palestine (Yishuv), agreed that in exchange for the Nazis facilitating Jewish migrants to Palestine in transfering a portion of their wealth, they would use their money to buy German products and support German industry at that time when the calls for an international anti-Nazi boycott were otherwise under way.[13] It was not documents but the material specificity of a certain white cement

manufactured at the time only in Germany that she identified in a stairwell, that complicated the prevalent national narrative where local modernism is presented as a fresh departure from, even perhaps an erasure of, a stale, dying and overabundant European classicism.

In direct relevance to our discussion here, in her edited book *Dust & Data* she further undoes the fetish-like quality of the architectural object into aggregates of ever smaller things, the smallest manifestation of architectural materiality: dust. 'Dust is never a single object. Dust is an environment, the thickness of our air. Its material contents are dry human tissue, biological and mineral substances and of course architectural residue and building matter. If we look at it close enough, we could see in it sedimented historical layers'.[14]

Hyper-aesthetics conceived in such ways is thus not an afterthought to political and epistemological enquiry but a crucial entry point to it. Nor, indeed, does it have to be worked from a necessarily 'beneficent' angle. From the point of view of a determining power, the world often looks like a mess. Things vacillate between the solvable and the irresolvable, the determinable and the undetermined. Sometimes, indeed, they are designed to be kept in such a state. Flushing relations through with power makes them stand to attention, exude data. (Like the 'incitatory strike', where a military probes its adversary with small-scale attacks in order to see its networks of communications light up in response.[15]) But formations of power, for instance those of a social movement, can also be militant and a hyper-aesthetic strategy can also be adopted from this direction. Integrating things, people, organisms, languages into convergent systems of power recalibrates their aesthetic dimension.

Once this process is under way, modules developed for one purpose can be more readily patched in, at lower cost, to achieve a more integrated system. This has been the case with numerous database, record-keeping and surveillance systems, for instance the way in which health, credit and police records

may, among others, be integrated for the supposed convenience of the data subject. Once integrated, they change the nature of what is being tracked and recorded, as well as changing its environment by reframing it in a wider grammar of analysis in which life – in its multiple dimensions – becomes legible and calculable across more parameters.

The life being recorded does not stay the same, since it is now probed and intervened in, indeed partially constituted, through the cross-referencing of categories of enquiry that may previously not have existed, or that may have been in place prior to digitalisation but were not readily integrated. An example would be the way the ready quantification of 'likes' changes perceptions of social interactions. This is something well shown by the artist Ben Grosser in the Facebook Demetricator project, a browser plug-in that removes numerical data from the Facebook interface.[16] These processes draw out, amplify, entrain, reward, wall off and render superfluous and difficult certain tendencies or possibilities.

———

But there are also counterreadings and counterstrategies. Forensic Oceanography (FO), a research group associated with Forensic Architecture has investigated a number of shipwrecks in the Mediterranean. These wrecks were of boats related to the failure of European states to care for illegalised migrants from the global South seeking to reach Europe by crossing the sea who often encounter situations of distress in rough waters.

Each shipwreck occurred at a different period and each is a result of different trajectories, histories and policies coming together. Threads pulled out of each of these 'accidents' may extend to the migrants' movements and routes, the policies used to contain and stop them, the smugglers that put them on lousy boats, the trajectories and origins of the military and commercial ships that they encountered on their way and with which they collided or which refused them help. These in turn

are accompanied by weather and sea conditions, the movement of devices such as smartphones along with the migrants and the transcriptions of their movement made by communications infrastructures. From each shipwreck FO followed the threads of causality outwards to capture the long-term racist and neo-colonial policies of domination at the threshold of Europe.

Reconstructing shipwrecks is difficult because, as Lorenzo Pezzani and Charles Heller, the directors of FO, observe, boats do not leave traces on water. Their response was to hyper-aestheticise the sea, to augment the sensorial potential of water with secondary sensors that translate fleeting, erasable traces. They mobilise digital sensors in both the depths and at the surface of the water and draw on data from environmental sensors in the air or that measure wave height. These data are then compared to satellite radar imagery and even OSRs – optical sedimentation recorders – measuring the ocean's carbon sequestration capacity and thus its surface disruption.

Speaking to survivors, FO helped them reconstruct their memories of the sea, the wind and the chain of events leading to the lethal incidents. They make freedom of information requests and bring lawsuits against the seizure of the migrants' boats, and have subpoenaed for the location data of the distress calls passengers made on their satellite phones before they were thrown into the water. Later, they established the common platform Watch The Med and the associated Alarm Phone, which was used both by migrants and by rescuers to coordinate rescues. In this way, FO demonstrates that to contest the violence of borders, one needs to contest the boundaries of what can be seen and heard, and that to provide evidence of past shipwrecks is also to provide information to help migrants decide upon future strategy.[17]

How to Inhabit the Hyper-aesthetic Image

Three other categories of sensing can throw light on hyper-aesthetics: kinaesthesia, synaesthesia and chrono-aesthesia. *Kinaesthesia* describes awareness of position and movement. This is something that varies across species. Take a frog as an example: its senses are evolved to perceive flies in movement, but it can starve surrounded by dead but equally edible flies. Different body layouts afford and block different capacities of sensing.[1] Kinaesthesia is important as a way of developing alertness to ways in which bodies or objects sense and move in space. But it also relates to the way in which different forms of sensing produce novel kinds of spatiality.

New forms of movement recording require sense-making bodies to understand them, and some of these may have to be invented, something that comes to the fore in contemporary studies of dance and movement by writers such as Stamatia Portanova and Nicolas Salazar Sutil, where the conceptual, bodily and technological combine in different ways.[2]

Police violence cases at Forensic Architecture often hinge on the minute choreography of all participants: their body positions, the movement of hands, and so on. These are sometimes traced by videos shot of the incident from many cameras. No single video could capture the totality of interactive dynamics of people in space, but a 3D model can help intregrate partial information coming from each video. The problem is complicated by the way in which people's interactions depend on what each character might see of the others' movement at each

moment as it is turned, by video, into a series of freeze frames. It is often in small movements of hands, wrists, torsos and legs that questions of intent, threat or compliance can be unpacked.

Another form of aesthetic awareness is *synesthesia*. Noted in art history through figures such as Alexander Scriabin, a composer who felt notes in colour, or Wassily Kandinsky, who experienced different chromatic tones in terms of sound as well as image, or more recently still, Brian Eno's installations of light, colour and sound in which each of these becomes almost interchangeable,[3] synesthesia, in hyper-aesthetic terms, is a synthesis and combination of different sensory elements. Where we see this extending specifically to hyperaesthesia is when they go beyond human senses to interlace with different sensing surfaces and substances, a suffusing of sensing with other logics.

In *synesthesia* the interpretation of stimuli around which one sense is built or evolved is channeled through others. One sensory or cognitive pathway – say sight of a particular colour or shape combination – involuntarily stimulates real sensory experiences in another – perhaps those that arrange a sense of smell or flavour. In everyday life, experiences of the various senses typically run seamlessly together – with no distinct thresholds or gaps between them. But just as *synesthesia* can also name a condition in which the senses come into synchro-nisation, opening up gaps in senses out of which sense-making can arise, it is also a useful concept when investigation takes place amid shifting thresholds of sensory experiences.

In the Saydnaya torture prison in Syria political prisoners from the civil war were kept in a constant state of disorienting sensory deprivation. Their experience of the prison was at the threshold of both vision and sound: prisoners were blindfolded or forced to press their hands against their eyes while being led into the dark cells. They were forbidden to utter any sound, to whisper, speak or scream both inside the cells and out. Because both vision and sound were at liminal states, prisoners gained

spatial perception through the detection of differences in temperature, moisture, light, vibrations and echoes.

The investigation into torture and murder in Saydnaya was based on an interrogation of these sensory thresholds when all memories are conditioned by a state of extreme deprivation, so that ex-prisoners could use them to make their accounts of the place.[4] Sensation emerges here through bringing together technology, social structures and sensing relations and processes. The environment itself is a distributed and variegated sensing assemblage, a non-totalised concatenation of sensory fields. Finding ways to tap into and chart these can be key to investigation just as much as entrenching pathways of sensing and sense-making across such assemblages is key to domination.

Lawrence Abu Hamdan, a sound artist and audio investigator, worked with Forensic Architecture on the Saydnaya investigation. The reconstruction of the dark prison needed to be attuned to their memories of sound. As vision was limited, prisoners developed an acute sensitivity to minute variations and nuances in sound. But sound was also mobilised in terrorising and dominating detainees: prisoners were even forbidden to shout in pain when being beaten and tortured. If they uttered a sound they could be murdered on the spot.

Witnesses to this prison recalled the way that the plumbing and air vents amplified and transported the sound of beatings and the silence of pain and terror through the building. Sound was one of the weapons of torture used by the guards, because being exposed to torture is in itself an effective form of torture. The guards, Abu Hamdan explained, played the acoustics of the space like an instrument. To his ear, the 'sounds of the beatings illuminated the spaces around them.'

But listening to and reconstructing the audio of the building was an act of investigative sensing and sense-making. To draw out their auditory memories as a way of understanding, and to analyse the form and events of the prison, ambient

and contextual background sounds were reconstructed.[5] Echo and reverberation modelling was undertaken to calculate the dimensions of areas such as cells, stairwells and corridors. Incidents were delicately reconstructed within them to test their accuracy. This sonically modelled space enabled the gathering of 'ear-witness' testimonies and started the patient work of assembling memories.

Trauma manifests itself in hyper-aesthetics. It exists as an amplification, a heightened sensation which sometimes accumulates as a degree of pain. Trauma introduces a third layer, a thick and troubled mediation, between sensing and sense-making, bending them awry, but also sometimes creating forms of access to them through the conditions of an anguishing memory.

Trauma can also induce a state of *chrono-aesthesia*. This is characterised by an ability or involuntary compulsion to simultaneously experience past memories, present sensations and imagined future scenarios. Chrono-aesthesia is, for instance, a common phenomenon in prisoners held in the dark or otherwise sensorily deprived. As with the prisoners held in Saydnaya, chrono-aesthesia loosens a person from their moorings in the circadian rhythm of sleep, and cuts them off from sensing the passage of time.

—

The Grenfell Tower fire of June 2017 led to the slow and horrific death of seventy-two people in inner London when the flammable cladding of a twenty-four-storey housing block caught fire and the rescue operation was mismanaged by the police and fire services. In this situation, for many of those that survived, trauma amplified some channels of sense and reduced others. Sensing fire and smoke, residents of the tower awoke, their windows lit up, and 999 emergency calls followed in a fast cumulative sequence, echoing the spread of the scent of smoke, upwards and across the eastern side of the building and across the north facade to the upper storeys.

Police and fire brigade channels were jammed with information. Residents were calling their family members to ask for help or say their last goodbye. Gradually nearly the entire city seems to have awoken in a fury of communication. Shocked at the sight of a residential tower block torched in the middle of their city, Londoners switched on their phones and recorded a few seconds of the horror unfolding before their eyes. Some later uploaded these videos online. Combined, these signals tell the history of the most horrific night we have witnessed in our city. But there were also large stretches of erasure. Traumatised witnesses struggled to describe their unspeakable memories. And there were also the dead who could never describe the slow agonising suffocation.

Each of several hundred people, mostly coming from a large multiplicity of migrant backgrounds, living in the 120 flats in the building had a different but simultaneous experience of the event. For those who could get out, or were rescued, each took a different escape route through the building. The path each took intersected with those of other residents, about 250 firefighters, more than a hundred medics, and dozens of police officers.

In phase one of its report the official Grenfell Tower inquiry attempted to include the testimony of each survivor and of many of the first responders. Although the gathering of testimony is important, the structure of the document is limiting. The problem is that, written sequentially, as a linear text, and with a volume of several hundred pages, the text either proceeds back and forth in time to account for separate experiences or provides accounts of complete, uninterrupted experiences. The latter results in, say, the account of a moment of an encounter or a collision between a sixteenth-floor resident trying to save her life by running downstairs through thick smoke with a wet towel to her face, and the account of the same moment from a firefighter rushing upstairs, possibly being separated by hundreds of pages.[6]

Responding to the request of groups of survivors, bereaved and their legal representatives, Forensic Architecture sought to find another way to convey the simultaneous narratives that wove into the tragedy. A model of the building was designed as an interactive spatial database, navigable in space and in time. The model combined every video taken of or from the building – from thousands of handheld user-generated clips, news footage and helicopter video as well as several CCTV cameras – into a three-dimensional film made by thousands of authors. The model also contained records of as many acts of communication as we could find – phone calls, SMS and social media messages – and then the known movements of every resident and firefighter.

These were synchronised with the oral testimonies of first responders and survivors, data-mined from reports thousands of pages long. To help those survivors who wanted to recover aspects of their memories, Forensic Architecture researchers recorded several 'situated testimonies' – immersive experiences of walking through an eye-level perspective within the model, recalling sometimes lost details as they do so.

The model, as it changes over time, acts as the index for different kinds of information. It is designed to respond to the community's wish for an effective and accessible way to account for what took place, to give a record of the actions of loved ones now deceased. But it also synthesises multiple forms of evidence, to help the legal teams of the bereaved observe and test correlations, connections and associations between events.[7]

The emerging story of the causes of the Grenfell Tower fire seems to suggest a catastrophe was fueled for the sake of a quick deregulated buck aided by the negligence of a racist liberal state. As with all of the incidents portrayed in this book, it is with some ambivalence that, after discussing it, we turn to making a theoretical point. Just a mention of the name of this atrocity should be enough to focus minds on resolving the

problems that it crystallises so brutally. But we felt it necessary because such change does not so readily happen and because counter-powers are necessary to force change, that we have to learn from experience and thus to produce theory.

———

Different figurations of hyper-aesthetics, with their specific augmentation, attunement and attenuation of certain kinds of sensing and sense-making, pose questions to the senses. Ancient and medieval ideas of vision, before the formulation of the science of optics in the seventeenth century, included descriptions of ways in which both the image and the eye were active. Perhaps infinitely thin filmic skins were shed by all things, falling onto each other, and into the eyes. Alternately, the eyes were the root-point of numerous feelers that touched the world in their search for light. In other formulations, the world itself came together at the junction of an eye and what it beheld.

Since the development of optics as a science, further genealogies of fantastical aesthetic formations may be drawn up where machines elaborate novel configurations of visual sensing. The field of media archaeology, for instance, develops rich accounts of historical systems and devices that aimed to produce compound images, sound images, or that entail other novel ontologies of perception.[8] Alongside such work, that of the late Paul Virilio analysed the history of weapons and imaging technologies, showing how the capturing of an image was tangled with the projection of force.[9] We now experience the post-photographic condition which, in theorist Katrina Sluis's account, there is a 'shift in which there is less value to be extracted from individual images than from the relations between them'.[10] The compound of relations between images is sifted and arranged as a new foundational condition for visual culture. That is to say, even photographs have become images in the hyper-aesthetic sense, sensing each other and trying to make sense of the interaction with multitudes of others.

This can be seen in a straightforward way. The software on our smartphones seeks to establish a simple space–time relation between images, one that can be plotted on a map and on a timeline. Equally, when the image reaches the cloud, a complex predictive and compositional relation between images is calculated. These may be to do with the subjects we are likely to focus upon, or with how we are likely to see one image as part of a population of feature-bearing entities. Often, on fancier phones, what the phone saves as a single image of a single moment is in fact a composite of the best elements from a pair or series of sequential photographs, compensating for when, for example, in a group photo there is at least one person blinking.

The post-photographic moment can thus be identified by two distinct processes: the former is the exponential increase in the number, frequency, resolution of images, and the relation between images. Within this multiplicity, viewers, investigators or artificial intelligence systems sieve for specific images, navigate within them or weave them together into narratives. The latter includes the way in which non-photographic material surfaces – the surfaces of our built or natural environment – could, with the aid of super-sensitive digital sensors, be read as photographic inscriptions, registering contact and remote traces. Clouds of millions of digital images join with material surfaces now functioning as images in their own right – an 'image space' or *Bildraum* to be inhabited, which is also always, in Benjamin's words, a *Lebenraum*, a space of being.[11] Inhabiting this hyper-aesthetic image means acknowledging the emergence of such photographic milieu and the way we transform it by moving through it.

Rather than proposing a particular kind of image as quintessentially hyper-aesthetic we want to think through the way in which the hyper-aesthetic condition could be an image-making process in itself. Hyper-aesthetics turns all

material occurences to surfaces or points of manifestation that, each with their own particular parallax, may resolve as images. 'Parallax' is useful as a term here in that it marks the alignment or displacement of a trajectory of seeing. A common example of parallax is the way that different materials modify the passage of a ray of light. A lens, or a body of water, for instance, will have different kinds of parallax effects. The way that an event occurs, in the widest sense of its coming together, will entail what is there to witness it. As we mentioned in Part 1, the surface of the Earth (as one example of a material surface) can be reckoned as an image not because satellite photos of it circulate online or appear on televisions but because the totality of elements in it continuously registers their mutual and highly varied and differential impact and interaction.

To see such material interactions as images is to become hyper-aestheticised to the world. But here, as we shall explain, to hyper-aestheticise is to inhabit. Inhabiting an image means accepting the image-being of all material surfaces, and one's own actions, and constitution, within them. Indeed to do so is to recognise the relatively contingent position of those figures, such as the artist or photographer, who might work with images. Every falling raindrop is a lens, we only need the right eyes and imagination to gaze through them.

Studying the BP Deepwater Horizon oil spill of 2010 in the Gulf of Mexico, Susan Schuppli saw, in the way the oil spread across the surface of the sea, refracting light in multiple colours, the creation of a new kind of image. Working on the insight through an installation *Slick Images: The Photogenic Politics of Oil*, she remarks that 'the photogenic quality of an oil spill ... is part of [the] geo-photo-graphic era in which planetary systems have been transformed into photographic agents'. In this installation she calls these 'hyperimages' not only because of their size but because they register and record the rapid transformations of ecologies.

Vision and other forms of sensing are thus warped by, but also embodied in, anthropogenic damage to the surface of the Earth, such as the changing diffraction of light caused by the melting polar ice caps or accelerated desertification, each entailing a change to the passage of light.[12] Damaged ecologies produce 'dirty pictures', Schuppli says.[13]

Hyper-aesthetic images are not part of a symbolic regime of representation, but actual traces and residues of material relations and of mediatic structures assembled to elicit them. They do not represent processes but are processes, ones that analyse through transformative operations. As such, an image is not different in absolute terms from the rest of the material world but is part of it. Thinking of these material phenomena as images, though, helps articulate a different way to investigate materiality. Each entity, process, event, device, organism and species inhabits and inflects, mediates and translates, embodies and reworks the hyper-aesthetic image. To act, to live is to continuously image and be imaged.

This changes a substantive thing: the relation between an event and an image is not one of action and its representation, but rather one in which the action of matter, from the most abstract to the most obviously physical, continuously images itself. This state paradoxically suggests that we need to be reading reality as a self-referential image: a meta-image. Here, the image is figured as a sensory trace, or cluster of sensory traces, that in certain perspectival conditions gains a capacity to cohere or perhaps to persist.

But – being material – images have real physical resistance, even when they are encoded data and their material surface, their micro-topography, can take part in and shape an event without going through communicative meaning. So the material and the conceptual, their dimensions as sensory surface, and their ability to cohere a meaning – that is, their sense-making dimension – are different facets (as a jeweller facets a stone) of an event, a reading of it, which can in turn become an event in itself.

Certain images indeed become crises, exist in crises, without being registered as events, and vice versa. Devastations of ecologies are thick with such images, for instance, and how productive the world is in this regard! Investigative aesthetics searches for ways of making such images become manifest, of translating them into terms that we can grapple with or that require new modes of understanding and sensation. Investigative aesthetics intensifies the materiality of the image and uses it as a physical tool, sometimes as a vehicle, at other conjunctures as an act of fortification.

Underlying this is the recognition of mediation which is a general condition of aesthetics. This work always involves transformation, as the more subtle or grosser differences between varieties of matter, perspective and situation entail transitions of sensing. Becoming something that stabilises as a fact or a hypothesis requires transitions, the observance and observation of the thresholds and consistencies of such transitions. Eliciting facts requires the invention and deployment of sensorial mediations attuned to catch and to count them as part of the process of the genesis of fact.

Whereas previous theories that suggested that 'all of life had passed into the image', and that this was some species of illusion, ranging, say, from Plato's cave to Debord's spectacle, what is shocking about the hyper-aesthetic inhabitation of the world as an image is that everything has passed into the real, even illusions. Trying to access the real, though, becomes a compounded difficulty since it is tangled up with the reality-forming consequences of myriad, often overwhelming, constraints and translations and the onrush of becoming.

Such a condition in its full sense, indeed, is largely inaccessible because its aesthetics is too intense for humans: there is too much information coming across too many channels, too many things occurring in ways that do not register with organised senses since that would take on too much evolutionary cost for any species to cope with, (requiring too large a brain to be able

to escape, and too much energy to process it all.)[14] Aesthetics is to do with the development of both abstract and concrete means to address this condition, and to make the experience of doing so alive with possibility.

Hyperaesthesia: Not Making Sense

Hyperaesthesia describes a neurological condition in which sense perception radically overloads. In this state, a distorted and even excoriating state of sensitivity can sometimes occur while verging on or tipping over into a crash. This danger zone of information overload is a crucial condition of aesthetic politics. It is the moment where our idea that aesthetics is about making sense breaks down. In hyperaesthesia, sensing pushes against sense-making.

As a neurological condition, hyperaesthesia is often associated with difficulty in enduring light and sound stimuli. In some cases, this saturation of the senses may be manifest to an unbearable extent. Indeed, hyperaesthesia can be a component of physical and mental trauma. Trauma over-registers sensation to a degree that sensation does not add information but erases and distorts it. Trauma's intensity can manifest as a trace that erases its own being. A situation of danger or shock may overactivate sense perception, with the amount of information amplifying, and neurological channels getting clogged, crossed over or splintered. Retrieval is often unbearable because fragments of traumatic memory erupt too forcefully and chaotically, breaking the psychic continuity on which a subject depends. The field of trauma studies has long learnt to accept and be tuned to memory errors, and lacunae that result. Witnesses mistake the length, breadth, height or number of the very things in which trauma is inscribed. Light and sound amplify. The error in itself is thus a record of an incident because it is an index of the way the brain perceived

the intensity and violence of that event. Paradoxically the gap or distortion confirms trauma, which is evidenced by the presence of a knot or an absence. As a record of an event, hyperaesthesia is also found, for instance, in victims of torture who have been inflicted with intense pain and the alternation between information denial (for instance, deprivation of sight and sound) and sensory overstimulus (repeated loud music – as used in Guantánamo, for example).[1] Suffering the trauma of excess pain, thirst and hunger distorts and amplifies the capacity of human means of self-constitution through the continuity of memory, shearing the space–time unity of experiences with violently triggered sensations.

As a manifestation of trauma, hyperaesthesia is not only a psychic but also a mediatic condition. As such it is also one of the limit conditions of hyper-aesthetics. For example: increasing a photographic film's sensitivity to light could be seen as simply aestheticising it to light, but there is always a point where its sensitivity is not able to hold the amount of light information and, rather than registering it, it starts erasing the potential for registration; the negative is 'burnt' clear and the photograph becomes entirely white. The moment when registration becomes erasure that arrives through oversensitivity is one of the basic forms of hyperaesthesia.

A particular aesthetic impression may erase traces of previous ones. When a magnetic tape is recorded several times over, each recording recharges the electromagnetic particles in a slightly different way. But this process sometimes carries over a residue of the previous recording.[2] Susan Schuppli's remarkable book *Material Witness* deals with the way matter – from a filmic negative to glacial ice – can bear more-than-human witness in both recordings and erasures. When a 35mm film begins to wear and crack when exposed to the sun, nuclear radiation or other elements it loses some information regarding the original exposure, but gains others because erasure is always also a form of registration.

Schuppli finds examples of this principle in Vladimir Shevchenko's documentary film on the Chernobyl nuclear disaster of 1986. Filming from a helicopter flying over the site, the celluloid of his film was imprinted with radiation in a way that left a pattern of white spots like exploding stars, as well as irregular audio distortions. Schuppli quotes the film's voice-over: 'It has no odour, nor colour. But it has a voice. Here it is. We thought this film was defective. But we were mistaken. This is how radiation looks.'[3] In this, Schuppli suggests for us the multiple ways in which aesthetics and hyper-aesthetics can slip over into hyperaesthesia.

Hyperaesthesia is not only inherent in the amplification of the sensitivity of single surfaces, but also happens in the massive multiplication of images that are seen as information. One of the recent techniques of war crime deniers is not to seek to remove information, say images, clearly showing their responsibility, but rather to drown these within a flood of other images and information. This is aimed at seeding doubt by generating more information than can be processed. After the Syrian Air Force chemical attack that killed dozens of civilians in Douma, near Damascus, on 7 April 2018, Russian media propaganda, aware that incriminating images were already in circulation, sought to create confusion by proliferating many other images related to the incident, aiming to create enough of a smoke screen to deflect from their allies' culpability.

Hyperaesthesia becomes a form of breakage in sense, a blockage in the capacity to make sense. It is a limit that haunts the artistic project of inventing new senses, new sensual objects of knowledge and new means of sense-making, but it is also akin to the old figure of the alchemist or the magician driven mad, poisoned, by the pursuit of knowledge just beyond their reach. As such a figure in culture, it is one that may in turn be used to refine and proliferate sense-making capacities.

The amassing of sense-making capacity in computational assemblages can trace a trajectory in which such technologies

have become aestheticised to such a degree that they have extended the franchise of the spectacle, turning it into something that machines can enjoy too. To paraphrase Guy Debord, lived reality turns into images,[4] but it also becomes massive arrays of numerical values: a general parametricism that calculates social relations and the relations between words and images like those of a building might be calculated to a certain pitch of grand optimisation via the calculative working through of millions of variables generating thousands of versions. Here is where the society of the spectacle goes out of control, collapsing under its own weight of communication and overwhelming messages.

Hyperaesthesia can be found at the edge of collapse. This makes it a dangerously uncontrollable condition. Hyperaesthesia is also found in the inchoate lava that lies under the temporary crust of the idea of control. Fear of hyperaesthesia, and its fatal allure, haunts and propels the rationality of domination and its post-rational kin. Whenever there is a demand to oversimplify, to assign a complex matter to a binary identity, say, one can wager that there is a horror of complexity at play. Such a fear is the panic induced by an overanticipated hyperaesthesia.

What does hyperaesthesia look like under these conditions? Rather than the loss of authenticity as installed by the spectacle, we can say that it is characterised by a loss of plasticity, of being stuck in a painful spasm, a crash. Hyperaesthesia may happen to complex assemblages. An ecology can, in its own way, suffer trauma. But, without offering a figure of hope per se, it can be observed that this may be the condition out of which something can arise.

The poet Kirill Medvedev remarks on an experience close to hyperaesthesia when, on an escalator descending into the Moscow Metro, he feels all of the neuroses of his fellow passengers suddenly 'pressing' on him.[5] This is a darkly ecstatic reverie. An overpowering awareness of the ongoing

consummation of the world, the myriad forces, neuroses, experiences and capacities composing it. As such, hyperaesthesia may occur through encounters with abstractions, ideas, the sensations of an impression given the requisite difficult delicacy of initial state. The complexity of an intellect, in a nervous system, in a city, may invite not only the occurrence of such an event, but also its interpretation. A question for aesthetic practices is how to develop or to recognise such hyperaesthesia as a collective event, or as a societal condition.

In introducing hyperaesthesia, we described it as being a form of sensory overload, of breakdown. The edges of this condition are something that Medvedev hints at, but they are also something plunged into, with trepidation and fear, usually unwillingly, by others – archetypally so, perhaps, by Antonin Artaud in his legendary text 'To Have Done with the Judgement of God'.[6] The nervous system is a complex internal network folded through the tissue of the brain, but it also extends outwards into the world as if the threshold of the skull is just another material layer to be traversed. A system of nerves can sometimes feel like it expresses itself as a radio telescope of thousands of steel wires strung out layer upon layer in a skeletal parabola extending for a kilometre or more. It reads what might be imagined as the clicks of pulsars in distant galaxies, except that what is sensed may be both more immediate and more cosmic, both the background hum lingering from the Big Bang and the jostling noise of electromagnetic communications and cruelties. Signals may be received or conjured up that obliterate the ability to make sense of them, or that may need such delicate disentanglement that the time taken can never be available to comprehend them.

While dealing with information overload has provided some of their impetus, the fact that information tends to increase has always been a problem with the design of political technologies of many kinds. From the perspective of policing, for instance, from its early inception the archive of photographs

and fingerprints seemed to its users to proliferate and not just capture information about the existence and location of dissident forces, criminalised people, rivals or revolutionaries. Overload and overabundance seem to be the very defining conditions of the archive and the database, and as such hyperaesthesia seems also to be a foundation of state and empire.[7] Finding the adequate political and technical means to assert control – whether by a bureaucracy of clerks, angels totting up a life's budget of virtues and sins, or AI-powered big data – control has to deal with the aesthetic and psychic condition that information panic tends to elicit.

Hyperaesthesia can be what reality forces into effect the moment it is no longer possible to reduce such a problem to a set of simpler ones. It occurs in a cognitive system, one that may be biological or programmatic, individual or distributed, at the moment evolved or designed filters and constraints fail to maintain proper levels of sifting and security.

There may be a single point of failure, or a condition in which all possible breaking points activate simultaneously, creating a new impulsively hyper-aesthetic body, a black hole that swallows all sense signals and sense-making. This is the reason why hyperaesthesia is also an opportunity, a moment of crisis that allows us to reorganise the field of sensation of the sensible, and its relation to sense-making.

In consequence we are calling for a terrain of experimentation. One that develops means of reading, perceiving and connecting sensory modes to aid and sometimes constitute political and cultural interventions. Indeed, even hyperaesthesia – in which sensing and making sense implode – can be worked through rather than simply rejected, as it requires that we relearn how to sense, to make sense afresh. Indeed it is sometimes in the aftermath of hyperaesthesia, from the ruins of perception, that sensing and making sense can be organised anew.

Hyperaesthesia has a corollary in the military terrain, where doctrines such as 'shock and awe' explicitly aim at

breaking the connection between sensing and sense-making by using overwhelming sensorial and signal effects – by using overwhelming force to generate a condition of overload that deprives an enemy of a sense of the normal. Inducing crashes through overstimulation and simultaneous attacks on information structures, 'shock and awe' marked the charnel house of the 2003 war on Iraq where terrorism became a state-on-state method for 'achieving rapid dominance'.[8] Here, in order to break sense, an amassing of sense-making capacity is required, something that remains crucial to aesthetic power in the present. In that sense hyperaesthesia is a central tool of state terror.

Bringing a system to the chaotic situation of hyperaesthesia is also one of the strategies of investigative aesthetics. We need not always make sense. Unpredictability, chaos and disorder can be useful or necessary. An unpredictable release of information such as a leak of petabytes of information derived illicitly from classified state archives can end up flooding the system, generating hyperaesthesial chaos. The resulting information overload is tumultuous. Rather than making sense, this information generates panic in the forces of domination based on the inability to process information. And on this mode of mobilisation of hyperaesthesia, more in Part 2.

Aesthetic Power

Historically, aesthetics is a deprecated form of knowledge, excluded from 'real power'. The artist – who is often equated with the term – is considered unreliable, a double agent or jester, working for themselves rather than for the stabilisation of order. As a result, aesthetic practices gained the potential to mock or critique the status quo from the outside.[1] This role could sometimes appear in the form of a licence, which can be revoked.

Aesthetics has, sometimes opportunistically, sometimes sincerely, also been seen as being of the highest value. It performs as a virtuous state for which all the strivings and strains of real power aim. That is, aesthetics sometimes appears as a code for 'civilisation'. This double condition gives aesthetic work a means of surprise, a tangential line of attack, a sabotage at the summit of its decorous function.

It is perhaps because of this ambivalence that many modern political actors believed that it was necessary to expel aesthetics from the sphere of authentic political decision making. Nevertheless, the more this expulsion was proclaimed the more the art of political power took on aesthetic dimensions. Power became saturated with aesthetics.

There are two crucial tendencies in the elaboration of aesthetic power today. The first mode of aesthetic power operates via *affect*. It involves politicians and others using images, words, memes and gestures, irate, alluring and wounded phrases, to intensify fluctuations of feeling. It is the scandalised, crisis-ridden psyche of the news cycle. Aesthetic power,

in this sense, is a power to induce rage and resentment, worry and fear, arousal and lewdness. Here, scandal travels faster than truth can be recognised, and the political leader has taken the role of the jester, with a licence to mock or critique the status quo from the inside.[2]

The other mode of aesthetic power seeks *effect*. It drives increased investment in detection, prediction and targeting. It aims to route round the perceptual limits of our species by elaborating forms of machinic attention. Where map-making introduced a real abstraction as a colonial technique of power, but kept the famous difference between 'the map and the territory', the tendency of the second mode of aesthetic power is to integrate everything as its own map and monitor.[3] In doing so, it introduces new regimes of accuracy and grammars of action, and novel kinds of error.[4]

The two ways in which political power manifest as aesthetics inevitably cross-fertilise. The first function is related to classical artistic sensibilities with their capacity to command feelings, or even to epitomise the masterful embodiment of feeling per se. Indeed, giving palpable shade to emotions is something that artists have traded on for generations as an alternative to, or protest against, a rational, systemic order. In contrast, politics has abrogated an aesthetic repertoire that involves the embodiment of an aesthetics of sensationalism: the raising of an inflammation of the senses to a condition of the highest value. Sensationalism – which is perhaps the key political 'ism' of the moment – effaces the distribution of sensing and inhibits sense-making.

Meanwhile, as the routine of sensationalism is occurring front-of-stage in a news cycle sliced into milliseconds of live updates and online forcing pens, other things are moving. This regime of sensationalism and its diffusion as a mechanics of participation has become part of a wider, and highly ambiguous, shift where what passes for emotions signifies sincerity, the ability to cut through to a truth rather than mere fact.

The extension of sensing technologies of effect thus tends to provide a ground for the techniques of affect.

A proper cynic, like the ancient philosopher Diogenes, subsists on an ethical and embodied capacity of doubt whose first target is itself.[5] The gullible cynic, one without doubt, who is the ideal subject, a node for this mode of aesthetic power, parades both their fervent belief and their irate disbelief: something not only fuelled, but certified, by emotion and hooked into a system of switches and stimuli. Affect and effect overlay and reinforce each other. In regard to this condition, a first lesson of science is a valuable one. It impels us to treat our emotions, our understanding, our sense, simply as a datum, one that may have significance, even if only as a measure of an error, or an indication of a position of partiality but nothing that is in itself decisive – that is, without composition with other factors.

Something of this kind plays into the second mode of aesthetic power – targeting and prediction – that is one of the main manifestations of state and corporate power today. This form of aesthetics does not operate through regimes of representation – the organising of spectacles of might and pomp – but rather as an *operative* aesthetic that is about establishing and predicting the position, movement and behaviour of things in the near future through systems of sensors.[6] Aesthetic power here is the mode by which people are tracked, surveilled and targeted, whether by advertisements or by missiles. Its characteristics are based on the twin capacity to increase individuated detection (sensing) and behavioural prediction (sense-making).

Prediction and detection are codependent: the power to detect over time enables the calculative capacity to predict. This form of aesthetic power is achieved not only by ever-more-sensitive digital sensors to detect actions, movements and tendencies, but by the capacity to access and integrate a huge number of sensory points from different sources that

surpass the conditions of ordinary sensing and sense-making; that is, it is predicated on hyper-aestheticisation.

How are these mechanisms aesthetic and not solely technical? In order to detect something in the world, a system has to be sensitised to a phenomenon: light passing through a lens, chemicals making contact with a surface, procedural or communicative events occurring in a network, changes in the gravitational field and so on. Since the revelations of Edward Snowden, many people are aware of the aestheticisation of spy agencies to phone calls, to emails, WhatsApp and telegram messages, to keywords in Google searches and to credit card transactions.

Deciding, if it is possible, what is to be aestheticised or tuned into is a sense-making act with political ramifications, as is being forced to be aestheticised to something. Frantz Fanon, for instance, writes about sensitisation to what is taken to construct race and the social fortresses that accompany it, and Judith Butler shows the ways in which the mechanics of gender are a process of sensitisation that is learned and repeated until it becomes what passes for nature.[7] Both show the disjoint and violent formations, the coercions and misrecognitions, the entrainments of lust and disgust and their translations into habit that such systems rely on.

———

Sensitisation is also calculative. Many such calculations we cannot know because they exist within the distributed black boxes of digital enclosures.[8] Such calculation faces in two directions. First, they face towards the past, evaluating how reliable the detection is, whether it has indeed taken place. The probability of an event is iteratively worked through a stacked set of further calculations. Each of these determines the thresholds of nested likelihoods within which it is evaluated. Second, such calculation also faces forward to the future, in terms of what it means for prediction.

Prediction is one of the oldest sets of techniques in human

culture. Each shift in kind of knowledge – from, for instance, magic, to religion, to science – entails novel modes of prediction. The shift from human reasoning to automated reason is perhaps one such shift again. In the Second World War the roots of cybernetics were formed in the development of automated target acquisition and tracking technologies for anti-aircraft weapons. Such developments follow through today in a far wider array of conditions, ranging from the development of new pharmaceuticals to the value of the shares of the companies that trade in such developments.

These techniques are also applied to populations, where interventions are combined with observation. Given their purchase record, their attributable gender, postcode and age, and other factors, which customer is most likely to be susceptible to which special offer? Given the archive of hit records, which kind of tune is most likely to succeed? Given their posts on social media, on any topic at all, what clusters in a population are most likely to shift their vote in an election? Here, there is a close overlay between prediction and speculation, in all senses of the word.[9]

Prediction is aesthetic in two crucial ways. First, it depends on what counts as the sensible. It entails a calculus of the ordinary, the likely and the extraordinary that also implies an understanding of what is or may become a matter of urgency or opportunity. Second, by setting up a mechanism to predict future actions and events and to enable action upon them, prediction starts to put into motion events that will have happened in the future. This happens on the one hand because various actors may try to avoid being predictable and therefore undertake other kinds of actions or evade detectability. On the other, it occurs by rendering certain kinds of events more recognisable and avoidable or achievable. Thus predictions of what will happen in the future feedback from calculations of possible futures into the actual present, shaping it, in sometimes determining ways.

A recent notorious example of the way in which prediction effects futures was the use of a crude algorithm, working with meagre data, to produce grades for secondary school students in the UK who were not able to take actual sit-down exams due to the coronavirus in 2020. The algorithm combined different forms of prediction, ranking and historical data in a way that biased results in favour of students in smaller classes in schools with historically higher grades.[10]

There is also a way of bringing phenomena into articulation or self-realisation, inciting a phenomenon so it can become detectable.[11] The old adage 'be careful what you wish for' is worth bearing in mind in such contexts, as unexpected consequences may feed forward from calculated futures, as well as feeding back from ongoing processes. The condition of multidirectional noise generated in such calculations means that power may be acting on the ghosts of predictions established by actions it sets in play to countermand the responses to phenomena that have not yet happened. The articulation of such a condition may be understood as aesthetic, since perceiving and differentiating between things and events is not only analytical, but perceptual. Surveying and detecting are not simply passive analysis of past data. Aesthetic power seeks to affect, stir and influence the very things predicted. By generating affects, and seeing how they influence a person, organisation, social group or other target, prediction can become more precise. It is perhaps through our reaction to the present varieties of absurdity of the mediatised political spectacle triangulated with our interest in upholstery, music or gymkhanas that our grocery shopping patterns can be gleaned, for instance.

Here, the two modes of aesthetic power combine and entangle: the capacity to stir emotion, and intercepting the signals from our reaction to these provocations, make prediction more precise. The surveillance, targeting, adjustment and modulation of human behaviour are perfected through leveraging preference, desire and emotion. Private experience

becomes the raw material of predictive behaviour. Information about each stage in peoples' mood cycle, desire and interest is bundled together and sold as a commodity. These two modes of aesthetic power – the manipulation of emotion and the techniques of detection/prediction – get tangled together, and shape how forms of both governance and resistance take on aesthetic forms.

The interwoven manifestation of aesthetic power has a place in the genealogy of state power. If the distinction between what Michel Foucault called the 'sovereign power' of the seventeenth and eighteenth centuries and the 'disciplinary power' of the nineteenth and twentieth holds, then perhaps the current form of government of people and things might be referred to as 'aesthetic power'.

A similar argument has been made by Engin Isin and Evelyn Ruppert regarding what they have called 'sensory power'.[12] This is a form of governance operating through techniques of sensing, enabled by big data to detect, organise, prompt and predict behaviour. But aesthetic power is also distinct from it because sensing is only one element of aesthetic power. Sense-making also has a part. Leveraging mood, modulating emotion and recording the reaction are essential for this form of government of desire and action. Desire thus becomes a necessary component in prediction.

Historically, aesthetic power owes its existence to two developments that defined the early twenty-first century – the 'war on terror' on the one hand and the development of digital economies and social media on the other. Building upon the sense of insecurity developed during the indefinitely prolonged wars on terror and the resulting set of murderous civil wars – such as those in Iraq, Libya, Yemen, Syria and Central and South America – publics were more inclined to accept surveillance. The mantra 'I have nothing to hide' and 'I have no secrets' became the defining lines of identity of the privileged who perceived surveillance as something done on their behalf,

for their security, and always done *to* others. Both at home and in the frontiers of the war on terror, digital surveillance and predictive behaviour analysis were presented as the only way for civilisation to defend itself.

This sense of insecurity was the eye of the needle through which populations in the West were ushered into the kingdom of their own surveillance. At the same time, tech companies such as Google and Facebook used the apathy towards surveillance to put into place a system of individual surveillance, surpassing the systems of all secret services combined.

—

Detection acts differently through various institutional frameworks. The judiciary, for instance, has a different tempo to a battle group engaged in network-centric warfare. Its speed is usually slower, and its focus is on what has apparently happened rather than what may be about to occur, or what we should pre-empt. In other respects they may have certain aspects in common in relation to questions of prediction. An example of the difference in time frame between law and military action is the way targeted assassinations are conceived. They are not permissible according to international law as retribution for crimes that have already been committed. In contrast, retrospective punishment is the purview of the judiciary. It requires habeas corpus, the presentation of evidence, and what passes for a fair trial. Criminal law is largely engaged with what has taken place.

Under the codes regulating targeted assassinations, however, pre-emptive strikes can be employed in a predictive manner in order to stop what are framed as 'imminent attacks'. Under this rubric a person can be killed not for what they have done but only for what they *could* do. And only if it is imminent, prospectively immediate. Over time, and with much abuse, what counts as imminent has become increasingly elastic, stretching and twisting the sense of temporal immediacy.[13] The assassination of Iranian general Qassem Suleimani in January

2020 notionally relied on this definition, to the point where imminence lost all meaning.

But Suleimani was perhaps the most visible of a more widespread tendency. The heyday of targeted assassination in areas such as Waziristan in Pakistan in the first decades of the twenty-first century relied on the area they were performed in being defined as a space–time of exception where killing for possible future crime is permissible. And it was often undertaken based on algorithmic processes that are unknown and unaccountable.

This time of imminence forms a window in time. But such an imperial technique – with exercises in Gaza, Yemen and Pakistan – has found its way back to the metropolitan centres of the global North, where it intersects with other logics.[14] A similar notion of imminence is best exemplified by the police 'split-second' defence. In the USA, the police killing of civilians – disproportionately black people – is often based on a 'split-second decision'. Here space and time are condensed and conflated. In a split-second a police officer has to decide whether the person they face will pull a gun or licence papers from the dashboard in which their hand lies invisible. In the mind of that officer a deck of multiple possibilities presents itself. What is taken to be the reasonable possible future will be interpreted by a learned bias such as an anti-black culture of guilty fear, and the experience of what other officers have done. So the racial categorisation of a person is often foregrounded as a determining factor in the implicit calculation of which possible future seems, to the police officer, to be most realistic. The fact that so many black people are being killed by police means that the split-second folds within it the long duration of racialised violence, slavery, segregation and apartheid.

Fred Moten made the connection between the murder of Michael Brown in Ferguson, Missouri in 2014 and the pre-emptive targeted assassination performed by US agencies like

the CIA within communities living in the frontiers of Pakistan and Afghanistan. Referring to Darren Wilson, the white police officer who killed Brown, as an 'armed drone', he claims that what is attacked is a form of life threatening to the dominant order. 'Because what the drone, Darren Wilson, shot into that day was insurgent Black life ... he was shooting at mobile Black sociality walking down the street in a way that he understood implicitly constituted a threat to the order he represents and that he is sworn to protect.'

Since Black life is constituted as an insurgent threat, destroying it is a pre-emptive strike aiming to maintain the already existing dominant order of white supremacy. 'Read in this way', Moten continues, '"maintaining order' should be understood as a polite euphemism for systemic violence against Black life.'[15]

The algorithmic process that guides the process of signature strikes and targeted assassination is replaced in this context by the neurological circuits in the brain of a police officer, itself conditioned by biases and hatreds which are cushioned by impunity. One result of this was the shooting of Harith Augustus, a Black barber, out on an errand through the streets of South Shore Chicago on 14 July 2018. The police performed an 'investigative stop' when they saw that he was carrying a gun. Harith was shot shortly after trying to show his gun licence. The superintendent of the Chicago Police Department argued that Augustus's shooting was a 'split-second decision'.

Forensic Architecture undertook an investigation together with a Chicago-based anti-racist group called the Invisible Insitute. Synching together and cross-referencing eight police body and dash cam videos (released not through police due process but after a freedom of information suit run by the groups) and handheld footage from protesters, Forensic Architecture could reveal the way in which officers of the Chicago Police Department incited or put into action the very incident they purportedly only responded to. The police provoked and

escalated the incident and then shot Harith Augustus to death for responding to their provocation, while he tried to escape. Throughout the encounter the situation went through several distinct legal spaces: alert, investigative stop, arrest, overwhelming force, lethal shooting, without any provocation on the part of the barber.[16]

Given the invocation of the split-second justification, and given that a split second has no defined duration, Forensic Architecture unpacked the incident of the shooting along six different timescales: milliseconds, seconds, minutes, hours, days and years. Each duration bore on the incident in a different way. The study of the incident at the scale of milliseconds unpacked the duration of neurological processes taking place in the brain, comparing what the scene looked like from the perspective of Harith and that of the officer who shot him. This showed how the implicit bias of learnt 'instincts' reproduces long-term social and political processes. The study of the incident along years showed how the designed social and physical deterioration of the neighbourhood of South Shore, how gradual changes in gun law across decades, and how the brutal and murderous history of policing in these parts conditioned different elements that manifested within an incident a few seconds long. Presented at the Chicago Architectural Biennale, the case led to mayoral and police enquiries, with the police superintendent spending hours studying the exhibited investigation and discussing it with Invisible Institute members.

That police officers can be acquitted for split-second decisions regardless of their consequences means that the unspecified duration of the split second (is it half, a tenth, a hundredth, a thousandth of a second?) is *in itself* a zone of exception where the prohibition against taking lives is suspended. This is a temporal state of exception. A state of exception that is not applied spatially, in a bounded area – as in the conception of the concentration (and later refugee) camp proposed by Giorgio Agamben or the colonial frontier

as described by Achille Mbembe – but in micro-temporality, a field of imminence that denies those entering it, often members of racialised communities, the right to life on the basis of prediction.[17]

When interpreting split-second decisions, legal practitioners – judges and juries – look at the same categories brought up to regulate drone strikes – evidence, risk, prediction, probability, reasonability, pre-emption, decision, action – as happening within the perspectival perception of the officers involved, their sensing and sense-making. At the end, the decision to kill is finally sanctified by the principle of pre-emptive self-defence, although, as Forensic Architecture demonstrated, Augustus was pushed to make the very motion that could be justified by the police as threatening. A subjective sense of threat and danger justifies murder by the police officer, just as a few bits of pattern-recognition triggering a 'threat' alert justifies drone operators pressing the red button.

Our argument here is that these new regimes of surveillance, control and domination – and the ways they are calculated – operate through aesthetic registers that are also inherently political, such as the learned and rewarded behaviours of racism and colonial privilege. They also develop via the emerging saturation of computational relations – using forms of artificial intelligence to automate propositions of connection between information and interpretive prediction, targeting and anticipation, between events in the computational spaces established by statistical logic and those in spaces less fully integrated into formal reason and representation.

These aesthetic decision-making processes are not open to scrutiny, perhaps in an analogous way to that in which eighteenth- and nineteenth-century aesthetics conceived itself as beyond reason and beyond calculation. Each of these stages of translation is aesthetic, but not because they necessarily involve an evaluative judgement of beauty passed through human discretion. These registers are aesthetic because they

involve the complex politics of sense and sense-making across contexts that are themselves the result of the ongoing accumulations of such processes.[18] Any challenge to aesthetic power will have to learn to recognise this and come from within the aesthetic field of operation.

Part 2 Investigations

What Is Investigation?

To investigate is to track movements, to disentangle the making of a situation, to work out the genesis of an incident. Sometimes, like the work of a hacker or a leaker, it aims to uncover hidden, obfuscated facts, at other times, like that of a detective, it is about combining and interpreting clues that are already in the open.

Perhaps the closest form of enquiry from which investigation needs to be made distinct is 'critique'. The investigative mode's commitment to establishing facts seems to push in the opposite direction to the critical mode's suspicion of the authority of established truths. The critical mode conjures a world view that is somewhat geological: composed of stratigraphic layers in which observable surface phenomena, usually referred to as 'representation' – political speech, films and photographs, or the tropes of popular culture – mask layers of obfuscated subterranean forces or ideologies such as nationalism, racism, privilege and so on. These forces are powerful precisely because they are camouflaged and therefore appear to be benign, as at least 'normal'.

The task of the critical scholar is to peel though these visible layers of representation and mediation, to tear off the benign masks and expose their formative forces. Early forms of critical theory, such as psychoanalysis, Marxism or Nietzschian (and later Foucauldian) analysis of power, seek to search below these surface representations and normative manifestations of common sense to find, lurking in the depths, the unconscious or the death drive, the eternal class struggle or

the will to power. Later forms of critique, such as post-colonial studies, for instance, function like a harpoon that pierces through layers of false representation to strike the leviathan of empire swimming in the depths under the surface of our glittering liberal democratic foam.

Sometimes critique seems close to archaeology – and indeed archaeology is one of critique's most recurrent metaphors – in that it aims to carefully peel back the surface to discover these hidden truths, to arrive at a 'real' that was gradually distorted, blurred or diluted by layers of representation. If the critical archaeologist teases away compacted layers of soil in order to find, say, the remains of a buried marble statue, hands and nose broken off, colour worn away, then the investigative researcher, by contrast, like a contemporary archaeologist, would also look at the specks of earth and dust that surrounded and held this statue in the ground – a mix of soils composed of generations of plant life, products of human culture, an ecology of technologies actively configuring their environment. Different particles of dust might contain different kinds of marble, coming from different regions or quarries – thus holding clues about trade routes and connections; other specks might be parts of bones, seeds, or fossilised plants that could help reconstruct the evolving diet or environmental conditions of the era and place in question. Such investigation requires economies of attention but also technologies of detection, of archiving and of computational capacity. If aesthetics is about sensing and making sense, its pairing with investigation is a demand for a reworking and heightening of the aesthetic sensorium.

A hyper-aesthetics of this kind is effected through different approaches: some through opening up a view of the material world as a varied sensorial field, some through social and technological means to generate relations between senses. As such, investigation interacts with critique, but sees it also as another powerful kind of generative operation acting in the midst of things rather than as a sole precondition to truth.

Indeed, critical theory is a superlatively potent way of not only *tracing* but also *constituting* truth. Once you know how to take something apart, to probe for its inner workings, you are part of the way towards knowing how it might be assembled, or how something else entirely might be made.

The investigative mode is based upon a variant conception of truth and promotes a slightly different process of discovery to the stratigraphic one. Here the debate about truth is no longer only bound to the rightful distrust of representations. Rather, it is concerned with assembling truth claims from a collage of fragments, each of them precious for holding some form of inscription or other clue. When investigators look at a video or a photograph they search for what can be gleaned, what is hiding in the grains or pixels.

The investigative mode does not simply distrust a photograph, but dives into the way it is encoded, compressed, formated, seeking to augment what can be seen in it. The catch is, however, that in order to answer the question of what can be captured in images, one needs to develop a good grasp of what escapes representation, and why. For this latter task, one needs all the illuminations one can muster from critical training and the critique of representation. Why are satellite images pixelated the way they are? What do the people seek to hide among the pixels? How can you read the dispositions of power not only from what the photograph shows but from the fact that it exists at all, from the way it is stored, traded and circulated?

So the investigative mode does not disavow critique but augments it with the capacity to assemble truth from clues. Besides critical ingenuity, investigations must rely on technical and aesthetic expertise. Like the critical scholar, the investigator needs care and patience. But here that patience must be spent in noticing particles of information found in one photograph, say, and connecting them with a multiplicity of others, each holding within it a hint that allows for navigation. Each

image is also a potential gateway into other forms and sources of evidence.

All surfaces of representation, photographic and otherwise, are also real: both in that they are celluloid, or an arrangement of pattern of pixels, file format data and metadata, and in that they are imprinted by material encounters, containing traces of touch, scratch, light spill or radiation. So the investigator sees images as simultaneously both presence and representation, matter and mediation, illusion and description, condensing and distorting lenses, all the way down.

Investigative tools may also sometimes be the means by which power both operates and can be confronted. Leaks, false-flag information, algorithmic prediction, hacking, open-source research scouring through thousands if not millions of posts on social media, artificial intelligence, algorithmic real-time analysis. All of these are mediatic in nature, some-thing often associated with the 'unreal', a world of illusion and representation. But what is common to them is that they emphasise that to uncover the real we must make the real.

And here's another catch: institutions of power come into being in contact with their decoders rather than existing somewhere in latent form. Often facts will only emerge as a response to provocation, rather than pre-exist the situation that brings them into being.

Here, the critical mode's nervous attunement to catching truth formation in motion, like a kinaesthetic frog catching a lively fly rising from the dung heap, is invaluable. The inves-tigative mode seeks to render the conditions in which facts become recognisable.

Investigative aesthetics proposes working with what have been constituted and refined as evidential materials, such as data, measuring apparatus, testimony, controlled recordings, but also with negative evidence, moments where the removal of information, its distortion or manipulation, become impor-tant information in their own right. Attacks on information

can take many forms, some of them through hyperaesthesia – generating a sense-clogging dust of too much information. Such dust can rise to speak back to the object.

Investigation works with techniques that are able to move across technologies, languages, ideas, economies, architectures, substances, representations and so on. In each case it looks for the telling detail. In order to do so it must engage with the specificity of each material. Such approaches allow us to see how abstractions, including those that are seemingly 'immaterial', such as numbers or ideas, act as sensors for, or perhaps tellingly fail to gain traction on, other kinds of substance, such as designed or affective sensors. That knowledge arises in coupling with social forces that may partially divulge themselves in chemical residues and in metadata means that we can, and indeed need to, work with abstractions, with culture, with different kinds of substances as part of the same composition, and to use the tools of critique, as well as those of science and other kinds of knowledge formation, to trace them and differentiate among them.

An investigation, like any perspectival operation, is *constructive* in that it shapes its relation to what it looks at, or what it understands by looking. It is *constitutive* because in making an investigation, in proposing new conditions of knowing, seeing and doing, it engenders the possibility of, or even makes, new consistencies of relation possible between these things and thus puts in play the capacity to experiment with reality formation more broadly.

Secrets

The role 'representation' plays in critical theory is related to the role that the 'secret' plays in the type of investigative research we propose.

Revealing a secret can sometimes be more radical than a call for accountability against the standards of existing normative frameworks. Indeed, spilling a sensitive state secret can generate chaos, rage or panic in the halls of power. Secrets hold elements of the variously enmeshed social contracts in play and their release unsettles incumbent hierarchies. This refers not only to close secrets. When people start challenging open secrets – such as racism, sexism or the brinkmanship of environmental collapse, for instance – the conditions for maintaining the status quo may start to pull apart and different kinds of imaginaries can open up.

There is a wide spectrum of things that fall under the definition of a secret, and thus also of different techniques and strategies of exposure.[1] The military secret follows a clear operational logic: it is necessarily hidden so that enemies cannot prepare for what is about to happen. Secrecy here keeps information, and hence the initiative, in the hands of operatives. But secrecy can also operate as a system of information-filtering among a group of operators. Security organisations are compartmentalised, siloed or cellular, with information not equally shared. Secrecy in this sense is about modularisation: who can get information? How much? How fast? How painful or possible is it to extract? Segmentation,

cellular structures and siloing exist amid a wider condition of sifting: systematisations of the flow of information that is consistently filtered. Rebel and partisan networks are also often equally cellular organisations with only minimal information shared. The Algerian FLN fighters for independence, caught by the paratroopers of Jacques Massu during the Battle of Algiers, could not be made to speak about other cells even when tortured with extreme violence.[2]

In this regard, a secret operation becomes the sum total of partial perspectives that are only woven together at the top. A major secret policy of the early 2000s was that of 'extraordinary rendition' run by the CIA. It depended on moving captives through a network of sites: warehouses, provincial offices, small companies, private or corporate jets, white vans, suburban houses. These spaces were run in different countries according to their friendliness towards such extra-legal activity.

A freelance pilot flying from, say, Lithuania to Pakistan or from Morocco to the US on an extraordinary rendition flight during the 'war on terror' would not necessarily know who they were carrying or even that they were transporting anyone against their will. Government-run shell companies subcontract part of a secret operation to chains of sub-flunkies acting as crumple zones against the impact of risks and information leaks. But while a state operation might be secret, its material infrastructure must necessarily intersect with elements that are in the public.

It takes the work of a 'total institution' to even pretend to be able to control significant data. Sociologist Erving Goffman used the term to analyse organisations such as the church, army, cruise ships and other controlled environments where many, if not all, variables are under the control of one system.[3] However, as the state outsources some of its tasks of repression and control, even under the rubric of austerity or the war on 'big government', the totalness of the institutions carrying out its operations starts to fray.

The connections between these institutions left traces – receipts, ownership documents, company membership, certain repetitions in behaviour, paper trails, credit records, invoices, CCTV footage. For an investigator each of these crumbs is a doorway into the logic of the network. Those investigating them, such as artist and geographer Trevor Paglen, or photographer Edmund Clark and human rights investigator Crofton Black, succeeded in connecting the dots.[4]

———

Revealing a secret is not only about exposing unknown information. It can have multiple other functions. The two speeches by SS chief Heinrich Himmler given in Posen on 4 and 6 October 1943 to SS officers and to the gauleiters and other regional leaders of Poland deliberately broke the silos of information within a system in order to form an irrevocable blood bond between them.[5] Himmler called all these personnel into the town hall of Posen, a small town in the south of Poland now called Poznań. There he delivered the infamous speeches in which he set out in words what everybody present in the room already knew but, given the turn the war was taking, did not want to be openly acknowledged: Operation Reinhard, in which they participated or which they had at the very least actively supported, had by then exterminated most Polish Jews. It was the first time a senior German official had spoken openly of the 'extermination' – *Ausrotten* – of the Jewish people. Those of the same rank who were not there were sent copies of the speech, and were required to sign acknowledgement of receipt.

Each one of the people present in the town hall knew about at least one aspect of the extermination process, but felt protected by the fact that they were told that it was top secret. Certainly, at that moment, they did not want to admit to knowing what they knew. By removing the information barriers that protected them, Himmler made everyone in the room – looking no doubt around them to learn who

knew their secret – complicit and codependent on the others present.

When such a secret is shared, a certain bond of guilt is formed. This bond has an inside and an outside. It creates a perpetrators' 'community'. When everybody in that room saw everybody else, they depended on their silence and cooperation. Not knowing can mean protection from possible retaliation, or indeed from the foments of a conscience, when the often-repeated 'I did not know' is the only available line of defence.

Public secrets can generate terror in other ways too. This was, for instance, the case in Argentina during the latter part of the 1970s. The function of the thousands of enforced disappearances conducted by the regime was to control the entire population through fear.[6] Students, trade unionists, journalists and other perceived or real enemies of the state were forcefully disappeared, sometimes pushed into unmarked cars in broad daylight and never seen again.

But behind these disappearances, some of which could be traced to CIA training, was an entire infrastructure of places and practices.[7] All the while the military junta that ruled Argentina denied any knowledge of the whereabouts of the disappeared. The population knew that, despite denials, these were the actions of the state and that such actions were happening around the corner, but they were not allowed to speak about it and so the open secret amplified terror through uncertainty. All these techniques intersect with secrecy in the sense that they create a gap between the perception of reality and the reality that is acknowledged and allowed to be spoken about.

Forensic Architecture's investigation on behalf of the parents of the forty-three forcibly disappeared students of Ayotzinapa in Mexico began by data-mining thousands of reported incidents, videos and phone logs and plotting these data within an interactive platform. It revealed both large-scale collusion

between state agencies and organised crime, and contradictions in the subsequent state account of the incident. On the night of 26–7 September 2014, a group of students and activists from the Rural Normal School of Ayotzinapa were attacked in the town of Iguala, Guerrero, Mexico. The attacks were committed by local police in collusion with criminal organisations and other branches of the Mexican security apparatus, including state and federal police and the military. Forensic Architecture's large-scale mural, titled *The Forking Paths of Ayotzinapa*, plots the narrative timeline of different actors in the atrocity – victims, state security agents and members of criminal organisations – as well as that of the federal investigators and the multiple versions of the event.

Enforced disappearance in Mexico and elsewhere was thus revealed as an act of violence and of political terror in two stages. The first is physical, directed against people, involving their kidnapping, likely murder and disposal of bodies. The second is a bureaucratic crime against information, involving false accounts, the destruction of traces, including those of bodies, the removal or destruction of documents and so on. The bureaucratic stage has made the enforced disappearance of the forty-three Ayotzinapa students, just like all the disappeared of the American southern cone, an ongoing crime, continuous to the present day.[8]

As this state persists over time, enforced disappearance generates a grim psychological effect, where every mundane element could generate a paranoid state, both a possible infraction of an unstated law, and a sense of uncertainty among the population.

Another kind of secret is made available by the logic of the contract. Subcontracting militia and even militaries has increasingly become the preference for states in the global North. From Cameroon through Libya to Tunisia and Morocco, such groups are engaged in policing European borders at a distance in return for payment or equivalent.

In other places, such as Syria and Iraq, Western interests are maintained by other proxy forces, sometimes involving Salafist or Kurdish armed groups. Both have been treated as highly disposable by the Western coalition. The Salafists can be attacked at another time, and, as we have seen with the Turkish invasion of northern Syria in October 2019, the Kurds can be readily betrayed.

Small fighting units belonging to these groups are supported by communication and weapons systems and most importantly by live intelligence. One problem is that the gap in the capacity for information gathering, through satellite, drones and signal monitoring, between Western forces and these groups on the ground turns intelligence from crucial information into a system of command and control. Under the guise of information sharing, equipping and advice, local armed groups are provided with precise GPS coordinates to which they drive or with targets to shoot towards. These and other mechanisms of network-centric warfare seek to turn local militaries and armed groups into something akin to Uber drivers, operators of mechanical systems who simply respond to information arriving on their screens.

However, as Machiavelli noted several centuries ago when discussing the use of mercenaries, such an approach carries multiple risks. For, regarding the secret, there is always the problem of the reveal, the misinterpretation of orders, desertion, and even disinterest that are the traditional worries for those who employ them.[9] Just like Uber drivers who learned to game the system, finding the sweet-spots within the matrix of algorithm, space and time, or begin to unionise, such groups can turn their guns around on their paymasters.

———

Every secret operation exists in the world and has to intersect with the world around it. Petrol is required, for example, along with food, clothing and medical care. These leave traces. Readily identifiable local products or services can get sucked

into the hidden supply chain. Khalid Sheikh Mohammed, one of the persons known to have been subjected to extraordinary rendition by the CIA, and still held in Guantánamo Bay, mentioned to the Red Cross that in one of the unidentified places he was held, he had received a water bottle with a Polish label, thus managing to identify part of his itinerary.[10]

An infrastructure that maintains an operation over time, even a fly-by-night one, cannot be completely introverted. So there are always points of intersection: with companies, with civilians, with other points of interaction or recording. Here, as above, even laying a false trail may create traces. In such cases, humans may keep their lips sealed, but the material world, and the organisational one, the economic one, can do the sensing required by the investigator.

Another example of this was the case of the social exercise app Strava, used for cycling and jogging. The app records users' movements and allows them to analyse and share their performance and create records of favoured routes. What it also did was to create a set of all the data of all its users. In November 2017, Strava released a data visualisation map – more than three trillion individual GPS data points that shows all the activity tracked by users of its app who had left the default settings on. This originally seems to have been done for marketing reasons, to show its popularity. But by revealing all jogging paths it also exposed the presence of facilities whose location is routinely redacted.

A particularly interesting subset of users turned out to be Western military and intelligence personnel stationed at various secret or less secret bases. Most of these locations are not visible on the satellite views of commercial providers such as Google Maps or Apple Map, where they are replaced with generic surfaces of fields, desert or forest.[11] In the initial Strava map, by contrast, geometrically predictable jogging paths were superimposed on such seemingly empty landscapes. For example, the entire layout of a little-known US

military forward base in Helmand Province, Afghanistan, was thus revealed, just like other military bases in Djibouti and Syria and other US Air Force bases and spy outposts around the world.

———

Some secrets are barriers to information while others operate in an inverse way. Unable to fully control the flow of information, due to leaks, social media and other open signals, when those in power want to hold something secret after it has already spilled, they often try to bury a signal under piles of other data. The best place to hide a secret is among other revealed secrets. The result of the exposed secret is thus not withdrawal or removal but hyper-exposure, so that the signal drowns. To hide, one does not go to the wilderness, but to the city to live amongst the crowd. To encrypt a sequence of letters, turn them into other letters. To hide stolen money, take it into a bank where it will have plentiful company. The East German Stasi is known to have put some of its secret headquarters and torture chambers in residential tower blocks rather than in forests far away from inhabitation. We can understand this phenomenon as bordering on hyperaesthesia, signal amplification to the extent that signal no longer registers.

After the Syrian government undertook the chemical attack in Douma they banned any journalists from entering the sites after the incident. However, images of chlorine canisters from the attack were already posted online, allowing Forensic Architecture and Bellingcat, working with members of the White Helmets and the *New York Times*, to undertake a careful reconstruction of the precise disposition of rubble, steel canisters and twisted metal captured on a dozen videos made by medical services, rebels and government sanctioned media in Syria to confirm that this was the site of a chemical strike, well before any official international body could arrive at a similar determination.[12]

Russian and Syrian propagandists attempted to drown the story in a flood of other images and commentary. A barrage of multiple self-contradictory claims was produced: that it was a false-flag attack, or that civilians simply died from dust inhalation, even that the chlorine attack was conducted by rebels. Together with their online supporters and operatives and more high-profile figures (such as the columnist Peter Hitchens of the *Daily Mail* newspaper),[13] public doubt was sown to obscure the incident. Such a polyphony of entropic statements, typical of the negationists' logic, is reminiscent of Freud's famous 'kettle logic',[14] in which a neighbour is asked to explain why the kettle they borrowed was returned broken. To confuse matters, and in the hope that one might turn out to be right, they say, 'it never happened,' 'it didn't happen because of me,' and 'it had to happen,' though 'it was already broken' may also crop up. These claims are employed simultaneously or in short succession, despite the contradictions involved. Such negation aims to create a miasma of inconclusiveness to sap the capacity to work towards fact. Here, the interaction of multiple perspectives and situated knowledge is gamed by spinners of partial truths and fabrications, and spurious questions are phrased as sincere doubts.

———

The public, generally speaking, supports secret activity. It might demand reform around the margins, but if the security services say they behave properly, most people in our societies are content to go along with believing them. The security services do not have enough people to spy on everything, and digital signal intelligence stores far too many signals. These agencies need to 'employ' the people they spy upon to make them police and monitor themselves. Sometimes, in Israel, when one's political action crosses a certain threshold, when one's activism seems no longer acceptable by the security forces, one gets told, usually by somebody close, that 'somebody that knows somebody' says you are being watched, and

to watch out and maybe consider getting back in line. Effectively, at that moment, if one retains a lingering caution, one becomes one's own police.

This is all to say that the politics of exposure, and of revealing secrets, is not an easy or simple thing. Every act of exposure is an intervention within the order of information flow, involving affect and effect, fear and politics. Sometimes the well-meaning gesture of an investigative exposure of a secret can become a gamble with unexpected consequences. The more something is exposed, the more the resultant terror and paranoia can actually serve those in power. This might be the paradox of the reveal.

One example would be the revelations of extensive state surveillance made by Edward Snowden.[15] After Snowden, the NSA and GCHQ are more effective at deterrence because we are aware of it with every email sent or every Internet search. Legal scholar Jonathon Penney showed this empirically in 2016 by counting the number of Wikipedia searches on topics, such as 'Hamas', that such organs of the state might find suspicious.[16] Before the Snowden revelations they were significantly higher. Once the surveillance was revealed, a lasting chilling effect on peoples' ability to source potentially meaningful information was found. When the watcher is no longer a spying human eye but a predictive classifier, the very idea of awareness of being surveilled and of deploying camouflage becomes less directly meaningful and more about the imposition of a calculus of error and interpretation.

The same goes for the form of secret known as *redaction*, in a term extended from the censorship of writing or of images to other domains. The visible manifestation of redaction is a section of text typed over other text or a black line or shape that hides the text or picture behind it. Redacted documents often become visible as the result of a successful freedom of information request or lawsuit that forces a government to release secret documents. However, the prerogative of secrecy

and security trumps some aspects of the release, resulting in partial redaction, sometimes obscuring the document to comedically great extent.

Bertold Brecht said, 'The situation has become so complicated because the simple "reproduction of reality" says less than ever about that reality. A photograph of the Krupp works or the AEG reveals almost nothing about these institutions.'[17] That might be true. By pointing out this problem for realist aesthetics, Brecht meant that all the exploitation and social and labour relations that take place inside and through a building housing such companies is masked. A facade is just that. However modernist they were, the Krupp buildings might reveal aspects of the building's organisational logic but not the abuse within it.

This might be something that Hans Haacke had in mind when he produced one of the foundational works of investigative art, *Shapolsky et al. Manhattan Real Estate Holdings: A Real-Time Social System, as of May 1, 1971.*[18] This project consists of a row of pictures of mostly slum tenement buildings in Manhattan's Lower East Side and Harlem. The 146 buildings are shot in a flat view from the street and presented in black and white. Underneath each image is another frame, this time presenting the ownership records of the buildings. They show a single family running a network of shell companies for purposes of obfuscation: exemplifying how buildings, in capitalist space, function both as habitation and as properties. These two functions may well be inimical to each other.

Facades are masks. In architecture, a facade is always an act of seclusion that exposes the fact of hiding. A redaction is like the facade. Unlike the envelope of a building, however, the reduction does tell us something. The nondescript buildings used in the networks of black sites in various countries, or the unmarked interrogation centres in certain cities, are tucked into rows of other nondescript buildings. Such constructions

are part of a network of mundanity operated by the CIA. What we see, as documented in works such as that of Edmund Clark and Crofton Blake's book *Negative Publicity: Artefacts of Extraordinary Rendition*,[19] is not torture or detention, but the attempt to mask these procedures. We see the materiality, or, so to speak, the architecture of the secret.

What is telling in the redaction of documents is not just what you are being allowed to read and what cannot be read. Rather, what is also interesting is the scope and pattern of the redaction. Initially, the redaction is a kind of self-referential sign, one that reveals only its own existence. It is the traces of the government's logic of information and of its actions: here was a government decision, here is something you are not allowed to see, that is curious. This is one incarnation of the 'difference that makes a difference' of information theory, which just as in Gregory Bateson's original phrase, can consist of any variety of difference at all, even a repetition of a mask.[20] This minor trace can be understood as a 'negative evidence' – where the absence of evidence becomes evidence in its own right – that of removal, of hiding.

State violence – under various codes, the crude violence of the police or the more lofty bludgeonings licensed by the *raison d'état* – often consists of two things: on the one hand violence against people and things, and on the other a violence against the facts, the evidence that such violence has ever happened. Somebody is assassinated by a state agency. The crime is not only the assassination; it is also in the denial, the cover-up, the counter-accusations. The pain an assassination leaves with society is multiplied into a general sense of terror by the denial of it happening, and by the power to maintain that denial.

Here, denial can take on the kettle logic: 'We didn't do it – somebody else did', or the incident never took place at all. There is also a further form of denial that seeks to add no information to the system whatsoever. This latter kind of

denial is called the Glomar response. Amid the shades of grey mixed by the colourists of the state, this is the tone designed to be the most neutral. The Glomar response is a form of denial that aims to add no information to the public domain. Under the terms of the Glomar response, state agencies, for instance, are authorised to 'neither confirm nor deny the existence or nonexistence' of documents requested under the Freedom of Information Act (FOIA).

The Glomar response is justified on the basis that the very fact of the 'existence or nonexistence' is itself information whose disclosure should be banned for 'security reasons'. The term is derived from a ship named the *Glomar Explorer* built by Howard Huges and used in a CIA attempt to recover a sunken Soviet submarine in 1968. When, nine years later, the journalist Harriet Ann Phillippi filed a request under the FOIA for documents related to the *Glomar Explorer*, the CIA, in its attempts to censor Phillippi's story, claimed that it could 'neither confirm nor deny' that documents about either the ship or the cover-up of such information existed. The Glomar response has since become so closely associated with the CIA that when it opened its Twitter account it tweeted 'We can neither confirm nor deny that this is our first tweet.' This is Glomar as a form of gloating from a perpetrator confident enough to flaunt its own actions and unaccounatbility. More functionally, Glomarisation, is a denial that aims to be the linguistic equivalent of a zero. But something curious happens, an information dust speck is found. The Glomar response cannot finally delete the fact of its own being. If it is there, it has been authorised somewhere.

The masking of a secret can hardly be kept secret and it exposes the possible presence of high-level decision-making in regard to what it covers up. In this, it is like the strike-out: redaction. Redaction can redact what is written or depicted but it always reveals itself in the very act. The Glomar response can neither confirm nor deny, but it cannot deny that the Glomar

response has been enacted. Both Glomarisation and redaction have their own grammar of sensing that establishes what they can and what they cannot hide from perception.

In a certain way they mirror the scepticism that marked the birth of modern philosophy. When René Descartes famously declared 'I think therefore I am,' he was grasping for the minimal proof of existence, a little toehold on which to establish thought. This tiny margin was simply that he could sense the fact of his own thought. Whether it was illusory or not was a secondary consideration. The significant fact was that the thought itself happened. Does the Glomar response point to a foundational glitch in Western thought? It is an attempt to negate the capacity to think about and inquire into what it masks by attempting to minimise the significance of such a sensual event. Instead, what happens is another kind of event: 'I blank, therefore I blank.' Attempts to leave no trace or to use the mundane as a mask are moments when this infrastructure is materialised into things and becomes visible. Even the Glomar response senses as it tries to efface sense-making.

Here both the secret and its exposure need to be thought in aesthetic terms. Violence against the evidence, forced disappearance masking, hiding, burying, negation and denial have anti-aesthetic dimensions, seeking to generate public anaesthesia. However, when we recognise the attempt to mask, we may start seeing the possibility of masks everywhere. Here, a paranoid form of the hyper-aesthetic emerges. Every mask becomes an index of a sprawl of other masks. There is a double reveal being played with here: that the secrets of power are being finally exposed by the internal outsider, and that their very mechanics are being blown open by the maverick conformist. This is the terrain of conspiracy theory. The conspiracy attempts to appear as an analysis, an investigation; it sometimes even has an aroma of rigour, indeed, but it is always directed towards predestined conclusions.

There are some modes of language or ways of speaking that are far more suited to telling lies than to trying to describe the truth. Some of these, of course, are those that appear to be most open and clear. There are others that establish their grammar and vocabulary through the operation of secrets, so that it cannot be remembered how they came about, nor what they contain, nor how to speak them. There are languages in which every case, even grammatical ones, has a false bottom.

The Cat and the Angel

Once upon a time, a Cat met an Angel. We start off this way because it is a traditional beginning to a fable, and we too have a moral to share.

The Cat and the Angel knew of each other, perhaps a little less than they should do, and a little more than they might want to. Each was able to do something that the other could not. But both also had a set of expertise and specialities that made their differences sharper. Both were fluent in the intricacies of information technology and both had clear views as to what was at stake. But they chose to inhabit their technological milieu in very different ways. So when they did eventually happen to cross paths, their debate could immediately take on a clear, diagrammatic form.

The Angel was fast and brilliant, spinning and cavorting, exalting in their virtuosity. They told how they believed that the most important decisions regarding reasons of state and thus of violations of rights take place in secret, and that secrecy, thus conceived, is a spatial condition, a limit marked around information, separating those who do know from those who do not and must not know. Activists and counter-investigators must puncture and penetrate the cordon that power erects around information, so that the highly pressurised secrets can ooze through and spill out. Evidence of state or corporate crime would, through this process, move from the inside to the outside of the circle of secrets.

The Angel saw ours as a moment to be seized. With the advent of digital technology, a propitious window had opened

to allow this breach to take place. Data, electronic files and documents, emails, messages, digital images and video transmissions had become the lifeblood of the contemporary bureaucratic state. As the speed and volume of circulation increased, the chances that files could be intercepted, duplicated and diverted increased. Paper bureaucracy offered much more limited possibilities. The Angel revelled in the lightness and speed of movement by which files could be copied and slipped across boundaries without a trace.

Almost without a trace, the Cat grinned, the *almost* being, as they pointed out, a crucial difference. The Angel tried to eliminate these traces; they had developed a set of technologies to help these diversions of data and to protect people who made them. The use of an encrypted network allows for the identity of a leaker to be kept secret. A paradoxical interplay between the public and the secret is thus set up. Secrecy is important in order to enable anonymous leaking in the public interest.[1] These things worked, but people were sometimes found out.

The fact of the leak, just as much as the leak of the facts, was important to the Angel. Like any border transgression, moving secrets into the public domain achieved an effect larger than the specific contents of the exposure or revelation themselves. Identity, even a political identity or an institutional one, is often border-defined, and breaching it creates, they hoped, a certain political borderline disorder, chaos and confusion in the political, social and organisational structures that have been punctured.

Exposure, of any surface, of the skin, of an image or of a document, that was not intended to see the light, can lead to hyperaesthesia – an overabundance of uninterpretable signals, a system crash. Making secret information public undermines authority, unsettling the relation between government and society. When this happened, the ensuing panic was great entertainment for all to watch, and the Angel's anarchic

inclinations delighted in that, but such acts also followed a political logic, one based on the belief that wreaking havoc within the centres of power would not only demonstrate the agency of the governed but also yield a position of possible change. Chaos is productive – an opportunity, if seized.

After listening to the Angel, the Cat murmured. In the revelations of certain military documents, those for which the Angel was best known, many of the secrets uncovered weren't really very secret. The state's rage was rather a response to the Angel's assault on their monopoly over the control of information, an act of sabotage of its information plumbing. The ferocity of the response from the state indeed inadvertently reinforced the Angel's claim.

Then the Cat made another proposition. They contested the inside / outside architecture of the secret the Angel proposed. For them, the assumption that the cordon around information was ever complete was an illusion. In fact, they reckoned that secrets always gave themselves away when part of their hidden nature inevitably poked up into more visible aspects of the material world. They thus concentrated on the interface between the domain of the secret and the muddled world of the open which was, to them, made up of thousands of points of contact. Rather than seeing a circle of force with a clear inside and outside, the Cat's ever-attentive eye saw 'the secret' as a constellation of traces, each being a potential fragment of a policy or operation kept under wraps: part secret, part open. The relation between the state secret and the open was often akin, if you were careful enough to look, to that of a Möbius strip.

The important thing, said the Cat, was to remain patient and attentive, to learn how to watch, and most importantly to connect traces – seemingly unimportant things, many things, the more the better. The Cat pointed to troves of data invisible in plain view. The secrets lay there on the surface and in what is recorded and uploaded as videos by citizens. All of this simply

needed a new way of looking: trawling for clues by connecting bits of seemingly unrelated photos and videos and building a narrative, or a counter-narrative, that undermines a manipulative or misleading official account. These could be brought together to reveal a government use of chemical weapons, a secret drone strike or the city-break of a pair of assassins sightseeing in a provincial British town. The art was in building an image from visual crumbs and cross-referencing them.

The Cat insisted that there is so much stuff out there, that we need to learn how to look again. That looking is hard, demanding attention to connections between things. Their method emphasised what is seen to be insignificant, trivial but telling; in short, minor details.

But the Angel had another part of the story to deliver. There are tactical advantages to depriving state bureaucracy and corporate agency of the uncomplicated benefit of technological privilege and the ease of electronic communications. Such state channels are subsequently forced to move into spaces that are more secure, more controlled, more cumbersome, less easily copyable, both more recorded, for some, and more off-the-record, for others. This takes time and resources and creates further insecurity with new kinds of structures necessary to compensate for the loss of the ease of the old ones. The new world of electronic free speech seemed to spawn more and more Byzantine layers in order for its slipperiness to be avoided, for the leak to be designed out.

The Angel had no patience for painstaking puzzles. They insisted on their system being anonymous. There was simply the necessity for a person willing to move data from inside to the outside, a leaker. The Angel's approach was based around a technology that allowed leakers to upload documents in an untraceable way, easing and securing their work. The system hinged upon a difference: the state secret needs to be exposed, but the person who delivers it needs to be protected, anonymised. Exposing a secret thus necessarily created new secrets.

This new secret was framed as undoing the structural asymmetry that exists between governments and people. Because the latter are often transparent to the former, inverting it on occasions was only a small reciprocation, which unsettled the geometry of domination.

'*Almost* untraceable', the Cat interrupted, to remind the Angel once more of those who sat in prison for participating in their system. The Cat turned their eyes, and looked out across the unspectacular daylight. If you watch closely, you do not need an insider. There are all the clues you need, and there is no one to risk. While it is important that there is a place for the whistleblowers and the outraged to drop their stashes of secrets anonymously, far more revealing is what people do not even yet consider to be an outrage. Indeed, the growing grey markets of data – for instance from bureaucracies and administrations of all kinds, or where one could even buy the logs of phone calls, including those of state security agents on an assasination mission – become a new pool of resources in between their two worlds.

As they spoke it became clearer that the Cat and the Angel each understood the ordering of visibility in the world in different ways. The Angel responded to the Cat by pulling document after document from between their wings. They drew out documents from soldiers, politicians, consultants, spies, executives. All of this, they said, should be brought out of the darkness and into the open air. Then the Angel stopped and smiled: 'Don't you see, I offer a means to reveal it, to gain direct access. My systems allow for someone with access to the truth to spill it out. You piece it together after the fact from little crumbs to be found scattered on the surface.'

'*Almost* anonymously', the Cat quibbled yet again.

In truth, the Angel insisted, the Cat could find traces only of what had already happened – the secret could only leave a trace once transferred into action in the material world – while

the Angel could potentially see into the future, crimes in planning that have not yet taken place. Intercepting discussions and decisions about plans, about things that could still happen, might mean that such plans could be averted. And this, the Angel insisted, was no small difference.

My approach, said the Angel, requires that people be brave. To gain secrets, people must transform themselves. Indeed, they will carry out an act that has to remain secret itself. Becoming a secret, he said, was creating a conduit from within a black box to the outside, from one box to another via another.

Then, sensing a line of argument that had hitherto not much concerned them, the Angel also added that, actually, making space for a one-off data interception to take place is a way of involving the disenfranchised and isolated rather than focusing on the work of well-connected teams of skilled editors and researchers. The Angel's way was to push the boundaries of the law in favour of the public domain. And they ended up in prison. The Cat was careful about keeping to the observant side of the law; some even (wrongly) suggested that they were working for the law.

The Cat stood up, stretching their tail. They were tired of hearing about the messianic truth. They wanted something else, and besides, most of the revelations made by the Angel created just a chaotic spill in their mind. Too many documents went unanalysed; no connection was drawn between them. It was a formless torrent, they thought. The truth can't ever be derived from a single source, a single leak, even if it was right at the heart of power. Multiple perspectives were needed, the corroboration of data from multiple sources.

But there was something they did have in common: both the Cat and the Angel were accused by their detractors of disseminating propaganda, and they even started accusing each other of indulging in it, perhaps out of the force of habit. Both were also accused of being agents or useful vehicles for various geopolitical formations and intelligence agencies. The

Angel for the Russian secret service, the Cat for the Atlantic powers. These observations also began to drive how they understood each other. This was not helped when the Angel's Manichaean worldview drove them to enter into partnerships with unsavoury enemies of the status quo. Both swore they had nothing to do with any intelligence service. This squabble did not much more than betray an old habit in thought: if anyone traffics in secrets they must be some kind of asset.

However, this debate did reveal something about the nature of propaganda in the present day. Propaganda no longer necessarily operates top-down as in the hot or cold wars of the twentieth century. In those, the people were perceived as recipients of centralised manipulation like an exercise in mass hypnosis or the creation of a false consciousness. Contemporary propaganda enrolled and involved people as both consumers and producers. This reality fitted the Cat well because data were being produced from many directions. It suited the Angel, since anyone could potentially become a source. But it also exposed both to the risk of manipulation: who is the source passing documents or uploading images? Both their systems allowed for the possible anonymity of the source, something that legal process, with its insistence on provenance and an unbroken chain of custody, finds hard to handle.

Indeed, the secret leaker can themselves sometimes be a state actor clad in the garments of a conscientious citizen or a grey-market data broker. Only careful cross-checking of sources can limit this danger. A secret, the Cat reminded the Angel, can also be a place to hide a fake. There is a long history of seemingly secret documents spread surreptitiously. The fact that something appears to be secret does not guarantee that it is true. Equally, the insides of the systems of power are as riddled with manipulation, as are their outsides. All finds are incomplete by definition and more information would always reveal more, add resolution, open up the story. A fake won't fully interlock with a web of cross-confirming facts.

The Cat surmised that the Angel might one day be given a gift so seemingly true and convincing that they wouldn't question it. 'Indeed,' responded the Angel, 'how can even you trust your data when techniques such as deepfake are so common, when image manipulation technologies may outpace techniques of detection?'

'True,' sighed the Cat. 'But,' they continued, 'there are ways to reduce the risk: one should always test lateral relations between different sources of evidence, a fake video would rarely be corroborated.'

———

The Cat and the Angel both tired of each other's zeal and irrefutability. Both were demonstrably right, since both had produced results. History and contingency would tilt the tables one way or the other at different times. *The moral* of this story is: the dispute between the Cat and the Angel was partially a difference between two systems. The systems are technical, but they are also about ethics and an understanding of truth and secrecy and how they are arrived at.

They are technical, since the Cat creates a platform for the stitching together of details to build up an incremental search for things that can be sustained as facts, and for the discounting of inconsistencies and obfuscations. The Angel creates a protected channel from an inside to the outside. As such, it does not emphasise work on the actual data. In both cases, the technique and the software designed and used constitute a grammar of action that allows for and encourages a different way of processing data.

Each system must navigate different ethical and political problems and realities. The Cat relished greater circles of participation, while the Angel had to keep their loyal team small and invisible.

Neither the Cat nor the Angel would describe their work in directly aesthetic terms. But in their combinations of technology and ethics, the systems developed by the two set up

different aesthetic modes, ways of sensing and acting that suggest that sense can best be made of the world in particular ways. With the Cat, the aesthetic criteria are initially about detection, such as particular details in videos and photographs; they are concerned with composition, combining disparate and separate sources of image data, and they are aesthetic in their matter of factual presentation. This is a hyper-aesthetic approach in many respects.

The Angel makes entities detectable in different ways, bringing previously hidden information into contact with new sensorial surfaces – peoples' eyeballs, for instance. The Angel's system relies on the way in which, once unveiled, a secret can unleash a cascade of action that challenges the very social order designed to be contained by solid borders separating the inside from the outside, the private from the public, on which power relies. Puncturing these borders undoes the very order of privilege behind the system, potentially generating chaotic moments where new, potentially fairer, social formations can be made.

The Cat has an affinity towards the polyphony of hyper-aesthetics and the Angel an affinity to the state of hyper-aesthesia. One approach is iterative, the other is revelatory.

———

Let's take a step back from observing this imaginary conversation at close quarters. In this fable, the Angel is, of course, a cipher for Julian Assange, founder of Wikileaks. The Cat stands in for the investigative agency Bellingcat (Though Bellingcat researchers actually name themselves after a children's story in which mice work together to put a bell on the cat that hunts them). We use the form of the fable here because it allows for a treatment of the formulas and principles concerned rather than a focus on individuals.

There need to be both Cats and Angels in this world. We need the revelatory power of the leak and the threat it poses to the regime of the secret. Further work must be done on

maintaining the technical and legal capacity for leaks to be made. The extension of this principle by groups such as Distributed Denial of Secrets and to some extent in the use of secure drop facilities by news organisations is welcome. Equally, the Cat's emphasis on patiently sifting through vast quantities of detail found in the public domain must be broadened.

Perhaps, then, besides these two, another figure is needed: the urban bird suggested by Farocki, insistently building its nest from these scraps of media, vegetation and plastic debris into a massive and shifting network of relations, a process of collective and potentially continuous construction.

Lastly, we cannot complete this section without reiterating our complete opposition to the persecution of Julian Assange for his work in Wikileaks. No one could claim that the life and legacy of Assange and his organisation are unproblematic. Particularly disturbing are allegations of active misogyny and sexual violence brought against him. Nevertheless, Wikileaks made powerful enemies through their work because they made sensitive but crucial information available to the public. The ferocious response they have earned from a range of governments is testament to this. The arrest and attempt to extradite Assange is one of the greatest attacks on press freedoms by the US administration, and connivance in it by other states is despicable. Attempts to punish individuals or organisations for publishing true information threatens all journalists and publishers and constitutes an attack on the fundamental rights of any society. The tremendous sacrifices made by Assange – and some of those his work empowered – such as Chelsea Manning – in the pursuit of radical transparency and the accountability of systems of power will have to be recognised and their work supported for years to come.

The Ear and the Eye

A strange coincidence connected the Cat and the work of the historian Carlo Ginzburg. It concerns an ear. Bellingcat's most famous discovery to date was the identity of the Russian secret service or GRU agents to whom the 2018 Novichok nerve agent attack in Salisbury has been attributed. Cross-referencing three photographs found online with data from a leaked passport database allowed the organisation to confirm the agents' identity. When Bellingcat's founder, Elliot Higgins, was asked about a breakthrough moment in identifying one of the suspects named Colonel Anatoliy Chepiga, he responded, 'As strange as it sounds, it's when I saw his ear shape in all three photographs we had of him. It's difficult to be 100% sure on facial matches, but something like the shape of the ears is very useful for confirming an ID, so that was as much … a Eureka moment as anything else.'[1]

Why look at ears? Faces age, light conditions change; on an imaging device, focal point length shifts, context and resolution changes; men shave or do not. Our faces change throughout our lives, smiling or stress pulls our skin in different ways. The ears, however, age differently, slower perhaps. They can stretch, yet whatever the facial expression, they are little affected. One may wear sunglasses, don a wig, tuck gum under lips or cheeks, wear make-up. One will also not necessarily mask an ear because it seems very insignificant. Who remembers to care about the ears?

This interest in ears has a precedent in one of Carlo Ginzburg's most important essays.[2] In 'Morelli, Freud and Sherlock

Holmes: Clues and Scientific Method', Ginzburg discusses the significance of details in the context of another media history, that of painting.[3] One of the biggest problems that preoccupied nineteenth-century art historians was the correct attribution of old master paintings. These were frequently unsigned, painted over or covered by soot, and sometimes kept in a state of neglect. Further, there was a pressing need for the identification of the forgery of old paintings – something of a prodigious industry in itself. The way identification was often performed was through the high connoisseurship of experts tuned to composition, themes and colour. But such sensibility paid little attention to details.

Ginzburg's essay tracks another route. He draws on Sigmund Freud's reading of the work of an art historian – an interesting character who originally wrote under a double mask, the pseudonymous name of a translator of an author writing under a pen name – who eventually revealed himself to be Giovanni Morelli. Museums, Morelli thought, are full of wrongly attributed paintings – indeed assigning them correctly is often difficult, and distinguishing copies from originals is also very hard. Morelli's method of attribution introduced the idea of the technical analysis of details to the examination of paintings. His work, jarring with the then dominant forms of scholarship, led to the discovery of numerous fake paintings and the reattribution of many works.

To attribute or to identify, Morelli thought, one must leave behind the convention of evaluating the most obvious characteristics of the paintings: colour, composition, references and genre. These could most easily be imitated if the forger is knowledgeable enough. Instead, focus should be on minor details. The crucial ones would be those least significant in the style characterising the painter's own school: earlobes – and here is the connection to the story of the Cat – but also fingernails, shapes of fingers and toes. The way these were painted was an inadvertent signature of the identity of a painter or a

forger, who paid much more attention to the main parts of the scene. Painters could be identified by the expedient shortcuts each characteristically took.

What became known as 'the Morelli method', which is still in use today alongside complex chemical tests and other forms of analysis, is part of the basic armoury of art historians and conservationists. For Freud, Morelli's approach was telling in relation to the unconscious. This was because painters seemingly revealed themselves the most when they were less intent on what they were doing, such as when assembling the parts of the painting to which they paid least attention. The manner of speedily painting earlobes was one of these. By paying attention to 'details usually considered of little importance', even those that are trivial or 'minor', an entry into the characteristics of the painter is opened.[4]

It is the inadvertent acts of our lives – what Marc Bloch called, in his book *The Historian's Craft*,[5] unintentional evidence – that reveal our characters and actions. This is in distinction to the *intentional* evidence such as memoirs, chronicles or letters that some leave with the idea that it will be incorporated into history and the court records, acts of state and so on that are left to entrain the future. To return to Ginzburg's account:

> Morelli identified the ear (or whatever) peculiar to such masters as Botticelli and Cosme Tura, such as would be found in originals but not in copies. Then, using this method, he made dozens of new attributions in some of the principal galleries of Europe. Some of them were sensational: the gallery in Dresden held a painting of a recumbent Venus believed to be a copy by Sassofei Tato of a lost work by Titian, but Morelli identified it as one of the very few works definitely attributable to Giorgione.[6]

The Cat was not an art historian and, when we asked him, he told us that he'd heard of neither Ginzburg nor Morelli. The

identification of this eerie state assassin was an intuitive move when it focused on the same organ, by similar means: a focus on the minor but telling detail.

The ear returns again in Ginzburg's account of the 'evidentiary paradigm' as an element that connects physiology and medicine with crime investigation through the father of all detectives, Sherlock Holmes. In this paradigm, Holmes merges meticulous observation, a synoptic scientific knowledge of a topic (the anatomical peculiarities of ears) and logical reasoning. Morelli's attention to detail is not, like the massive data gathering of colonial or police archives of fingerprints or faces, designed to impose a relation of power, but is about sustained careful attention.

In relation to the problem of identifying a crime victim, Holmes explains to Watson the significance of ears in an example closer to the work of the Cat, not as a painterly signature, but as telling objects in themselves. The context is a package he examined containing two severed ears: 'Each ear is as a rule quite distinctive.' Holmes then makes an identification: 'There was the same shortening of the pinna, the same broad curve of the upper lobe, the same convolution of the inner cartilage ... It was evident that the victim was a blood relation, and probably a very close one.'[7]

Here again, the ear appears, within a version of the idiom of the science of its time, as something upon which a comparative analysis can be hung. Close similarities in the miniature landscape of the ear are a sign, according to Holmes, of kinship. Observing this landscape is a means of seeing affinities and links that are hidden in plain sight and when discovered could potentially be connected in a matrix to many others.

Ginzburg's essay is, of course, somewhat larger in scope than ears; it discusses the development of the concept of evidence. His focus on details for the elucidation of relations between cause and effect connects the practices of medicine, detective work and art with his own concerns with history at

the micro-scale – what he and other Italian historians associated with the journal *Quaderni Storici* called microhistory. Dissatisfied with the quantitative and statistical methods of social science and the history of the *longue durée* which glossed over individual lives, their question was, what is the minimal residue out of which some historical processes can be discerned and made knowable? In turn, Ginzburg asks, how can historical tools and sensibilities of micro-detection establish means of making sense of larger formative forces?

For Ginzburg, the entry point is frequently a record of an individual caught up within the web of power, those who are often written off as the 'simple people' without agency. His point is that, within the period he closely studied, post-medieval Europe, the lives of most people rarely left traces in writing and thus in archives. When they ever did, it was often only when they interacted with the institutions of power. One of his most influential books, *The Cheese and the Worms*, concerns the court records of the inquisition for heresy of a rural miller, Menocchio, who also went by the name of Domenico Scandella.[8] While it often achieves a kind of history from below, in Menocchio's story the micro-scale is translated by the protocol of the trial. The guilt or innocence, the pleading and evidence regarding particular thoughts at particular times, the means of extraction of confession, and the dark consequences of a judgment of infraction all colour or contaminate, indeed constitute, the nature of the account. But through and against these layers of process and the imbalance of power, some faint echo of the individual, a life and beliefs, comes to the fore. It is through these voices, though they are threatened, pained and terrorised, that Ginzburg manages to distil and propose something about their lives.

The detail thus acts as a nexus of causal chains and force fields. This is similar to the work of Forensic Architecture, and other open-source investigators whose voyages start from an incident then cut across scales, frames, durations and

disciplines to reconstruct the world of which the incident is part: from a detail, say an interpretation of a photograph, an investigator might travel to encounter different elements, the weather, vegetation, an encrypted statement, or a tweet, pointing outwards towards society and power relations. But such navigation is never easy as every detail potentially exists in, holds together, multiple worlds. The threads it binds are often fractured and tangled, and in the records from which it arises, voices are drowned out, coerced into testimony and filtered into the language of the court so the untangling and the scaling-up work is never easy.

In his discussion of clues, Ginzburg shows how the relation between incidents and history can be articulated by different principles. In medicine, for instance, symptoms are considered special kinds of evidence, never the illness-in-itself, but once, twice or more removed from the cause. They provide potential, never guaranteed, means to establish the presence or a history of a disease. This required the provisional reading of conjunctures leading to the naming and diagnosis of a malady involving the cross-referencing of other signs, scraps of chance evidence alongside more readily detectable symptoms. Conjecture in itself is a kind of logic that is imperfect and incomplete, acknowledging its reliance on chance, imperfect in its reliance on intuition, but it is something that is integral to both the physician's and the detective's trained eye.

Epistemologically speaking, to determine something as a detail in the first place entails a transformation in the conception of the relation between the detail and the whole of which it is hypothesised as part. When you take something as a detail, there is an implied relation to an imagined whole. The addition of a detail that needs to be taken into account implies a reworking of the idea of a whole. Such a transformation can diagnostically unmake the assumed whole, turning it back into the conjuncture of its composition, its coming into being as something that might be otherwise. In this manner the

detail invokes the renewed interplay of different formations of sense-making. Here, sense-making becomes a thick involvement with the relations between the probable and the actual.

As an example of this effect of working the relation between small details and historical process, indeed a historical trauma, is Adania Shibli's remarkable short novel *Minor Detail*, which makes a methodological allusion to Carlo Ginzburg's essay.[9] The novel has two parts. The first describes the capture, rape and killing of a Palestinian Bedouin woman by a platoon of Israeli soldiers in the Negev/Naqab in 1949. This event is set against the Nakba – the massacre and expulsion of Palestinians from their villages and land and the erasure of traces of their lives. The second part, taking place in the near present, describes the attempt of an amateur investigator to find out details about this case. The investigator, a Palestinian woman, is drawn to the incident because of a minor detail: 'The incident took place,' she recalls, 'on a morning that would coincide, exactly a quarter of a century later, with the morning of my birth.'[10] She is freighted with anxieties, has to struggle, dissimulate and wrestle with her own conditioning, and the general bewilderment and peril of life under Israeli colonial domination.

The two parts have different tones and, until the parts connect in the book's surprising end, both manifest different kinds of relation between small details and historical process. The first part is narrated in excruciatingly flat detail that does not differentiate between scenes of extreme violence and descriptions of the mundane: every moment in the capture, torture, rape, and killing of the woman is described with the same level detail as the use of a bar of soap, as the repetitive movement of an officer's hand while shaving and the minutiae of the soldiers' routine.

The second part testifies to the total erasure of details, of Palestinian life from landscapes and cartographic coordinates. The investigator struggles with her investigation, working out

what one system of navigation – an Israeli tourist map – means versus another – a map of Palestine from before 1948 – while the ground has already been so radically shifted. Despite exhausting photographic and documentary archives, and endlessly scouring the ground for traces of the place in which the murder took place, the investigator recognises the impossibility of the task she has taken on.

What the novel brings to the fore, for us here, is the place of detail in the traumatised historical imagination. Narrating details in their full vividness, in the merciless description of minutiae and their repetition as if lived again, puts the reader in the horror of an endless present. This is the time of the Nakba that has never ended, a trauma that is still ongoing, at the same time historical and collective, but that can only be accessed in fragments. It is thus through the repetition of a minor detail – both lost and impossible to forget – that the Nakba manifests. It is a 'way of seeing,' Shibli continues, 'which is to say, focusing intently on the most minor detail, like dust on a desk or fly shit on a painting, as the way to arrive at the truth and definite proof of its existence.'[11] It is in this relation between the mundane and the historical that Ginzburg becomes relevant – it is around the microhistory of this incident as a historical 'detail' that the history turns, and as it does, the whole shifts.

But probing such gaps between systems of wholes and details is perilous. Some systems of coordinates are designed to take away any ability to navigate.

The Eye and the Office

Like Ginzburg, investigative aesthetics aspires to find the fault-lines of history writ large in the smallest of corners, even those of faces. Let's move further in towards the centre of the face to two other sense organs that provide figures for detection.

First, the eye, the private eye. JJ, the inquisitive detective from *Chinatown* played by Jack Nicholson in one of his best screen moments, becomes a means for making a literal connection between the eye and the nose. The criminal character played by director Roman Polanski places a blade up JJ's nostril, '*You are a very nosy fella ... you know what happens to nosy fellas ... want to guess? They lose their noses...*'[1] Abruptly, the knife is cut sideways out of the nostril.

Developing a nose for things is a key aspect of inquiry, a way of thinking for the eye. The 'nosy eye' stands for the individual detective as opposed to the large bureaucratic organisation, the office. The detective novel tends to contrast police procedure with the maverick working their own idiom.

The office, in contrast to the eye, is the figure of the bureaucracy of knowledge that works by amassing data and establishing connections between it. It is based on archives and classifications, on data about citizens, on the power of the state. The eye's often damaged cogito causes tangential insight that allows it to arrive at a glimmer of a clue. Hierarchical, observant and relentless, the office is a figure of the production and acquisition of knowledge that is slow and reliable, one that is able to tabulate, track and cross-reference multiple positions.

It does things by the book to outwit reality's capacity to hide in the sheer mass of numbers. The bureaucracy of investigation regulates the rules of evidence, engages issues of admissibility, probity and 'chain of custody'. In their dreams, the police see themselves operating in a Fordist factory of facts.[2] The office, where budgetary allocation allows, follows up all good leads in parallel, amassing and sifting to let nothing go amiss, whereas the eye zigzags across the city on the basis of intuition.

Hierarchical, observant and relentless, the office is the figure of the production and acquisition of knowledge that is slow and reliable, that is able to tabulate, track and cross-reference multiple positions to evade the propensity for brilliantly costly rookie errors. The office is a mechanism designed to keep hyperaesthesia at bay.

The idiosyncratic eye might even thrive on it; it understands the archive's blind spots, biases and inertia. The private eye operates by stitching together the splintered synapses of the *polis*. The eye finds illumination where the procedural rigidity of police work leaves unnoticed blind spots. From the ratiocinations of Auguste Dupin in the founding detective novels of Edgar Alan Poe to the erratic detective Qussim Dhatt of Ul Qoma in China Miéville's *The City and The City*, through Coffin Ed Johnson and Grave Digger Jones, Chester Himes's wry knockabouts in his Harlem cycle, to Peter Plate's image of a homeless patrolman living in his squad car in the gentrifying vortex of San Francisco, the detective is understood as operating in the image of the city in all its multiplicity and oddity.[3]

The duality between the eye and the office is blurred by a range of other figures of investigation. Agents for the intelligence services freelance at the weekend in order to pay their ambitious mortgages. Special forces operatives take early retirement and do consultancy gigs. Fatigued soldiers 'go on holiday' as volunteers across the border. Precarious operators provide plausible deniability to state operations and renegades move into offices to generalise their methods. The material

worked with may also have the quality of vapour: arms-length inquiries provide pivot points for assets that may or may not yield use in the future. Informational derivatives hedge the result of the use of gossip, tip-offs, leaks, recordings, ghosting, blackmail, malware, disinformation and surveillance.

The 2016 Trump dossier assembled from a series of memos by a British intelligence agent turned freelancer provides a condensed sample of kinds of sources. From a primary subcontractor, several other sub-informants were reached. Here, the fruits of investigation included notes on claims to the existence of *kompromat*, compromising material such as leverage-providing records of dodgy sexual or financial transactions. Short remarks on hacking teams, leaks, bugged conversations, bribes and payments via real estate interests and pensions show the mix of age-old and newer techniques. Information comes by the squeezing of assets and contacts, back doors introduced into IT systems, tip-offs, back-channel reports. The interception of communications provides validation of the techniques of the Angel, but there is also the building up of an atmosphere of suspicious indications.

Such freelance spooks have to work as both the eye and the office at the same time. Much of this work also relates to classic 'shoe-leather' journalism, asking direct questions to persons able to verify or falsify a supposition or line of enquiry. This is work that relies both on doggedness and non-linear effects, the idea that a string will be pulled, at some point, that will wrench the drapery from in front of our eyes and reveal the truth. For the figure of the eye, the idea is that procedure itself hinders investigation, that investigation needs to be unleashed from rules. Indeed rules are what allow, in their predictability, for things to be masked even more effectively: investigative bureaucracy is a factual form of inquiry whose focus is too narrow, its constraints too rigid, that it is often insufficient as a way towards the truth. For a precariously employed spook, however, procedure may be a sign that they can reproduce the

dependability of bureaucracy, without the costs of being the state. For the eye, the crime scene is always larger than the cordoned-off area. It takes place in institutional meetings and boardrooms; it takes place at the heart of the office itself.

The outsourcing of state functions has epistemic effects. We have noted the 'Uberisation' of forces in many recent conflicts. This structure of precarity can also be seen to be moving higher up the food chains of governmentality. When chains of command and renewals of contract come into play, intelligence reports may be toned by marketing and self-aggrandisement, thus rendering such documents noisy and unreliable in a different way than they might be from the tropes of self-aggrandisement *and indifference* that haunt the dossiers of the state.

Equally, certain contractors, for instance those with military experience, may come with mentalities and approaches derived from prior training. When military techniques are applied to a social movement, the operatives see less of a society, and more of a theatre of operations. Intelligence and monitoring reports may be heavily laced with misconstruals by framing all contexts within a reduced military playbook. This can lead to problems of the overstatement of threats that can be interpreted as either cynical or stupid.

The techniques and vocabulary of imperialist counterinsurgency learned in the US Army by a mercenary start-up called Tiger Swan (one of a number trying to angle a slice of the lucrative business) were applied to civil demonstrations, for instance those against the Dakota Access Pipeline.[4] These were treated as 'insurgencies', with significant consequences for how they were interpreted and acted on. In a related way, previous 'counterintelligence programs' of the United States readily mixed blackmail, disinformation, assassination, the abundant use of informants and the framing of activists as informants. All of this combined with the gathering of what could pass, in the lugubrious mayhem, as intelligence.[5] Outsourcing

illegalities and repression, like other kinds of public–private partnership with revolving-door recruitment and a chummy sharing of information, readily leads to such blurring.

Pre-emptive Investigations

Not everything that happens is an incident. As we note above, it should be a word reserved to describe a point of singular transformation, a collision of vectors with a potential to reveal underlying forces or to knit those visible on the surface together in significant ways. Incidents are thus starting points for investigations. They are the points through and from which larger causal threads and field causalities can be traced and reconstructed.

However, investigations need not always come *after* the incident. The prompt of the rear view is not the only way to start to engage in microhistory. Indeed, an investigation might sometimes have to come beforehand. Or itself become an incident in order to investigate a situation. In a sense, all investigations concern themselves with trying to encourage learning or the preparation of countervailing measures that act on possible events in the future. But here we want to talk about something more.

Investigations can sometimes act to bring an incident into being, provoke it, cause forces to collide, so that larger political or other currents can burst themselves open, much like geological layers of rocks are exposed by an earthquake – with the seismic crunch being the precondition for a geological study to take place. Studying such forces may involve both the 'stratigraphic' work on the hidden and then revealed layers that we mentioned in Part 1 as being the core of the work of critical theory. But it can also take place through bringing into simultaneous focus elements and forces of different

kinds active across different domains. Such a focus may be refractory and synthetic simultaneously; that is, it breaks apart and pulls things together. In either case, pre-emptive investigation is not only about reading, but also about *working* the conjunction.

The philosopher Brian Massumi has called this kind of action 'incitatory' – a research action ceaselessly producing its subject. Investigations could be considered incitatory in as much as they seek to provoke and bring into being a dormant, latent and undetectable phenomenon.[1] Incitation makes something reveal itself, become detected, sensed and made sense of. Often, indeed, systems of domination and institutions of power become common sense, work their way into the practical metaphysics of life as 'the way things are', and as a result we are de-aestheticised to them – worse, constituted by them.

Too frequently, for instance, we are inured to everyday violence, nor do we begin to figure sufficiently the ecological dimensions of systemic devastations. The one is too mundane and self-evident, the other too abstract, too ineffable and long-term to be bothered with. Incitation aims to break this, and it works on two levels. First, it works on inciting the capacity to sense. This may be coextensive with the second: that the as-yet-invisible phenomenon being researched needs to be provoked into palpable being.

Inciting capacities to sense may happen all at once, or may range in time towards a slow process of learning. One hopes that the time available to the process of learning is commensurate with the problem being addressed, but things can be complicated, ambivalent, time-devouring, insufferable – or actively rendered irresolvable – requiring a short cut. In such cases, and there are plenty, provoking an incident into being, something that in turn may be the result of slow work, may become necessary.

Working at the capacity to constitute sense can simply be looking in a new way, or an adequately realistic one; this is the

moral of the story of the emperor's new clothes, for instance. Stating the obvious may also be stating the abstract – arriving at an unnoticed, or hidden, common denominator. But by setting 'dormant situations' in motion, one may also provoke systems to reveal their tendencies and inner organisation and so by provocation produce or induce forms of knowledge.

This might actually invert the concept of theory and practice. If we once thought that theory was a prerequisite of practice, creating its conditions of possibility, and that you needed to know in order to act, a provocation might reverse this logic: you act in order to find out. That is the essence of some of the kinds of investigation we propose here: artistic, architectural, and cultural practice as the production of knowing.

An ethical problem is immediately implied by such a figuration, of course. If accreted thought produces the templates for the knowing subject, and a way to work at cracking the grip of this code is by acting, then one risks inheriting the arrogance of the authoritarian activist or a belief in the absolute purity of one's own actions. Both of these imply the correctness of a pre-existing answer and their problem is in trying to enforce it rather than open a situation up to common enquiry. It is the latter that is necessary.

———

It is a commonplace in social movements to say that people learn through struggle. Testing and challenging a political condition are a way of learning about it and of transforming the scales of the self and the social in so doing. Meaningful political struggle always involves direct action – direct change to a situation by the people experiencing it.[2]

One example can be found in the 'Spies for Peace' incident in Britain during the Cold War. In order to reveal the intentional build-up to a nuclear war a group of peace activists revealed the locations and plans of nuclear bunkers that were imagined to be future 'regional seats of government' for a post-nuclear Britain.[3] This information was discovered by

entering a bunker near Reading where documents relating to this planned nationwide network were accessed.

How bunkers are made, what kind of war they are designed to anticipate and who they are made for has been a concern of architecture since Lubetkin, Skinner and others in the Architects & Technicians Organisation, founded in 1936, campaigned for adequate air raid shelters during the Second World War.[4] In the Spies for Peace case, making the location and kind of bunkers common knowledge was a way of pre-empting the preparations for war, of acting on its incitement. If power works by action on action, as Foucault put it, then the direct action of the pre-emption of such preparations is a crucial means of investigation, with attention on the secret.[5]

Investigations are not only about finding things out, the mere exposure of fact; nor do they rely on a naive conception that 'showing is making believe'. The field of investigations involves an intricate dance between showing and masking, between hiding and drawing attention, withdrawing and exposing: all of which are strategic and tactical interventions in the field of the sensible. Simply put, it is often necessary to hide (for instance, one's identity) in order to reveal (for instance, government secrets). It is in fact the balance between exposing, occluding and withdrawing – all manifestation of the sensible and knowable – that some of the important political struggles of the present will unfold. It is in the preparation and the working of this balance that pre-emption may also play out.

13

Many Logics of Fact

The allure of the minor detail can, of course, be a means of throwing investigation off track via the subtle play of a logic of suggestion. Here, the detail stands in for a whole, but there is no concern for the work required to arrive at fact rather than fabulation. The decontextualisation of minor details has sometimes been used by anti-epistemologists to deny and negate inconvenient facts. Just remember the way Holocaust deniers often emphasise minor details. Master negationist David Irving often repeated the phrase 'no holes, no holocaust' when referring to the difficulty, since resolved, of finding remnants of an opening in the pulverised roof of one of the Auschwitz gas chambers through which Zyklon B canisters were introduced into the room.[1] This technique, which is sometimes more of a neurosis, is also used by climate damage deniers and other conspiracists. Here the detail is designed to derail.

But there are other figures that operate by a different logic. One of these is that revered incarnation of the eye versus the office, Sherlock Holmes. In a famous phrase, Arthur Conan Doyle had his hero remark that in analysing an event, 'when you have eliminated the impossible, whatever remains, *however improbable*, must be the truth.'[2] This is a succinct statement of the *apagogic proof*, a proposition to which the contrary, or anything different, is absurd. The method goes like this: assemble all possible candidate facts, remove what cannot be true, what remains must be the truth. No further reductions can be made without causing a crisis in truth itself.

The method is a recursive logic of analysis and removal. If the police, in their bureaucratic form, are a factory that chews over and churns out facts, here the detective is the cold assassin of putative facts, the annihilator of tall tales. This is the logic of removal.

Coupled with removal is another movement by which facts are assembled, which works via synthesis rather than reduction. In his inspiring book on contemporary mathematics, philosopher Fernando Zalamea discusses some of the means for problem solving described by Alexander Grothendieck.[3] These reflections on ways of working are set out in Grothendieck's *Récoltes et semailles*, a lengthy text examining his time as a mathematician.[4] Our interest here is in relation to what Zalamea describes as the figure of the 'solution' – in its chemical meaning of substances dissolved into a medium.

The solution is a means of absorbing the data about a problem and the ideas or propositions that address aspects of it in a new proposition that, at the same time, composes a wider field. Zalamea's book itself makes a claim that synthesis, a movement towards establishing a framework that can absorb all factors relevant to a problem, is a necessary characteristic of contemporary mathematics. He counterposes this to its historical fragmentation in the twentieth century when much of the originality in mathematics was also in finding and formalising gaps in knowledge – via figures such as Turing and Goedel. Such a condition also emerges from longer-term distinctions between, for example, the formulation of the discrete (the separateness of numbers) and the continuous (their ability to generate and to map things such as curves, for instance) and the ability of geometry to rework relations between these. Arising from this context, Zalamea's description of Grothendieck's practice of solution provides an analogy for investigation of other kinds of problems.

Different mathematical problems may be addressed by various kinds of mathematics. But solving some problems may

require the invention of new forms of commonality between seemingly distinct theoretical approaches. Indeed, the distinction between fields may itself represent a certain kind of problem to which a synthesising form can provide an answer. Grothendieck's great insight was in part in establishing the possibility of translations between fields to produce a new commonality of solution.

And here's where Zalamea's account becomes particularly useful to us: he describes two kinds of approach to the investigation of mathematical problems. Grothendieck offers the image of a nut as a metaphorical stand-in for a problem. One way to crack a nut is by using a hammer and chisel, gaining access to its interior at the risk of pulverising its contents. The nut is the prize, and the force of insight is rewarded by it.

A different aspect of the cognitive faculties allows for another way of approaching the nut. That is by 'immersing' the problem in a more general field within which it can be won over with great delicacy.[5] This softens the shell and the skin of the nut, loosening them, in order to arrive at its kernel. Such an immersion does not lose the precision and specificity of the problem, nor does it render the internal and local differences within it meaningless; rather it dissolves the irregularities that had previously made it incoherent in a wider, more encompassing formulation. It is this latter movement that Zalamea sees as representing the crucial work of the mathematics of the latter half of the twentieth century: the work of synthesis. For investigation, finding unexpected commonalities and perspectives that illuminate and align previously hidden aspects of a problem can often be necessary for coming to a solution.

The process of immersion is not one of subsumption and disappearance of the problem and its particularity into a homogenised substance. Rather, the kind of synthesis proposed is a polyphonic movement in which a plurality of questions, notions and approaches establish relays and concatenations of ideation between each other as they overlap.

Perhaps Grothendieck's two approaches have analogies to those of the Cat and the Angel in some ways. Piercing the space of secrets to get at a juicy piece of information is well understood by the Angel. The process of suffusing a problem with prognoses in an open terrain has a certain affinity with the work of the Cat. There is a parallel too with the complimentarity and difference of critique and investigation.

For the remarkable thought of Grothendieck, there is also an ethics among and between ideas as much as between those that have or entertain them, so the question of solution is intended not to disturb them but to find the potential grounds for their mutuality. Indeed, he relates mathematical curiosity to a form of love. One must recognise the delicacy of the way in which an idea is formed, the specificity of its individuation and its idiom, while working at the possibility of a solution. One can see this as a form of the careful construction of forms of solidarity between ideas.

What we want to entertain here, though, is the idea of synthesis as a form of investigation. This would be a situated synthesis, rather than one that imagines a super-set in which all difference is erased. Such an approach immerses the case along with the hypotheses pertinent to the incident. It draws these in at the level of minimal causality and of field causality.

While an investigation is ongoing things are still not defined as yet. They can only begin to become so by potential relation to fact or what might yet be articulated as fact. Synthesis must seep into the situation, absorbing the evidence, sorting its possible affinities and contradictions. Facts, indeed, must be discerned by their ability to settle around the evidence of the incident. In this, they must be recursively tested by the apagogic proof of Holmes.

Part of the question of investigation is to work out what are the significant factors, what comes into play in any given situation. You will see that this book moves backwards and forwards between different techniques or methods of investigation,

testing their capacities and their limits, but never limiting them to a sole approach. This is an attempt to find a rigorous but polyphonic form of reasoning and enquiry that does not too readily cease in testing and modelling its presuppositions. If you think back to the opening discussion on hyper-aesthetics and hyperaesthesia, part of this potentially schizoid condition is this avalanche of sensing and sense-making, and the tumbling, overturning, explosively extrapolatory movement of sensing sense-making itself. There is an art to exploring, and investigating in, this extrapolatory state.

Another way of working into this question is via the theoretical propositions that have some partial traction on it, asking not only what directly caused it, but also what induced it to crystallise. In turn, what are the modes of sense and sense-making that are commensurate to it – that are capable of recognising it as they come into composition with the process of investigation?

————

The relation between the eye and the office could be captured under the term 'counter-investigations'. The eye investigates the office; these are investigations often conducted against the very state agencies – such as the police or the military – that usually monopolise investigation. Just as the state legitimises itself by assuming a monopoly on violence, it also does so by imposing a monopoly on enquiry. Counter-investigation is not a mirror or mimicry of such state procedures of investigation but seeks to exceed and to circumvent the procedural limitations and necessities entailed by the modes of power they embody. In fact it strives to reverse the trajectory of sense-making that characterises state procedure.

What is often investigated is an incident. It may be a slow one or a fast one: a years long process of deforestation or the millisecond of an assassination. It may consist of gradual accumulations, or it may come into being as an accretion of absences. Integral to its specific condition as a particular

occurence, such an event is also a crucible in which to investigate the latent tendencies and forces that compose it, forces that do not necessarily manifest themselves otherwise.

It is important here to offer our distinction between an incident and an event. Incidents are moments when contradictory forces collide. From one perspective, the collision may reveal the inner structures of the objects, agencies, systems of infrastructure or bodies involved in the rupture. Such an incident might draw investigators in a hurry, like geologists scurrying to the site of a seismic crack which exposes the order of the layers of the earth, their interstices and lines of least resistance. Because an incident is a moment of intensification revealing the intertwining of forces generating historical transformation it also becomes a moment of epistemological opportunity.[6]

Perhaps we can make an analogy with what Paul Virilio said about the accident – that it is the most revealing way to understand technology: where a black box is opened and the components that make a train, an aeroplane or spacecraft are spread out, when the modes of assembly and their implicit imperatives become momentarily transparent to interrogation.[7] From a railway accident one can navigate outwards to the production of an engine, tracks, communication systems, architecture of relay and central stations, but also to the experience and shaping of the world that these things bring. The accident is to technology what the incident is to history.

An incident may take many forms. It may take the form of something like a joke that makes a fissure between different principles laughably apparent. A telling instance of this is when, in Moscow in 2019, a spokesman for the LDPR, a loyal opposition party, who in the midst of a live television interview proclaiming that there is no unnecessary violence by police against demonstrators, is himself mistaken for a protestor and bundled off by armoured cops.[8]

An event, in the way we understand it, is more processual and may spread across multiple time frames and speeds. But

temporality is not the only crucial factor. An event is also something that can be said to occur – and to manifest as an incident as such – from certain situations or perspectives. What is read as the composition of an event is thus folded into the question of its sensing and sense-making. History thus unfolds on different scales, over different durations, and at different speeds. It manifests itself in the instantaneous, eruptive force of the incident, a moment of break with the flow of time with something emerging out of or destroyed in that break. It speaks and stutters in patterns and repetitions, then manifests itself in the slower, incremental hum of processes across wider territories and extended timescales. Counter-investigation must start from an incident or rupture but capture events on multiple scales. A counter-investigation should strive to open up from a singular incident to describe events that have simply been naturalised or taken for granted as 'business as usual'.

Pursuing incidents as entry points to political critique challenges ideas of scale: that certain kinds of politics stack neatly inside each other, the bigger matryoshka dolls always being the structural cause for the behaviour of the smaller ones. In counterinvestigation, lines of causality can move from the incident to the structural forces. Sometimes standing at a specific location allows us to test a condition better than what could be generated by a long remote shot. 'Ground truth' is not simply nested in or a function of the 'larger' image, but is the hinge around which it turns. The term 'ground truth' refers to a process used by meteorologists and remote sensing or aerial-image interpreters to calibrate the analysis of large-scale images, mathematical models or simulations. To arrive at 'ground truth', an aerial-image interpreter must measure and compare the ground elements with the elements that compose the image. Elements of a larger system of analysis are here anchored in small-scale evidence. Just as a satellite image analyst needs to compare pixels in an image with empirical data of the elements on the ground in order to calibrate

material, colour and scale, so mathematical or historical models of analysis need to be aligned with empirical evidence on a local, small scale.[9] In this, there is no simple inversion of a hierarchy, in which the micro-scale is superior per se, but there is a necessary movement backwards and forwards between them that implies a work of testing, iterative increases in certain kinds of precision.

But to make this statement entails a movement across forms of knowledge and the kinds of things such forms refer to and work with. Certain scales come with modes of knowledge that have accreted over time for dealing with them and, in a certain sense, to which they are answerable. The scale of the molecule comes with the discipline of chemistry as an entailment, for instance, but depending on the molecule or atom concerned, and what it conjoins with, it may also be necessary to talk about it in political, ecological, medical or other terms. Moving between the investigative modes is also to move between different disciplines, requiring transdisciplinary or even anti-disciplinary formations. As we have suggested, investigation should move from the micro to the global (in space), and from the split second to the long duration of history, and even to deep environmental or 'geological' time.

Countering is an active instrument of enquiry, but goes beyond contradiction. Counter-investigations are an evaluation not just of what has happened, but of all possibilities that might have. As such they differ from official investigations in another aspect. Investigators routinely discount the counterfactual. It's hard enough to establish what happened without thinking about what could have happened. But in the context of the counter-investigations the counterfactual could be an essential mode. A counterfactual is a hypothetical possibility, but one that is contrary to currently known proof. Counterfactuals can be formed in close dialogue, critique and struggle with state-sanctioned facts where a comparison between what happened and what might have happened is essential.

Minimal Causation and Field Causality

When following the material threads from incidents to the scales of broader events and processes, we need to think about what constitutes causality. There is a plethora of entry points for a discussion of relations between cause and effect. We want to propose here that we pay attention to the differences between two limit kinds of causation: minimal causation and field causality.

In legal settings it is only proximate, direct causes that count in coming to a determination of cause or of guilt. This can be called the requirement for *minimal causation*. The complex multiple causes, which may be social, cultural, economic, environmental and so on, that bear on a particular event – what we call *field casuality* – are discounted in such settings, or heard only as mitigating circumstances.

Counter-investigations try to work with both minimal causation and field causality: to study the mechanics of an incident, an act of police shooting, perhaps, and do so within the constraints of its time and space, by establishing trajectories and culpabilities. But for counter-investigations, violence is also always larger and more pervasive than the cordoned-off area of the crime scene. Pervasive environmental, cultural and economic forces bear on the incident, often crystallising it. It is thus the task of those practising counter-investigation to follow the threads leading from the minimal cause of the incident outwards, towards the world of which it is part.

The choice between these two types of cause is not only a question of aesthetics, of different regimes of sense-making,

including what is admissible as something that makes sense in each case, but also of ethics and politics. It touches on one's relation to the structure of society and domination, to what, given such a framing, should be criminalised and what should be naturalised.

In judicial settings where there are legal demands for evidence of a particular sort, it is hard, if not impossible, to talk about background causes. A legal argument will concern itself with the smallest possible chains of causation between a recognisable cast of identifiable people and things. It asks, what is the minimal act, or inaction, that causes a crime to occur? As such, a crucial threshold for formulating minimal causation is a constrained version of the incident, the specific interface with the law's ideal humanist individual and the recognisable objects and systems, such as property, that pertain to it.

The foundation of Aristotelian metaphysics is the unmoved mover, the single ultimate fulcrum which turns everything around it. In turn, legal requirements for minimal causation look for movers in the *last*, rather than first, instance. The requirement to identify a mover in the last instance asks the question of who finally pulled the trigger, who behaved in a menacing manner, or gave the order, who exercised will or reasonable agency in making an event happen, rather than examining the penumbra of fields around and forces running through the crystallisation of the incident. These may include economic inequalities and racist bias. Field causality, by contrast, is attuned to diffuse and moving movers.

How might a jumble of scattered phenomena come to be seen as a set of related events? What are the effects of a slow build-up of distinct forces in crystallising a break, a fissure, in an ongoing process? And how, once that break has occurred, might we read back from it into its determining fields? These are ongoing problematics in many areas of science – and even play a role in mapping the genesis of scientific ideas themselves. But they are less controversial in other areas such as

structural engineering where the materials and objects concerned, such as concrete and steel, are more well-known, and have been refined over time in dialogue with that knowledge. Even here, though, aspects such as the dynamics of fractures can be complex and unpredictable.

An argument of a related kind is made by organisations such as the United Families and Friends Campaign. This is a long-running alliance, founded in 1997, of people whose families have been killed by the police, prisons and psychiatric hospitals in Britain and Ireland. The campaign gathers seemingly separate cases to show a pattern between them. When agents of the state end peoples' lives the law is predisposed to see it as a one-off, a result only of minimal causation. What such campaigns do is to show how there is a pattern to such crimes and judgements and that there are ongoing, and institutionally sustained, fields that cause them. This important campaign allows people to move from the understanding of an 'I', perhaps feeling trapped and isolated in dealing with the impervious and disdainful state, to that of a 'We', a campaign produced in common. This change creates a new field of causality in itself: a movement.

Equally, the theatre of operations that makes minimal causality convincing relies on stabilised categories that render entities and processes knowable and workable by certain repertoires of techniques. In the case of law, these techniques might correspond to formations of liability, responsibility and agency, and notions of the individual in relation to them. These are in turn articulated in relation to a milieu that is thick with formative structures, such as legislation, social and economic structures, property, contracts and technical devices and so on.

These tend to shape individuals in relation to a constitutive grammar of action that renders minimal causality more readily describable in many cases, but absolutely off-limits in others. For instance, within the terms of reference of a court it is 'easier' to say that a police officer that killed someone

is 'a bad apple' than to look into wider factors such as systemic racism that drive patterns of such killing. To carry out the latter would require more work for the institution, indeed involving the fundamental reshaping of ideas and institutions of justice. The legal system, and the political one that frames it, effectively offloads an understanding of the wider causation of such killings onto the population and especially those who are its targets. By such means, culpability can be effaced, diffused, rendered insoluble. For counter-investigations, the inter-operation of minimal causation and field causality need to be described together, to open them up to change, in a manner reminiscent of the synthetic interrelation of removal and solution.

—

The composite argument of field causality does not solve all problems for certain contexts. When presented in isolation, particularly in legal settings, field causality may end up becoming the bastard's best line of defence. Often, perpetrators will attempt to use such explanatory structures to deflect accusations of their own criminal minimal causation. They may claim they were, 'only cogs in a machine,' a product of a culture, or a larger field of action. Field causality might perhaps currently be more common as a form of deflection than as an operative form of forensics. Against a persistent defence in the context of a criminal trial, it is often hard enough to establish and defend very basic mechanical facts against persistent counter-interrogation, let alone the wide influence of ambiently determining forces.

Proposing field causalities in a court case might result, in the eyes of legal professionals, in the production of 'dirty evidence'. This would be an excess of information, a hyper-aesthesial condition. Lawyers often feel compelled to distill such a cloud into a linear chain of minimal causation, a sequence of distinct cascading actions. The conventions of minimal causality make it necessary to draw straight lines

between perpetrators and victims. This 'billiard ball universe' seems suspiciously mechanical at times and at others merely too mechanically suspicious.

But whatever evidence is excessive in relation to the protocols and institutional needs of one forum might become important in another: the confusing 'dirt' in one context might be exactly the operative element in another. The necessary fora for dealing with field causalities are rarely juridical, but cultural and political. To identify field causalities for environmental violence, racism or patriarchy, for instance, is to articulate the imperative to fundamentally reconfigure the political field. As such it challenges the tendency of justice to isolate and punish a few individuals and leave the social and economic structures intact.

Field causality consists neither of solely direct nor of simply indirect causes, but conditions that induce possibilities and constraints of action and modes of being. Field causality is not uniform, but highly varied in its characteristics. Causality may act by means of strict demarcation, or might shape a context by means of a subtle shift in a gradient of force or conditioning. Fields may be highly internally differentiated and heterogeneous rather than simply uniform and monotonic. Interactions between fields, and they are usually multiple, introduce further dynamics and ranges of constraint and capacity in the interference patterns set in play between them.

One complex of fields is social class. For Marx, the defining field is established by dialectical tensions between capital and the historical figures it brings into being, specifically the bourgeoisie and the proletariat.[1] Within that field all human relations are somehow magnetised and reworked. Subsequent Marxian work develops an account of how the bringing into being that is ascribed to capital is actually the reworking of social forces that themselves drive change, that force, sometimes in subterranean ways, new equations of

power.[2] Intersectional feminism reworks such insights and those arising from the formations of race, class and gender to figure a wider matrix of oppressions and identity-formation, as multiple fields of force flow into and modify each other.[3] Posthuman feminism builds on this to attempt to sense how, for instance, questions of ecology and technology should be factored into such interactions of fields. It emphasises how the racialised, gendered and classist universalising figure of the human tends to curtail attempts to think beyond it by imposing a norm that is always loaded.[4]

In different contexts, these fields can be highly dispersed. They may occur irregularly, and be sporadic rather than uniform in terms of their effects. One formulation developed in cultural studies to talk about field causalities implies that they are dynamic movements of forces that inflect and are embodied in different timings. Antonio Gramsci's notion of the *conjuncture* is, for Stuart Hall, 'a way of understanding the condensation of all these elements at a moment which is not repeatable, in a condition which is not repeatable'.[5] Field causalities are thus dynamic and mobilising formations in many cases as much as they might force a stasis in others.

—

One historical way of describing field causalities and minimal causation in parallel is through the technique of perspective. Renaissance images, where perspective is invented as a technique, pivot round a face or a gesture and are arrayed in spaces that describe a theatre of vision organised around the appearance of vanishing points. The principle of perspective helps depict a direct cause. Perhaps this might be the moment when an order is given and when it is acted upon or interpreted, or a moment when a gaze passes across a room.

Perspectival geometry offers the ability to pinpoint something (a figure, a line, a quantum) that can stand in for a location or a moving object. The move to the images constructed through the technique of perspective emerged in the

Renaissance partly because perspective provides a means of describing an individual between the twin poles, or vanishing points, of heaven and hell. This tension satisfies the requirement to be located in religious terms. But it also allows for humans to be seen in and among other beings in the world, horizontally. The Renaissance world is caught in this tension between these vertical and the horizontal fields as it negotiates the new conditions of humanism. The relationships established by this matrix are intended to be legible and work as a narrative and diagrammatic whole. Contemporarily, we are compelled to work with and assemble other axes; the geometries of our time are differently contorted.

Part of the history of this problem of the way fields enter into painting can be traced in the history of the depictions of the sky. In his book *A Theory of /Cloud/*, art historian Hubert Damish describes this trajectory.[6] He mentions a decisive point of incongruity: the ground is arranged under the rules of perspective; turned into a series of cadastral lots, it is measured and owned, while the clouds in the sky move faster than the painter's hand can capture them. Such clouds had to be imagined, imputing mood, ambience, divinity. Thus, for Damisch, while the lower parts of landscape images were in modernity, the skies were still in a medieval mode long after that period had gone.

John Ruskin, the prophet of modern art, offered one way in which this disjuncture could be resolved: in his book *Modern Painters*, he claimed that, rather than extending the grid of perspective into the sky, true modernity began when the cloud descended to the ground, turning painting into a new optical reality of significant indistinctiveness, of blurring and deflecting fields saturated with light and moisture. He was thinking of the painter Turner, of course, and of the way in which enjoyment of such art was hintingly analogous to the acceptance of partial knowledge against the illusion of absolute intelligibility.[7]

Indeed, not only has art, as a self-consciously constitutive form of aesthetics, been a laboratory for the creation of new relations between causes and effects, but it also allows for investigating the nature of these two terms. The problematic of a painting might pose a run of questions. How does one mark on a canvas lead to another, and under what terms do they cohere, or not, as a whole? How, perhaps, might a painting be made in order to evade the fate of being a singular mode of coherence?

The circuits such marks are routed through as they come about include possible waymarkers, for the painter in front of the canvas, such as the eye, hand, brushes, knives and paint. Each has their individual propensities and difficulty. Training, contingency, the composition of a surface, questions of minimal and maximal expressivity of parts, the arrangement of an implicit geometry, and many other factors may play a role. These in turn may be supplemented, supplanted or varied through other mechanisms, such as chance-based or collaging, citational processes integrating the painting into other systems of reference. Further, such circuits are run through a relation to the interpretation of the world, drawing in questions of figuration.

Over time, as imaging systems such as photography, television, print and computing, with different vocabularies and modes of alliance with different systems of aesthetics and power, also enter into the compositional plane of the canvas these circuits are tweaked and broken into by different kinds of social and subjectival agents. This engenders additional routes and relays of event, process and interpretation. Paint, in turn, full of its own quirks and accretions, becomes a means of registering and probing the particularity of such imaging systems.

To take another example, in his essays on the later work of Paul Klee, written between 1948 and 1950, the critic David Sylvester discusses a painting and drawing style that

he describes as 'afocal'.[8] In such work, the eye moves around the composition, without any place to rest on. His account of skeins and streams of intersecting lines and budding forms suggests an articulation of networks, but he also talks about an aesthetic of scattering, of creating a non-tensile set of relations between things in which the eye drifts and thickens rather than travels. The work can be said to disaggregate seeing, give it a new terrain rather than a gymnasium of focuses that entrain it. In this field of sprouting marks, the seeing eye moves through fields of forces which it jointly composes.

These formulations can be seen as part of the modernist aesthetics of simultaneity. Simultaneity is not simply the structure of the 'all-over image', but a formulation of the universe as incessantly being made and unmade, in many directions at once. Later, art's emphasis on process, and what the Brutalists called the 'rough poetry' of materials in context,[9] placed an emphasis on all forms of matter as revelatory. In their interaction indeed, the very forms of noise and interference that obscure or texture what is viewed in processes of observation are also, if sufficiently cross-referenceable, those things that verify and authenticate the condition of observation. This is a particularly important question for thinking about the nature of investigation – how do the conditions of investigation shape what can be known?

Here we need to loop back to the intersectional idea of conjuncture. These kinds of material forces require non-representational accounts of culture; they can also be potent in developing an analytical account of the world. The developments in the history of art mentioned above, amongst others, allow us to propose that aesthetics can be crucial as a laboratory for working out the possible modes of interaction between minimal causation and field causality where the inflection that a posture, an image, a brush stroke, a style, and so on creates enacts the specificity of such concrescences.

———

A kindred formulation to that of the field is the statistical idea of multidimensionality. Events or entities are read as having multiple dimensions that can be assigned a numerical value. The assumption is that they can be described in numerical terms with some sort of interpretive efficacy. That is, that they are made up of different quantities, or that they yield these when viewed statistically. These are linked together, but individually discernible under correct methodological scrutiny, and the variations in consistency and kind between their linkage can be significant.

Here, one deals with interacting fields by quantising their elements and processes. Such an approach allows for elements and dynamics that may, under certain conditions, be the most crucial determinants of a situation to be lifted out and identified. In such work there is a movement back and forth between field causality – the entity being enquired into understood as a putative whole – and minimal causation – a specific quantity or factor – that aims to find a way of describing them both simultaneously in their intricate interrelation.

For instance, epidemiologists and clinicians working on COVID-19, trying to nail the variables of transmission, would work with statistical models and with testing to establish the range of probabilities for the presence of the virus. Serology testing, for instance, is a test for antibodies generated by a person's immune system. No such test has absolute accuracy, and understanding the rate of fallibility of the test by statistically modeling it helps in understanding the degree of accuracy of diagnosis of the specific case.

In turn, the recording and analysis of the specific case feeds into knowledge of the wider state of the epidemic. In such cases uncertainty is part of the composition of the fields. Systemic uncertainty, caused by the lack of testing, aggravates the problem of the specific test's reliability and its ability to diagnose a particular infection that may in turn have been caused due to lack of testing. Coupling serological testing with

another method, for instance questionnaires on behaviour that might have exposed a patient to the virus, is a further way of calibrating probabilities arranged between the specific individual and the wider population.

Such multidimensional problems recast the twin figurations of the discreet and the continuous that run through the history of mathematics. Ultimately there is no absolute contradiction between the two kinds of description or formulation. After all, a field is, like perspective, a geometric idiom, in that it uses the techniques of this field of mathematics.[10] This is not to say that the varying formulations of field causality and the geometry of the event ever exactly coincide. There are sometimes, often crucial, missing links that an investigation must work towards identifying. But they can be brought together, as different cross-cutting facets of a problem.

Fields, since their earliest formulation in the mathematical elaboration of the work of Michael Faraday by James Clerk Maxwell, are an inherently spatial phenomenon. But we can also say that geometry *plus* politics can help understand the way fields are intersected and produced by hierarchies and other forms of power. In the present, and doubtless also through a range of historical precursors, the intersection of politics *plus* information creates its own fields of action, and the conjunctions that form events.

Investigative aesthetics proposes a geometry of space–time–information–politics as a way of cutting into such fields with new perspectives. Reckoning with this geometry allows for the shapting of fields of counter-investigation. These may start from the spark of a violation and move out to recast the ways in which hierarchical power and its informational coefficients flow into and format space, communication, experience, sensation and knowledge. We need to map these implicit philosophical operators and dispositions, their situatedness and perspectives, at the same time as working to produce the facts of the incident.

In order to deal with the interactions of field causality and the precise individuation of an incident simultaneously, investigative aesthetics also attempts to develop and work with new kinds of images. We have discussed the notion of the hyper-aesthetic image, but here we want to focus on the construction of new kinds of *composite image*, an adjacent general category to that we described earlier, paraphrasing Harun Farocki's fascination with *operative images*, as the *operative model*.[11]

Historically, some kinds of composite image can be seen in phenomena such as the diagram and the timeline. In making such kinds of work, there is a perpetual problem of how to bring different kinds of data into meaningful relation with each other. In their book *Cartographies of Time*, Daniel Rosenberg and Anthony Grafton uncover the ways in which time has been conceived and graphically represented in different periods. Two-dimensional charts that bring together heterogeneous elements in space and time have, for instance, to contend with the problem that geographical space 'obeys different rules of contiguity and continuity than does historical time'.[12] This means that entities that are perhaps far away from each other in a chart based on chronological time may end up being squashed together in a way that obscures the history being presented when geographic proximity or distance are also brought in. The two-dimensional nature of the timeline in effect flattens things that happen in four dimensions, or makes an event into something discrete, a mere dot on a timeline, rather than something spread out and uneven. Again, the question of the specificities of media as an active compositional force in the work needs to be taken into account.

The differential salience and scales of intersecting fields and particular chains of minimal causation in an event require canny sense-making in their diagramming and analysis. Different contexts and conditions require variable but

precise articulations of an event or process. Certain, often politically silenced or culturally or technically invisible, perspectives may need to slice into or synthetically suffuse fields in particular ways in order to elicit evidence or to magnify an enquiry.

For instance, in the 'War Diary' database of the Afghan War released by Chelsea Manning via Wikileaks in 2010, one often finds that the reports given by soldiers on patrol conform to a routine where all of the events that occur are nameable within the system of acronyms and shorthands that NATO uses. When a slightly unusual event happens, however, and soldiers have to file reports containing more unexpected words, one starts to see the budding of a narrative because the event is not directly mappable to a system of codes, and improvisation must be performed. When a greatly unusual event happens, things start to spill out of the grid. The reporting system used must be capacious enough to handle it, and this is not always the case. Action happens too fast, the protocol for encoding information doesn't quite grasp the moment, a soldier's interpretation of events becomes verbose, and so on.

The intersection of formal imperatives, of the war, of military hierarchy, of the combat management system, and of facts on the ground produces strange bulges and efflorescences. At the same time, the language of military jargon normalises and flattens the many moments of horrific violence, the condition that it is cumulatively designed to help sustain and facilitate.

This material is enquired into in the *Endless War* installation made in collaboration with the artist group YoHa: Matsuko Yokokoji and Graham Harwood.[13] Finding a way of showing the composition of the war and the ways in which information systems play a role in *managing* the labour and technical mentalities of this new manifestation of imperialism means making an enquiry into these files at multiple scales. As an installation, *Endless War* usually runs over a long period of time, being installed for between one and three months in

different locations in order to work through the data, comprising 91,000 reports.

The installation consists of three screens, each showing a different view into the database. The first shows the text in linear form, one event after the other as it unfolds in time. The next screen shows clusters of descriptions of events that have the same acronyms, place names and other terms appearing within them as those on the first screen. It will list, for instance: repeated GPS coordinates, lists of places where children smiled or scowled at NATO soldiers as part of their mapping of 'human terrain', reports of incidents of attacks of various kinds, killings and injuries, requests for air support; sometimes hours will go by when all that occurs is emails listing their attachments. The third screen shows patterns of matched phrases over time. Through the entire database a mixture of field causalities can be read against specific narrative accounts of minimal causation with their neutral nomenclature showing the interaction of the various media, forces and powers at play. The way an event is interpreted and reported, turned into jargon and into data, is key to normalising it, making it manageable. Mapping the mentalities and techniques that carry out this translation is key to investigating the way they entrain societies into conditions of war.

Machine Investigations

One of the crucial ways in which the world is understood and constituted in the present is through computational media. This creates interesting conditions for investigation and for an expanded aesthetics. Algorithms, data and other formal structures in computing are aesthetic formations. Machine learning, for instance, as a technology of sensitisation, of detection and of the calculation and arrangement of significant difference, can play a role in investigative aesthetics.

Events happen more and more in and as media, or *in media res*,[1] as Wendy Hui Kyong Chun calls it. This is necessarily the case in the computational field, where events occur as part of, and are transposed into, algorithmic logics and the network composition of events. This can entail an event being composed as part of a network, structured across sites and processes, happening at multiple scales, speeds and time frames and with potentially myriad actors and forms of encoding.

The integration of scales in such systems, from highly granular actions in specific kinds of pattern to those of immense categories of data generated on the fly, or that repeat and entrench long-term social categories, carries with it and renews some of the problematics of the history of discrimination and other political formations. There are a number of ways in which this occurs and scholarship on social biases, particularly racial biases being built or trained into technologies such as machine learning, has itself produced novel forms of investigation.[2]

One of the most obvious findings is often that there is something wrong with the data, resulting in the old problem named 'garbage in, garbage out'. If a system contains biased data it simply replicates it, or learns to replicate it, and even exaggerate it. What is wrong with the data can take many forms. Further, a system that has learned to unjustly discriminate either by training or by conscious or unconscious perception built into the model that it has been trained on may be applied to other contexts, further reinforcing inequality.

A second problem is that systems such as facial recognition may have been trained to work better on certain skin colours and facial geometries.[3] This can sometimes mean functional exclusion when, for instance, your mobile phone or the doorway of your workplace does not have the capacity to recognise your face. There may possibly be subsidiary benefits if those systems used by police do not recognise your presence.

Third, there is the very simple problem of overattention: of the intentional targeting of certain communities, geographic areas or activities for surveillance. This adds to the explicit and implicit duress of daily life, and intensifies during certain processes, such as crossing a border. This condition ties into an under-recognised problem in the politics of processing and of being processed. The techniques of what can be called 'hassle politics', are those of being kept in various stages of being processed and being inquired into. Every aspect of life is encumbered by having what neo-institutional economists would call 'transaction costs' applied to it.[4] The expanded managerialism of advanced capitalism and of colonial domination distribute hassle in an uneven economy of entropy.[5]

Fourth, the processes of reason that are built into such systems embed or rely on formations of logic that implicitly or explicitly enforce certain ontologies. This was self-evidently the case in the earlier forms of AI where top-down reasoning was king, with all its potential for baked-in flaws. That kind of AI often relied of clear logical structures to automate decisions,

but foundered on the difficulty in making them applicable outside of narrow areas. Machine learning, a revival of neural network techniques, aims to succeed where that prior programme of research found its limits by routing round log-jams in meaning by enrolling learning. This then creates the 'Black Box' problem, when a trained algorithm cannot describe what it has learned or the principles by which it operates.[6] A fifth problem is that the vast resources and power of the systems that are currently deployed and in development tend to consolidate the positions of dominant language, cultures and political formations since these are the most processed, most available and most distributed.

In computing, there is a need to step outside the logics and structures of reason that have characterised patriarchy, colonialism and militarisation, as well as many aspects of different phases of capitalism and its ecocidal bent. The development of systems of reasoning and evaluation that are more adequate to a wider conception of life on this planet requires a reworking of the aesthetics of automated sense and sense-making.

But it is also necessary to be alert to the tactical deployment of deliberately weak ethics in relation to such systems. By weak ethics we mean a reduced and functionalist form of ethics designed to ensure continuity of business practices and to hold off any regulation of the activity of technology companies. Indeed, 'ethics' has become so instrumentalised by companies attempting to boost their profile that it is sometimes used to signal that a technique is being 'held back' for fear of its consequences if unleashed, something that hypes the technology rather than adressing the possible problem. Even weapons manufacturers are now asking for more integration of ethics into the use of autonomous weapons. One such manufacturer even recently called for more schoolchildren to be trained in philosophy so that a stable and properly trained workforce of future operators and overseers of military operations can be ensured.[7] Mechanical forms of utilitarianism can

be algorithmically encoded to license lesser evils and given the quality-control thumbs up from school leavers in military call centres.

Such self-serving forms of ethics tend to be concerned with minimising the grounds for accountability for the consequences of new technologies. Driven to maintain the self-regulation of companies against the idea of socialised control, their terms of reference are composed more in the manner of an insurance company's prophylactic risk assessment than in that of a genuine ethical encounter. That would involve transformation and learning. Too often indeed, 'algorithm ethics' is an obliging form, even a complicit one couched in the terms of the liberal humanism that camouflages and structures much in technoculture.

Fields such as software studies that include investigatory aspects, among other approaches, aim to ask more profound questions about the nature and actions of software. Making explicit rules for the governance of rule-based systems that generate non-explicated operations is a worthwhile endeavour. But it is the genuine ethical encounter that must be engineered. Such an encounter would close down many of the systems that such industrially weak ethics condones and protects.

Given these multiple lines of conflict operating through computing in the present, it is inevitable that it becomes a space of investigation. There are many forms this is taking, from hackerly experimentation with structures and access, or the release of files, to the systematic probing of the geometries of space–time–information–politics as they are served up by large-scale digital systems. Indeed, one of the first areas of machine investigation has been the programmatic investigation of machines. Often such work takes the role of a procedure, creating mechanisms for a system to be tested step by step with thousands of variants, to effectively reverse-engineer the computational logic that underlies the contours of its power and make them open for common inquiry. Such work has increased over the

last few years, and looks set to become an ongoing means of holding algorithmic power to account.

Some of this investigative engineering can also be done through the redrawing of the diagram of space–time–information politics, and that means a fundamental challenge to the digital enclosures. One way into this is via the differential of access and information: what data on whom are open-source to whom or what? How to invert or at least adjust the diagram? We need many Angels to turn the machinic secret into open data and we need many Cats to piece it together. One will not work without the other. In fact they are more interdependent than it seems. It is necessary to both open the source of those whose code is closed (Angel) and connect the dots when it is spilled (Cat).

But the art of leaking and the investigation of the leaked materials need increased capacity. For this, automation of sensing and sense-making can be advantageous. Some of this will also require further methods to tune investigation into its own mediatic conditions. Some of these are mathematical in nature, and some are rendered as such in their mediation. As translations of the world into number gain efficacies of sorts, such translations begin to circulate as entities in the world in and of themselves. Precursors to these can be found historically in conductors of ways of thinking and acting such as calendars, architectural models or the functions of component-based assembly lines. Numerical symbols and structures also begin to act as stand-ins for entities, or chains of other entities, sometimes in turn replacing them as objects of knowledge and experience.

For instance, let's examine how to identify an image of a military tank in video footage. In classical symbolic AI the tank would be understood as a symbol, or a set of clustered symbols, nested inside a system of other such structures (models of orientation and of location in relation to a set of typical volumes, of colour – perhaps understood as a set of three dimensions,

hue, saturation and lightness). It would be set out as an explicit and rationally determined conceptual description of the shape and features of a tank. The key thing is that the tank, or other such object, would be described in advance of the system's encounter with it.

This is in contrast with more recent machine-learning-based work. Here, a set of visual phenomena that correspond to the greater probability of an entity being diagnosed as a tank is something that emerges out of training. By repeated exposure to a phenomenon under various conditions it aims to create a stable enough set of responses by which a reflective decision can become a reflex.

One of the appeals of the symbol-based approach was that it imagined a world that corresponded to clean, hierarchical and categorical ordering, something that facilitated sustained conduits of funding from military sources who had a liking for such things. This imaginary has been partially left behind. Nevertheless, the more emergent and 'chaotic' styling of the genealogy leading from early neural networks to, for instance, techniques such as deep learning has its own style of funding charisma in the present – epitomised, for instance, in Facebook's maxim 'Move fast and break things.' Hence, rather than aiming for a systematic overview of a topic before they start to work on it, many contemporary corporate initiatives attempt to train their computers by retraining reality. Humans, social structures and economic incumbents are taught to adapt to new rules instead.

———

Key to creating a convincing deepfake video (where, say, simulated images of the face of one person are mapped onto the body of another) is using source footage that is of high enough resolution for the output medium. This requires that the dataset used for learning is large enough for the neural network to map across to the output of facial expressions it is being required to generate.

At present, for instance, it is hard to produce good deepfake videos of, say, historical figures. This is because there is not enough film of the right quality of resolution and because such source footage can be quite rare. Abstractions from such film are needed to map onto contemporary footage without the signatures of different kinds of processing becoming detectable. Conversely, those who appear most in the media in the present day contribute to an ever-growing data set of hours or days of footage that makes them easier to deepfake. Each new angle or facial expression makes further proliferation possible.

There is also an inverse but related problem. Often, the events under investigation involve rare entities such as unusual weapons systems. Banned weapons and munitions are hard to find depicted online. Images of these objects – say particularly rare but crucial to find chemical bombs – are insufficient in quantity to train a neural network on because there are so few examples, if any, of them to be found. Those images that do exist can often be of quite low resolution – sometimes this is because images of conflicts are controlled as part of military operations.

This is something we have encountered in different ways in two investigations. The first was in Forensic Architecture's open-source investigation of the 2014 Ilovaisk battle in eastern Ukraine. Russia was alleged to have invaded Ukrainian territory and provided military aid to separatists, but had always denied it.[8] Attempts to scan tens of thousands of pieces of footage uploaded online in order to find evidence ran into the problem of the labour, time and resources required. Since much of the material that researchers end up reviewing is irrelevant, Forensic Architecture set out to examine whether some of that process could be automated, saving valuable time. We used computer vision classifiers and trained them to recognise a specific model of tank, the T-72B3, used exclusively by Russia.[9]

Public videos on YouTube were selected according to a set of search terms and a date range relevant to the battle.

The software downloaded and analysed these videos frame by frame, then flagged those frames that possibly contained tanks. It would flag a still frame and inform the researcher that there is, say, a 64 or a 28 per cent likelihood that it contained a tank. Together with manual open-source evidence gathering, we identified 150 separate incidents of Russian military presence, supported by thousands of sources. The case was the first example of evidence submitted before the European Court of Human Rights to be based, in part, on machine learning techniques.

In another case, in order to deal with the problem of small amounts of visual data, yet still use machine learning to save labour time, Forensic Architecture experimented with training machine learning classifiers on 'synthetic data'. Synthetic data are created when there is not enough material 'in the wild' – the open channels online – to train a network on. In such cases, data that accurately models what is being sought can be used to train the system to find similar objects online. From an accurate three-dimensional model highly detailed photo-realistic digital images of an object can be rendered and give the neural network sufficient data to train on and refine its capacity to sense.

The Triple Chaser project was a response to Forensic Architecture's invitation to the 2019 Whitney Biennial. This is an exhibition held at the Whitney Museum in New York and there was a controversy that Warren B. Kanders, a weapons dealer, was vice chair of the museum's board. Working with director Laura Poitras's Praxis Films, Forensic Architecture trained computer vision classifiers to detect footage of a specific type of tear gas canister. This canister, branded the Triple Chaser, is manufactured by Safariland, Kanders's company. It is used by police and military in several countries to violently suppress protest and dissent. Video or photographic images of the canister would occasionally appear among the millions of images shared online all over the world.

The task of training a computer vision classifier to reliably identify a particular object usually requires hundreds, if not thousands, of images of that object taken from many different angles. Images of the Triple Chaser canister are, however, relatively rare. To fill the gap, a digital model of the canister was constructed and rendered from many different perspectives. These in turn were placed in thousands of arbitrarily generated or in photorealistic 'synthetic' environments, re-creating the situations in which tear gas canisters are documented in user-generated images. In this way, synthetic images created by Forensic Architecture helped the neural networks trained on them to search for images of real canisters in use. This software is still in development and is also active, monitoring the Internet, so that when Safariland munitions are used against civilians, and images are taken, they can be flagged.

The tank and the Triple Chaser canister are at the core of what Forensic Architecture calls a 'Model Zoo', a growing number of synthetic classifiers based on photorealistic digital renderings of 3D models of objects. These include other tear gas canisters, military and police vehicles, banned munitions, chemical bombs: a catalogue of some of the most horrific weapons used by states in conflicts today. The collection has been made because either few images of these objects exist or the process of collecting and annotating them can be extremely labour-intensive.[10] Building a 'zoo' and making its contents open-source aims to provide other researchers the means to train their own classifiers.

The employment of machine learning and artificial intelligence in human rights investigations is useful. In addition, controlling the process of training and being able to correlate variations in input against observable outputs also provides an opportunity to 'introspect' machine learning systems themselves to better understand the computational processes underpinning them, processes that are otherwise often opaque and unaccountable. It is the unaccountable nature of many

implementations of AI that constitutes an urgent concern for civil society. To introspect the algorithm is to peer inside the black box that, increasingly, surveils our shared environments and attempts to define our social, economic and political standing. In pursuing machine learning methodologies, Forensic Architecture thus finds itself investigating two simultaneous conditions: the sites of violence and repression, where physical and photographic evidence is contested, and the computational field of the algorithm, striving to unpack and make accountable the very tools of analysis.

In the process of introspecting the algorithm, Forensic Architecture started to experiment with the use of extreme variations in the patterns, backdrops and form of the objects they modelled, to ensure that the algorithm significantly improved its capacity to identify the object in the more regular environments in which it is photographed or filmed.

We have learnt that machine learning classifiers that use rendered images of 3D models, or 'synthetic data', can be made to perform better when 'extreme' variations of the modelled object are included in training examples. In addition to realistic synthetic variations, we textured models of the weapons we were looking for with random patterns and images. Extreme variations refine the thresholds of machine perception and recognisability. They improve the classifier's aestheticisation to their shape, contours and edges. The more distinct the features, the better recognition worked.

This discovery raises important questions about algorithmic culture in general. To enhance their own predictive capacity, it might likewise be in the interest of those generating behaviour-prediction classifiers, such as social media platforms, to reproduce and exacerbate extremities in the data space where they are looking to make predictions. In other words, Facebook, Twitter and others are better at predicting user behaviour if users are extremely different, and noticeably so. This raises an important question: while

purportedly fighting to eradicate extreme political and social behaviour online, are social media platforms actually designed to exacerbate them since it makes their predictive algorithms better?[11]

———

In a machine learning context, images and videos are considered high-dimensional data. When classifiers sieve through sets of images, noise can often be a problem, something that appears significant, but that is not, or that impedes recognition of what is significant. The problems here are shadows, occlusions, perspective distortions, light effects such as glare and so on. Ambiguity can form another kind of noise: where the same shape could correspond to two very different objects.

The informational dimension of a problem may also be drawn out along the lines of custody or knowledge of information, its processing by certain devices; or, among other things, by the mapping of phenomena to their sensing by certain filters, procedures, action grammars and sensors.

As some of its evangelists may have neglected to mention, machine learning does not render an uncarved block of fully synthesised calculations. It is riven with numerous fault lines that come from its inherent relation to what it calculates and the ways it does so. Adrian Mackenzie's insightful book *Machine Learners* recognises the 'friction, blockages and compromise that often affect data practice'.[12] This is not to expiate machine learning by rendering its breakages humanising, but to recognise the aesthetic and practical conditions of such systems. As Mackenzie says, work with data requires moving backwards and forwards between question, hypothesis, data, the articulation of information by multiple mediatic translations, and other factors.

It could be argued that all of these factors in an ideal scientific sense might need controlling for. The ramifications of such control, and hence sometimes the difficulty of a practical political investigation into machine learning, are substantial. As

Mackenzie notes, there is a multi-form pragmatics of machine learning that is essential to take into account, and which itself constitutes a form of learning.

And there are further complications. Artists have often worked into the aesthetics of glitch, noise, interference and so on. These are part of the idiomatic material substance of computing. But as archaeologists and curators of digital media have often noted, the data stored on centralised platforms, or elsewhere, may often be lost.[13] Indeed, the very processes designed to induce these data may be changed several times within one day. Such changes may not always be so rapid, but in the case of large digital enclosures they are often covered by trade secrets. So although these platforms create certain kinds of publicness for data, their workings are only marginally public. These shifts may occur according to a tilt in emphasis in a business plan or a change in a certain kind of treatment of data of specific sorts (for instance, data deemed to be off-limits to the public in different territories),[14] or they may vary or come to a halt according to calculations of the perceived value of addressing certain targets, segmentations of users and other factors. Such factors complicate, but also motivate, programmatic enquiry into digital governance via the machine investigation of machines.

———

In a sense, part of what machine learning does is to virtualise and speed up the condition of the office, the state bureaucracy and archive such as the police or intelligence services. Both involve many lines of enquiry being taken up in parallel to be evaluated and focused on an ongoing basis until a conclusion or classification is reached. As well as being related to the operation of a bureaucracy, which, after all, is one of the fundamental roots of computing, this approach is effective because it allows for the establishment of a fuller statistical distribution. Many thousands or millions of enquiries or tests can be made.

But this virtualisation of the procedure of the office may also be said to free investigation up to adopt the more free-wheeling perspectives of the eye. If large-scale and systemic work can be automated, then human aesthetic capacities can focus on what they do well. We can perhaps expect novel hybrids to emerge between programmatic investigation and nosey, motivated curiosity. Indeed, OSInt establishes grounds for new forms of collective investigation that could build on such hybrids.

The ability to test data with a computational sensorium that is – in the best cases – detuned from the mores of human aesthetic training, including reasoning and habits of sensing, allows for a wider set of aesthetic capacities to come into play. As such, machine learning is a way of expanding the scope and nature of the learning that an investigation necessarily involves.

Part 3 Propositions

16

Investigative Commons

Film director Jean-Luc Godard famously described the interplay between making political films and making films politically. In the former, representations of politics are stored on celluloid. In the latter, the way the film is made, not just what it shows, is subject to political enquiry and reinvention. Following this, we are concerned not only with ways to make political investigations, but also to think about investigation politically.[1] This demands a different response in relation to each of the different sites in which investigations are performed: the *field*, where incidents happen and where traces are collected; the *lab* and the *studio*, where they are processed and composed into evidence; and the *forum*, where they are presented. Each site requires a different level of participation, a different process by which evidence is worked on and socialised. The community of practice that arises around the process of evidence production is an *investigative commons*. The *investigative commons* brings together a combination of aesthetic, political and epistemic structures.

Let's unfold what we mean by a commons here by looking at these different sites. In the *field* of investigation, the notion of the commons is established through the assembly of modes of sensing that can be referred to (without tongue in cheek) as a 'common sense'. In this we seek to help extract the term 'common sense' from the banalising context of an assumed wider consensus. There it stands in for a thought without thought, a vision of society taken as natural and given, a reasonableness without the necessity of reason. In the *lab* and

the *studio* the commons emerge as sites of the diffuse and collective labour of enquiry forged through composition and invention. In the *forum* the commons emerges by socialising the presentation of evidence, and finding new locations and platforms where the articulations of political claims can be seen and heard.

The formation of common sense can be seen as a mode of creation, the ongoing development of a commonality – built into the creation of knowledge. Indeed, when common sense becomes recognised as a problem of creation, rather than being a repressive set of implicit norms that are taken for granted, it becomes open for reinvention.

Let's recoup how this can relate to the three aspects of aesthetics we proposed in Part 1: aesthetics as sensing and sense-making in which all entities in the world play some part; hyper-aesthetics as a mode of amplification, multiplication and recomposition of sensing, including the creation of new devices – both abstract and concrete – for the creation of an expanded and varied sensorial terrain; and hyperaesthesia as a condition of excoriating sensory overload, when sensing and sense-making part ways.

Sense-making implies a certain kind of invention in creating alliances and relations between sensing entities. Sensing entities include technical instruments of measure and material substances that are not designed to be sensors but that do indeed sense the world in idiomatic ways. In turn, there are forms of sensing that are specific to the material formation of things or species and the way they interact with their environment. We showed how, for instance, plants, synthetic environments and algorithms all function in this way. Building on this, sensing and sense-making entities can also include alliances between communities attuned to different aspects of their environment. These alliances can be understood as social formations, groups, movements and the like that are aestheticised to their political and physical environment in different

ways; that is, that they are politically sensitised, sense-makers and transformers.

Hyper-aesthetic invention operates in concrete, technical, social and political terms, but also at levels that are conceptual and perceptual. If everything senses in some way, and certain entities (ranging from organisms to technologies) are involved in sense-making, then we can see what arises as a result of their interactions, and of enhancing these interactions. What arises is the world and what arises as the world is something collectively produced. We do not mean to say that this collective work is in any way necessarily, or even accidentally, fully egalitarian to start with, but that it strives towards the flattening of hierarchies. The world is, in part, the common result of myriad processes of distributed and negotiated sensing and sense-making.

The composite world that is made up of all of these processes is what we are stuck with – it is our lot, even if it is being continuously remade. As such, it forms something of a commons, something that is the result of common work, the work of structured negligence, as much as, say, the interaction of evolutionary forces or an idea of progress. The common terrain of sensing and sense-making, could be considered to be reality and it is this that is held and struggled over in common, regardless of one's ontology. Access to, and determining power within, this commons is what establishes politics.

This idea of common sense challenges the notion of universalism. One of the historical legacies of the idea of the universal – a notion of homogeneous totality applicable to all cases – is grounded in the imperial and colonial projects of the Enlightenment. It assumed the ability to flatten the difference between people, perspectives and modes of sensing while arranging a certain kind of European culture among them as the most significant and as the common denominator to be strived for, even at the price of ignoring or destroying that which does not conform. In this model, the role of aesthetics

is pegged to an imagined and shared sensing that is notionally prior to culture and extended as general to the human species. Every person was understood to roll off the production line loaded with the same operating system, but with some kitted out with the premium version. This ideal of the universal is one that delimits the aesthetic as something that primarily refers to sensing, rather than also involving sense-making. Everyone senses the same, everyone responds to beauty identically, but only some can interpret it adequately.

Unlike the universal's implication of a norm that it presupposes, the commons is woven together by a multiplicity of differences – of participants, perspectives, situated experiences, positions and forms of knowledge produced and worked at by practical and experimental intersections. It is a shared rather than a unified or unifying condition.

Such an aesthetic commons is not just held in common by people, but is generated ecologically. It is based on the multiplication of what counts as sensoria and sensing. When you unmoor aesthetics from human judgement, other possibilities open up. In this commons, to work aesthetically means eliciting other kinds of allies. It sometimes means to open up to subtle, perhaps imperceptible, means of collaboration with entities that are not yet considered to have agency for sensing or significance within the schemas of power.

In such tensile conditions, there are multiple materials – ranging from the biological and mineral to the political and experiential, including mathematical conceptions and computational devices, stretching from base matter to abstract materialism – that together can constitute an aesthetic commons that has consequences for investigation. Such an understanding of a commons requires a recognition of the ongoing and massively diffused sensing activity of living and inorganic processes. It implies the development of an inquiring disposition towards being with matter, code and organic substances in aesthetic assemblages.

In this context, practices of investigative aesthetics develop a focus on the political dimensions of sensation as they are crystallised in specific incidents. The practical question is how to bring these together in ways that both enhance the repertoire and precision of sense-making, and also nourish the troubled commons.

The formation of the commons against the universal has many historical threads. To mention two currents that are exemplary in their understanding of the difficulties and intensity of collectively forged realism is to sketch the richness and polyvocality of the problematic. The avant-garde movement surrealism is one example, one that grew strange in its insistence on the struggle for adequate formulations of absolute candour.[2] Another can be found in the extended genealogy of hip hop, from, say, Afrika Bambaataa to the current surge in UK drill. This movement emphasises a myriad of constitutive routes to the real via the assertion that the real must be invented through the force of lyrics and beats, as Kodwo Eshun memorably demonstrated in his book *More Brilliant than the Sun*.[3]

Both of these currents, and others, produce terrains of joint action that entail making the commons a place of collective differentiation. Aesthetic commons can be developed through shared ideational resources, for instance, in the collective development of beat structures and rhythms, that in turn prompt differentiation, or as sets of techniques for achieving the marvellous. They insist on the real as something that must be invented, on the one hand, and to which new means must be found to arrive at, on the other.

One of the sites of such experimentation is the formation of communities of practice that bring together collaboration, a *working with*, that expands to include more perspectives and allies, because it recognises that if we are to understand the present we are constrained to work ecologically. And establishing investigative ecology entails working with the multidirectional relation and feedback loops between media

and communication, technology, and material, social and natural environments. This means to draw upon and work with, and to be influenced by, multiple perspectives operating across many scales and durations, but also to recognise that, just like the tensions between the universal and the commons, there are tensions with other logics and fields.

Gestated in the scar tissue grown in the interaction of the still-active idea of the universal and the construction of the commons, there are many of these. While recognising the difficulties of the universal, it is prudent to be aware that there are other modes of the flattening of differentiation and the erasure of commons in circulation. One of these is, for instance, the mode of power achieved through binding heterogeneous formations in a unilateral formation, whether of the state or of the corporation. This 'vertical of power', as it is described by Vladimir Putin, is an integrating authoritarian force that is by no means offered as a universal but whose merit is seen to be in its ability to impose from above.[4] Such a formation is all too familiar in its capacity for destruction.

Another kind is lucidly described by Christina Sharpe in her book *In the Wake*, which traces the enduring patterns set in place by the enslavement of Africans and the patterns of endurance that persist beyond them.[5] Here, life still retains the roiling anguish and brutality of the Middle Passage, a movement that is still ongoing, sending its ripples through the present. The trafficking of humans across the Mediterranean only to crash against the white supremacy of Frontex's lethal and bureaucratic violence, and the continuity of roles between the plantation overseer and the police officer of today, are only some of the ways in which the hold still has a hold on the present.

Finding means to work collaboratively in conditions textured by such formations, and to fight against them, is difficult. Work must be done, hacks must be tried. One route to these may be in eliciting other kinds of allies.

Such an aesthetic commons is, of course, not just held in common by people, but is generated ecologically. It designates a recognition of the ongoing and massively diffused sensing activity of living and inorganic processes. It implies the development of an inquiring disposition towards being with matter, code and organic substances in aesthetic assemblages. As investigative aesthetics, such practices develop both a focus on the political dimensions of sensation and feeling as they are crystallised in specific incidents, and also the experimental multiplication of what counts as sensors and sensing.

Not everything that senses can be easily integrated into sense-making. Finding the grounds for such a bringing together is the work and skill of investigation, of extrapolating possible consistencies and media to allow for a provisional terrain of analysis. The struggle over sense-making has always been as epistemological as it was political. At this point, what we want to say, then, is that reality is a commons, of a certain sort, and at times, one that needs to be fought for, composed with a lot of negotiation, love and skill. Reality is an ontological commons, in that it is all that is there, all that we have got. It is an epistemic commons in that it is what we must use to test what we can know. It is an aesthetic commons in that it accrues out of tension between sensing and limited sense-making.

A significant rupture can arise when the common fabric of reality is deliberately broken politically. When those in power, or seeking power, try to break apart the fragile constructions that tether sense-making to reality, they may do so, for instance, by spreading disbelief in the networks that hold them to account or seeding racially motivated suspicion towards the testimony of people who are under attack. When they delink, when they use an unproven or more fragile part of the network of sense-making to question or dismantle the entire assemblage, when they insist that only they have the privilege of knowing, denial is aimed not at making new sense

but at the uncommoning of the commons. Such fissures in the commons must be repaired. When police say they have shot a person legally the commons has to be similarly repaired. When those in charge claim that the destruction of forests by fire is a seasonal event, rather than a consequence of industrial-strength greed, social bonds with nature have to be mended. The stakes, thus, of the formation of reality as a commons are thus of many kinds. Nevertheless, such ruptures can also travel in other directions than simply downwards. The reality-formation routines of hierarchical power can also be broken.

———

In order to develop the concept of the investigative commons, it is useful to turn to the earlier philosophical considerations of the commons as a mode of sensing and sense-making in the work of philosophers Baruch Spinoza, Ludwig Wittgenstein and Paolo Virno.[6]

For Spinoza, sensing is something that can be held in common by bodies – extending to the corporeal substance that he called, after Descartes, *res extensa*, a full cosmos in contact with itself. Sensing is something that contributes to the coming into being of both collective and individual entities. In *Ethics* and other texts he proposes the idea of the *conatus*. This idea is a description of the way in which an individual substance or body has a certain self-perpetuating force. In sustaining and developing itself (whether biologically or ideationally, in the imagination or desire), an entity enters into conflict, but also co-composition and collaboration, with other things. *Conatus* is in the essence of a thing but also in its striving, its tendency to becoming: the way in which it is in the nature of a child to become an adult, for instance. It can also be found, there-fore, in mixtures when things are combined. The sustaining and development of this condition creates a commonality. The being in common of citizens creates, for instance, the city, and the political order of a society derives from its capacity to realise the *conatus* of its inhabitants in the most adequate or

just way. In this process, there is no ideal form per se, but an ongoing combinatorial process entailed by the mingling conatus of the people and the wider world.

We can understand how the common comes about in a different way by reading Wittgenstein. For Wittgenstein, the meaning of something was always in its use. Aesthetics, in various forms of sensing and sense-making, is something that undergirds much of his work and is derived through experience, the development of mutual and customary interactions, bemusement, of course, thriving alongside understanding, and through the constraints and capacities of formal systems. To take one example from his work, it includes a discussion of the phenomenon of *appreciation*, the acquired skill of coming to understand something deeply, often in a non-verbal way. Appreciation comes about through practice and emerges in experience, negotiation and common work between people.[7] Such work may happen between collaborators with different skills, knowledge or hopes. For example, in his discussion of the work of someone making clothes, collaboration is expressed through gestures, of marking a contour with chalk on some fabric, and the cross-checking of agreement, through small remarks of coordination. Making a piece of clothing arises through being in common with techniques, knowledge, fashion, materials and so on. The common arises through this process of iteratively cross-checking and working.

In his book *A Grammar of the Multitude*, Virno builds on Aristotle's *Art of Rhetoric* to develop a theory that posits the common as the inconspicuous basic precondition for social life and for communication. The common, and in particular what are called the commonplaces of speech, phrases that embed thinking and behaviour, express the ethos of a group or an organisation, even a city. One will inevitably live across many of these systems of commonplaces, and each expresses a collective public toolbox of thought and expression. Developing this toolbox constitutes the public life of the mind, and it relies

not on acceptance of these forms, but on recognising their strangeness and contingency. The condition of the contemporary world obliges its inhabitants to struggle to recognise and to produce what it is that provides a means of knowing, communicating and thinking. Virno emphasises the creation of societies by those who are not accepted by them, migrants, women, racial and sexual internal outcasts and others such as those who suffer class domination, all of which he calls the multitude. Only those who don't fit can fully think, and their condition of strangeness is what allows for the struggle to form the commonplaces that partially overcome this condition. Indeed, the common arises, one can say, from a belonging to a sense of non-belonging.

From all of these writers we can draw a sense that the common is produced through communication between a collectivity that emerges around the problem and the activity of making sense of the world. This includes working at an understanding of what it is to make sense with our imperfect and perspectival capacities and contexts. At the same time, arriving with the acquisition of skill, one has to recognise one's privileged access and the wider social encodings it entails to sense and try to undo them.

We need to further differentiate the commons we call for from three other kinds. The first are commons in the strict sense. Described by the economist Elinor Ostrom as 'common-pool resources', this kind of commons is usually something like a pasture or a forest, a river or lake, an element of the world worked by humans in a shared way. In such places, conventions and protocols are developed to arrange the use of the resource in a way that does not deplete it or wreck its limits, but that maintains or improves upon it.[8] Sophisticated traditions, rules of thumb, customs and ways of attending to the condition of the places involved are generated in order to manage human relations with the commons. These may need to be mutually limiting, perhaps involving punishment for infraction.

This approach has also been extended to the development of artefacts such as software, where free and open-source software (FLOSS) produces a novel digital commons that provides a model for other kinds of digital entities.[9] In this kind of commons there is a relatively tight formulation of social control by those concerned with the specific commons that provides the grounds for commonality. Some regard this as an over-limited framing of what constitutes the terrain of the commons.

A further kind of commons, but of a quite different sort, is a 'public good'. Societal infrastructures such as the Internet, transport or water systems and so on can be arranged in a way that orients their governance towards a societal benefit but with a looser set of arrangements that may include state or corporate administration and profit seeking. Such arrangements remove this form from being a commons in the strict sense since there is no inherent grounds for the mutual or communal governance of the resource. A public good of this kind might be the provision of accessible clean drinking water and unpolluted rivers, say, as compared to a water system primarily oriented towards private profit. Public goods act as the basic platforms for an economy and a society as a whole to operate; access to them is at least nominally universal.

Indeed, among the first and second sort, we can generally differentiate what can be called toxic commons.[10] These may, for instance, be formed in a freshwater lake or river or in air, but represent the socialisation of a cost or a burden, through depletion or pollution. Such commons are often imposed upon a society or a place by, for example, a chemical spill, deforestation or climate damage. These are often imposed in order to sustain an economic form that believes itself to be ideally distinct from its surroundings. Hence the formless cloud of higher CO_2 concentrations, moving across or cutting through national borders, is one such manifestation of a toxic commons.

Less chemical, perhaps, but also toxic and malign are the commons of certain cultural and political forms, such as patriarchy, racism or class domination, which, for those whom it entitles, can be freely called upon to indulge in at any time in a full-blown utopian communism of the worst. This would be the inverse of what Paulo Virno called the commonplace. The wide fields of the toxic commons of this kind are a form of public secret that investigation must be addressed to.

The third kind of commons that we want to propose, and that was the concern in various ways of the three philosophers we signalled to above, is of a more chaotic type. An example would be that of language, say English, the foreign language with which we wrote this book. We all contribute to and make such a language every time we speak or write. That is, we contribute to the stabilisation and evolution of sets of meanings around words. We may invent new meanings or uses and new words in multiple ways, as they cross between languages, or as new scientific, cultural and phenomenal occurrences produce new terms. Different positions in societies and cultures may be densely generative of new linguistic commons.

Language is inherently a commons, except when it is a secret one, an encrypted code, in that it is necessary that it be used publicly for it to work. For it to continue to work and remain current, it needs to change, and for those changes to be made by those who have the need to use those changes. (This may be different in languages where a central codifying authority ratifies new words.) Language is thrilling and essential because it conjoins so many things. The same words, even the same phrases, may be uttered by otherwise seemingly incommensurable people.

To work in language is to work with this inexpressibly complex conjointness and to wrestle too with its capacities for differentiation. Sometimes, indeed, for language to function as a commons it needs to be decoded in certain ways; this decoding may entail further differentiation, even breakage and

the construction of an incident, or the construction of direct action in sensing and sense-making. It is a vastly multidimensional and experiential space which is composed in conflict but also in community, in conformity but also in the brilliance of invention.

It is this kind of quality that we want to propose that language has in common with what can be called an investigative commons. Reality, whether we like it or not, is a commons of this sort, being something arising out of a disjointly collective process of work and becoming, one that is, of course, inherently post-human. Studying and discovering, and indeed inventing, the terms of this process are crucial. Finding the ways in which reality as commons can be attended to and discovered also implies wider forms of commons of the kind to which language belongs. Here, an aesthetic commons would consist of the sensing and sense-making processes that make themselves available for other processes of sensing.

This aesthetic commons provides a common ground, something that may be negotiated, fought over, niggled at, worn away, or otherwise 'contributed to'. It may indeed get self-organised around or against elements of the toxic commons, those elements of reality that generate entropy, that reduce or devastate possibilities of becoming. Such aspects of the inverse commons can also consist of an actively depleted version of language, or a reduction in the collective capacity of conceptual or computational thought. The commons could also be under attack by deniers and negationists that seek to tear apart the complex ways in which sense-making is socialised.

In this context, an affirmative understanding of an aesthetic commons follows through as a political understanding of hyper-aesthetics. If hyper-aesthetics is a move towards understanding an expanded ecology of sensing and sense-making, then the notion of an aesthetic commons articulates crucial aspects of the collective political stakes of this condition. It is an open form of assembly that includes humans and other

living and inorganic matter alongside sensual technologies such as code.

Take, for example, simply the complexity of a distributed human network of practitioners necessarily working together to articulate the logic of the violence inflicted upon it: the communities on the ground that suffer such violence at first hand lead and take the initiative, collecting information by undertaking recordings such as videos and testimonies; then there are lines of solidarity that develop with activists who stand hand-in-hand with them; then there are lawyers, scientists and other investigators; then publishers, distributors and readers; and then multiple mainstream and alternative media channels and cultural institutions, in which the accounts are circulated and contested. The list of kinds of entities and of involvements goes on. These polyphonic networks are uneven and asymmetrical, skewed by different privileges and degrees of access creating difficulties that need to be recognised and worked at. Creating the commons is hard work, but creates a possible foundation for politics, while itself being a form of political action.

With each new investigation, a new community of praxis is woven from the interaction and mutual testing of divergent viewpoints. The struggle for common ground is an essential meta-political condition: a precondition for any political initiative and struggle to take place. Such a common ground requires invention and needs to be continuously remade, reinforced and fought over. This common ground must not be fenced off, but must maintain margins that are open to new information and ever-newer perspectives, evidence and interpretations that test prior ones. As such it must take the risk of disagreement as an imperative. In this way, it has something to do with the foundational formulations of science as a commons.[11]

Working within the polyphony of the investigative commons is what sharpens it, renders it able to sense and make sense.

But expanding the sense of what constitutes the grounding for adequate knowledge entails further difficulty. This is part of the reason why traditional modes of enquiry have some-times succumbed to hermeticism, becoming sealed off, only recognising certain techniques or forms of investigation. The challenge is to work openly and polyphonically, but rigorously.

Constructing an aesthetic commons requires socialis-ing the production and dissemination of what comes to be understood as evidence. It establishes a sometimes unlikely but fundamental alliance in which the work of the production of facts constitutes the foundation of an expanded epistemic community of practice built around collaboration on a shared perception and understanding. Creating such an epistemic community means recognising and bringing together, debat-ing, a plurality of experiences and means of sense-making. The need to understand an incident is what can bring together such a concrete plurality.

Achille Mbembe's proposition of the *pluri*versity, drawing on the work of Boaventura de Souza Santos and others, envis-ages something that improves on the *uni*versity. It is a brilliant argument for reshaping the possibilities for knowledge and organisation. 'Knowledge can only be thought of as universal,' Mbembe says, 'if it is by definition pluriversal.'[12] In the context of thinking about investigative commons, Mbembe's proposi-tion about pluriversity – a process of knowledge production that is predicated upon epistemic diversity – is crucial because it entails a way of thinking collectively about knowledge for-mation, where, as Mbembe notes, citing Bruno Latour, 'to be a subject is no longer to act autonomously in front of an objec-tive background, but *to share agency* with other subjects that have also lost their autonomy.'[13]

Such a differential spread of agency is essential in the devel-opment of investigation, in that it recognises non-mastery – that is, learning and being informed – as a prerequisite for knowl-edge. Mbembe embraces it 'via a horizontal strategy of

openness to dialogue among different epistemic traditions'.[14]
The loss of the illusion of autonomy, and of the techniques
that sustain that set of special effects, requires not a loss of
agency, but an understanding of its pragmatics. The pluriver-
sity suggests an art of the commons working with affordances,
and capacities for invention and for becoming that is ecolog-
ical in its recognition of multiple and interacting processes of
formation and intelligence.

Earlier, we spoke about direct action as a form of research
and learning. To work in this way means to try to make the
most immediate – but patient and careful – contact with reality
possible and to change it and ourselves in so doing. Direct
action, at its most profound, works to recognise the difficult
intermeshing of events and understanding. It aims at being
immediate and to have effects by recognising and working
with mediation.

———

The reworking of the incident in the formation of an investi-
gative commons has a topological character in that it renders
two things clearer. First, that an event of every kind, including
incidents, always has more participants than antagonists. All
participants are all the material and sensing entities enmeshed
in the event. The antagonists are necessarily a subset of these.
The loss of the illusion of autonomy that Mbembe speaks
about means recognising hyper-aesthetic agency in the world,
and the political necessity of augmenting and working with
that diffusion.

Second, this means that there are multiple pathways into,
and fields suffusing, an incident and its investigation. These
can be traced through the details that Ginzburg showed
could be an entry point to historical understanding but also
through the wider fidentification of causal fields. The forma-
tion of an investigation must thus ceaselessly shift back and
forth between close-ups and extremely long shots, moving
transversally and laterally between different source points,

perspectives and world views. Such an arrangement allows for a reworking of the incident into the event of the investigation, an event which is a political community in the making.[15] Each investigation and each participant need not conform to a specific diagram, but produces its own, which at another scale contributes to a wider knowledge of what it is possible to do and how it is possible to work. Every investigation produced in such a way is thus not only evidence of what has happened, but also evidence of the social relations which made it possible. Thus the aesthetic commons feeds back into – indeed requires – the wider constitution of other forms of being in common.

Similarly, the event of the investigation draws together and constitutes a collectivity that, rather than positing a totality, creates a conjunctural process of enquiry, bringing together elements, participants, disciplines, institutions and sites of production that are sometimes understood as incompatible and jostle each other with the idiom of their conatus.

Recognising this difficulty, its estrangement, if it is done well, is also supremely interesting and aesthetically complex as different forms of sensing and sense-making encounter and grapple with each other. It is great to listen to a talented lawyer speak, for instance, with their idiom of precision. Having this idiom driven by its conjunction with, say, someone whom a colonial or a post-colonial power has attempted to figure as merely a victim, but who is forceful and cogent in their description of an incident and the wider field causalities around it, renders it vividly potent. This person's force of experience and intelligence can then guide practitioners with expertise in documenting, measuring and analysing an incident, honing their skills with the precision earned over a lifetime.

In turn, the work on such joint projects can allow for and sustain the possibility of the work on techniques. As this capacity grows, further possibilities, fragile though they are,

are established for those who undergo and who witness incidents to develop means for constituting capacities and powers of investigation. Let us be honest – and contradict our notion of aesthetics being distinct from the evaluation of beauty – in such moments there is a certain beauty.

The Lab and the Studio

The investigative commons also comes into being in a min-gling between two distinct spaces representing different kinds of common labour: the laboratory and the studio. The lab is the site for the isolation and testing of phenomena accord-ing to the strict protocols of scientific practices. The studio sets up a space for elaboration, imagination, composition. It is a kitchen for play, attentiveness, free association and the perverse. Each thus offers infrastructure for different kinds of sense-making and testing of propositions and ideas. Both have their own grammar of action and sometimes develop a differ-ent kind of striving for their own independence or conatus. Both are sites where problems and propositions are worked on with a set of internally coherent protocols and with differ-ent modes of connection, but also of seclusion.

Artists or scientists set themselves apart for work in relation to aspects of the world. This seclusion is necessary for focused attention. We write at a point in history when certain differ-entiations between the lab and the studio have already taken place. We are interested in how to maintain and proliferate differences in a hyper-aesthetic manner, but also in the way this forking can produce novel syntheses. Indeed, before they became distinct, the connectedness of visual art, architecture and science could be traced back to early modernity.

In sixteenth-century Europe, for instance, knowledge about nature was produced by practitioners who occupied a liminal space between what would later be formalised and separated out as science and art. The European art academies of the

following century, and into the twentieth, exposed the still arti-sanal artists to experts on anatomy and technical approaches such as linear perspective and anamorphic projection, or the chemistry involved in preparing paint. But gradually the shared workshop of empiricism started diverging into separate subjects and specialisms with their own ruling and divergent aesthetics and epistemologies.

The studio has a longer history than the laboratory. The laboratory proper was founded in the scission of science, or natural philosophy, from a wider configuration that also included art. This separation came with a whole host of debates around the way in which it entailed a polity – who was to be allowed into the laboratory.[1]

As the historians of science Simon Shaffer and Steven Shapin recall, the question of the publicness of the work of science in the nascent space of the laboratory and its relation to the political order of the day always involved controversy. Further-more, it was the very notion of controversy that shaped and tailored both the domains and terms by which debate about facts might occur.[2] Much of their book concerns a detailed and lively account of the practical and theoretical problem of creating vacuums through various instruments called 'air-pumps'. The procedures of the physical sciences, of review, expertise, reproducibility of results and so on were gestated and refined in those days, but also a certain constitution of what reasonable deliberation and proof might be, both in poli-tics and in science, and how, in the 17th century Restoration or reimposition of monarchy in England, which the book covers, the ability to question certain kinds of 'truth' was curtailed. The laboratory gradually evolved to focus on accreditation, probity and hygiene for the non-contamination of evidence, and developed a pathway to the establishment and refutation of facts of certain kinds. This has made it into a political tool too, one potentially disruptive in its relation to political power and religious doxa.

This process of specialisation meant that by the nineteenth century science and art were positioned in opposition to one another – and certainly this 'time apart' proved very fruitful in certain ways. Indeed, one can say that the principle of each was in some manner predicated upon different kinds of operative isolation. Science aimed to isolate and work on a particular phenomenon in the world. Art aimed to declare autonomy for the sensual intellect and technique that elaborated itself through practice.

A century or so later, multiple epistemic and aesthetic barriers had been erected to make cross-communication difficult in many kinds of ways. At the same time, transgressing these barriers became uncannily productive. Numerous mediating categories were set in play between art and science, such as the idea of the 'experimental', which became a key term for the field of art following the Second World War, or engagement with technology as something they held in common.

Art historian Ina Blom, for instance, shows how there is a constant and vivid movement between ideas of technology and the life sciences, such as ecology, in early video art of the 1960s.[3] Notions such as feedback and liveness – and of video having its own agency that worked its way into memory and culture – demanded different organisational forms, including media labs and new kinds of machines and aesthetics to assist and experiment with video.

In the meantime, the lab and the studio have also expanded, as new modes of scientific work and of art and cultural practice developed. Since its inception, science has been concerned with diverse set of operations ranging from live work in the field in the natural sciences, to understanding the sub-atomic and its connection to the cosmos in physics, through recognition of complexity that anticipates the hyper-aesthetic in ecology, to development of the capacity to deal with increasing domains of multidimensionality and probability in modelling, simulation and data in numerous fields. It has gradually shifted from

focusing on external variables, to understanding the way in which scientists and the tools of observation are themselves implicated in what they observe.

At the same time, art has, in analogous manner, moved well away from a focus on specific techniques and the expression of subjectivity and of feeling, to include the domain of critical work, encompassing reflection upon its conditions of becoming, on its own complicity with the way it is financed and displayed. Further, in many cases, art works on the problems and modes of knowledge historically linked to other fields and disciplines. Alongside this it engages in the development of research, investigation, community building and direct commentary on and intervention in current issues.

Both the lab and the studio have thus become sites of self-reflexive labour. They could be thought of as spaces of differentiation where entities such as images and ideations, physical and organic substances, processes and problems – the things to be investigated – are brought together with concepts, equipment and techniques and those who work on and with them. Both sites entail the work of moving between hypotheses and reality, cultivating attention to reality while constituting it.

We are interested in the continued differentiation within and between the lab and the studio, but also in the affinities they engender as they become different to each other – even sometimes weirder than each other. Today there are compelling reasons for science and art to resynthesise and merge the different modes in which each undertakes open-ended experimentation on things and the modes of seeing them. One way into this is via a re-coordination around the notion of objectivity suggested by historians of science Lorraine Daston and Peter Galison.[4] In the often conventional view of the term, objectivity is taken to be a form of knowledge that bears no trace of the knower. Rather than this reductive ideal, Daston and Galison suggest that objectivity could be something

worked at through commonly held projects, such as the generation of knowledge about particular problems or phenomena. Objectivity, they argue, is produced in relation to an object, a map, a diagram, an instrument that bears the traces of, and is indeed propelled by, the specific interests of those that develop it. The object in turn is the means to bring their enquiries together in order to understand them. Following this conceptualisation we can propose that the enquiry increases awareness of the object and, at the same time, expands the multiplicity of subjects and subjectivities involved in the investigation. In the development of a particular kind of knowledge through artefacts designed to probe it (perhaps the object might be something such as the diagram of a certain species or the map of a terrain), objectivity becomes a process of work in which knowledge is constituted in and about the objects and tools – human and non-human – of investigation.

Whereas, in the nineteenth century, the epistemic virtue of objectivity was understood to be a property of the subject, that of the idealised scientific self, Daston and Galison's book flips the meaning of the term back towards the object. The scientific object gains value precisely through emerging from the interaction of multiple particular interests. It is in these relations, that an object is founded. The object – evidence, in our context – becomes a joint site of work, one that can extend to providing a field of liaison for self-reflexive artists and scientists, and others, such as those in political struggle, to jointly create. In such creation, situatedness is the defining feature of the very notion of evidence. It comes into being and is enhanced through the practices of interweaving and cross-checking of perspectives and epistemological frameworks. In the investigative aesthetics which is the subject of this book, this interweaving is also organisational and political. Rather than being confined to the coherent logic of black-boxed institutions of authority, a constitutive objectivity is based on open processes and new alignments between different sites,

organisations and institutions of diverse natures, standing and perspectives.

The capacity to pay attention to differentiation also requires certain forms of autonomy. Forging independence from other kinds of demands or impositions may often have spatial, economic, procedural and other dimensions. Indeed, this is one of the key lessons of intersectionality in terms of political organising. People resisting a certain kind of oppression need to have the ability to organise independently of those who may benefit, even unconsciously, from sustaining that oppression. Autonomy here is a means towards differentiation, of intensities, not of kinds rendered as absolutes or essentialisms. Further, differentiation is also a prerequisite, in conceptual and practical terms, for understanding the way in which hyper-aesthetic sense-making arises as a coming together of differences without uniformity.

We are not calling for a simple collaboration between art and science; there are plenty of good examples of such, but for a development in which both the lab and the studio expand their range, to generate a complex of mutations in the pursuit of different kinds of investigation.

Each new alliance between the lab and the studio may reconfigure the entities involved. Possible confluences and variations are teased out in each of them, aspects that may have been considered minor or matter-of-fact may come to the fore as something to be reworked and examined. Here, perhaps, a new kind of lab can be produced in the *conjunction* of variables rather than primarily of their separation. Such hyper-aesthetic labs simultaneously involve sensing, simulating, modelling, testing and refining the work of empirical speculation. They weave themselves into the world, perhaps cautiously and slowly, as suggested by Isabelle Stengers, taking the time to really think about and work with the problematics that they engage with, and their wider composition.[5] Capacities for testing and making propositions are synthesised with criteria

that have other urgencies, such as experience, political insight, observations that have previously been discounted because of who they come from or the language in which they are made.

Organisations such as studios sustain sense-making capacities. They invent and concretise sensoriums that are able to elicit and work on aspects of the world. Here, among studios, we are thinking of experimental workspaces such as Lee Perry's legendary Black Ark studio or Prince's spaceship at Paisley Park, where new forms of music were invented and elaborated, as much as of the now preserved paint-spattered studios of figures such as Francis Bacon. Amongst labs we are evidently thinking of heterodox and open processes such as those of citizen science but also those of any kind that are engaged in combining direct action activism with deep speculative engagement with the world.

Indeed, the design and formation of organisations beyond the studio becomes central to forms of culture as collective forms of sense-making. As aesthetic practices more broadly migrate towards being an open field of enquiry that is able to gain and invent forces of sense-making, new organisations that embody and experiment with different diagrams must proliferate. Organisations, indeed, have their own implicit and explicit aesthetic. Their structure, their diagram, constitutes rather than simply and neutrally conveys sense-making processes. This is part of why struggles over institutional forms, such as growing demands for the decolonisation of museums and other cultural spaces, are so urgent.[6]

Just as the field, the lab and the studio must undergo mutation, so too must the last domain within which investigative aesthetics is enacted, its sites of presentation, debate and deliberation. These are different kinds of *forum*, sites of public ritual of truth formation, of institutional sense-making. It too has its own priests who follow their own protocols. Truth claims are performed. Juridical wigs are sometimes worn. Speech acts are enacted, and a determination is reached.

As aesthetic practices change, so too do their other associated spaces, such as museums, schools and galleries. To open up problems and events that have been rendered secret, investigative aesthetics rewires relations between such places. In doing so it finds ways of making new kinds of forum, such as collectives and publics. Exhibitions in art and cultural venues can act as fora that are complementary, and sometimes even alternative, to processes in law or existing political fora though they come with their own problems that need to be addressed. Evidence presentation, just like its production, must be socialised through the formation of investigative commons.

This is particularly necessary when evidence of the kind investigative practices tend to produce is not admitted in court due to the necessary 'surplus' – the 'dirty evidence' produced by acknowledging field causality. Equally, when judicial processes function like rabbit holes, disappearing cases for years, or indeed when the law is, as is often designed, turned against those which it plays its part in rendering weak, other processes have to be designed and come to the fore. One might work with cultural institutions as forensic fora and act curatorially and performatively within legal ones, or indeed establish new fora in which investigations can be performed.

Collaborations with cultural venues are useful in other ways too. It is curious to notice how, as the art of lying undergoes a renaissance in institutions of power, the craft of truth can find its place in museums. Working with art and cultural venues is not only a pragmatic move. Both investigative and curatorial practices share a concern for knowledge production and display, for the presentation of ideas and issues through the arrangements of evidence, objects, conversations, screenings and the perceptive capacities of bodies in space.

Art and cultural fora are often no less compromised than legal ones, however. Any given public forum – university, court, gallery – renders articulation of fact through their own structuring and protocols. Each allows different facets of an

incident to be heard and seen and reinforce different fields of power. Each has its own financial and other economic fields of influence. Sometimes one has to turn one's investigative gaze towards these very institutions designated as custodians of or platforms for presentation.[7]

At other times one needs to keep moving between them, presenting the same evidence in different fora: national and international courts, art and cultural institutions, truth commissions, in multiple media, in the improvised tribunals of social campaigns, in the field and on the streets. This may help offset some of the associated problems, the refracting and distorting lenses that each institutional form brings to bear through the biases and tendencies engrained in each. Further, opening new conduits between the lab, the studio and the forum offers ways of recognising and reworking the reality-forming fields in which incidents are woven. The work done through them enables movements that are both hyper-aesthetic and precisely focused. It is in forming this opening to work on fact as a common problematic in all its plurality of conditions, and with all the demands it makes, that investigative aesthetics can take part in the unfolding of the present.

Acknowledgements

Thanks to MACBA, Barcelona, which hosted the first iteration of this text as a conversation in the context of Forensic Architecture's Towards an Investigative Aesthetics exhibition in 2017. The Institute of Contemporary Arts, London; the Seed Box, environmental humanities collaboratory at Linköping University; the School of Communication and Culture, Aarhus University, the Centre for Research Architecture, Goldsmiths; the Postmedia Research Network at Tokyo University of the Arts; and e-flux have all provided places for the presentations and conversations that gave rise to further iterations of this text. Thanks also to the many communities, artists, organisers, researchers, activists and others whose brilliant actions we attempt to catch a glimmer of in these reflections.

Many thanks to Leo Hollis for his almost infinite patience and insistence on sense-making.

And finally, thanks to Forensic Architecture members, past and present. Christina Varvia, Forensic Architecture's former deputy director and 'researcher in charge' of so many of the ideas, investigations and exhibitions presented here. As Forensic Architecture's senior researcher, Samaneh Moafi provides conceptual and technical leadership across many projects and primarily oversees our environmental investigations under the title of 'The Centre for Contemporary Nature'. With much attentiveness and care, research manager Sarah Nankivell built our organisational architecture, supports all of our investigations as well as the presentation of the work in exhibitions and documentaries. As an investigative journalist, Robert Trafford

contributes to the development of the field of open-source research and analysis, as well as doing much of our writing and reporting. As research coordinator, Nicholas Zembashi is the person in charge of overseeing innovation, the careful development of methodologies and verification of results. Shourideh C. Molavi is the lead Israel–Palestine researcher, linking our investigations to the work and research of civil society groups, cultural institutions and human rights defenders in the region, establishing a Forensic Architecture unit in Al Haq in Ramallah. Nicholas Masterton focuses on developing and dissemination, within and outside our group, new technology for the analysis of spatial video and other open-source media. Artist and writer Hannah Meszaros-Martin is in charge of coordinating Forensic Architecture's Colombia projects, while developing original ideas on the nature of environmental violence. Nathan Su invents new technologies and modes of visualisation and storytelling when he feels existing ones won't do. Lachlan Kermode has developed the practice and theory of open-source software research, manages our machine learning projects and promoted the critical introspection of the algorithms that enable it. Ariel Caine is an artist and writer whose PhD research and work at Forensic Architecture help us evolve our three-dimensional photographic practices and their application to Palestinian Bedouin struggle for liberation in the Naqab/Negev. Stefanos Levidis's PhD research and work at Forensic Architecture focuses on migration across borders, combining direct-action activism with historical and theoretical research. Martyna Marciniak undertook thorough documentary and media analysis, especially of police conduct. Omar Ferwati's work with us started with a number of investigations he coordinated in Syria, his birthplace, involving local communities and is now running his own investigations there and elsewhere. Imani Jacqueline Brown an artist, activist and researcher from New Orleans, USA, initiated, conceptualised and led a number of projects

around environmental racism and claims for reparation. As a software developer and activist, Ebrahem Farooqui combines the know-how of a technologist with the spirit of a community organiser. Zac Ioannidis works on the design and development of platforms and interfaces that enable the multidimensional navigation and cross-referencing of data from investigations. Tom James's work focused on deriving insight from extremely detailed digital modelling and fine-grained animation and the implementation of new tools and workflows. Olukoye Akinkugbe's work engages three-dimensional spatial analysis through photogrammetry and detailed remote sensing, bringing his skill to deal with issues concerning environmental violence. Lola Conte's attentiveness to the consequence of digital violence is recorded in some of our recent video investigations and edits of cyber-surveillance and police violence. Alican Aktürk creatively applies game engines in investigation. Sergio Beltrán-García is a researcher and activist equally committed to detailed counter-investigations and to developing new mnemotechniques and commemoration strategies in relation to state and state-induced violence in Central America. As an architect, Tamara Z. Jamil uses spatial models to notice and document what others can't see in videos. Elizabeth Breiner is a curator and scholar helping manage our interaction with the outside world, including our new book-making project. Sarah Saraj introduced new ideas and sensibilities about community and activism. Antoine Schirer has raised our level of video investigation and editing. Manuel Correa, a film-maker and editor, is equally interested in archival research, filmmaking, and liaising with communities. Robert Krawczyk was an excellent research assistant on this text and others. Simone Rowat established the template and benchmark for video investigation and strategic communication in film, exhibitions and judicial presentation. Nadia Méndez is an urbanist, a skill she uses to offer a unique set of investigations in text and image. Chantal Stehwien formed delicate connections with

art institutions. It is from their different individual skills and intelligence, their diverse life experience and the traditions of political struggles or activism that they each come from, as well as from the ever new forms of interaction between them, that Forensic Architecture has itself become something of an investigative commons.

Notes

Introduction

1 Forensic Architecture and ECCHR, the European Centre for Constitutional and Human Rights, are engaged in a project trying to identify the supply chain that goes into European-manufactured munitions in Yemen. The above description is the basis for their investigation. The bombing of Dresden in rewind is in Kurt Vonnegut, *Slaughterhouse-Five; or, The Children's Crusade*, New York: Delacorte Press, 1969, Chapter 4.

2 Stéphane Mallarmé, cited in Matvei Yankeleivich, 'Critics Page', *The Brooklyn Rail*, April 2018, brooklynrail.org.

3 Harun Farocki, 'Computer Animation Rules,' lecture at the IKKM, Weimar, 25 June 2014, vimeo.com. See also a special issue on navigation: Tom Holert and Doreen Mende, eds., *Navigation beyond Vision*, *e-flux 101*, 20 June 2019, e-flux.com.

4 Walter Benjamin, 'The Rigorous Study of Art', in Walter Benjamin, *Selected Writings*, Vol. 2, ed. Michael W. Jennings, Cambridge, MA: Belknap/Harvard University Press, 2004, 670.

5 The Tribunal was initiated by the activist alliance 'Unraveling the NSU Complex' to promote what it called 'situated migrant knowledge [of] those affected by racism' See nsu-tribunal.de; forensic-architecture.org.

6 On 'evidence not art' see Hili Perlson, 'The Most Important Piece at documenta 14 in Kassel Is Not an Artwork. It's Evidence', *Artnet*, 8 June 2017, news.artnet.com. On 'Art not Evidence' see Pitt von Bebenburg, CDU beklagt 'Verschwörungstheorie' FR, 8 January 2019, fr.de/rhein-main.

7 Jasmine Weber, 'A Whitney Museum Vice Chairman Owns a Manufacturer Supplying Tear Gas at the Border', *Hyperallergic*, 27 November 2018, hyperallergic.com.

8 Decolonize This Place is an action-oriented movement and decolonial formation in New York City and beyond. See decolonizethisplace.org. Close collaboration was also received from Emily Jacir.

9 Matthew Fuller and Nikita Mazurov, 'A Counter-forensic Audit Trail: Disassembling the Case of The Hateful Eight', *Theory, Culture & Society*, Vol. 36, No. 6, 2019, 171–96.

10 Martin Feuz, Matthew Fuller and Felix Stalder, 'Personal Web Searching in the Age of Semantic Capitalism: Diagnosing the Mechanisms of Personalisation', *First Monday*, Vol. 16, No. 2, 2011, journals.uic.edu.

11 Forensic Architecture, *Introspecting the Algorithms*, San Francisco: The Young Museum, 2020, deyoung.famsf.org.

12 Kate Crawford and Trevor Paglen, *Imagenet Roulette*, 2019. See for a discussion of this project, Kate Crawford and Trevor Paglen, *Excavating AI, The Politics of Images in Machine Learning Training Sets*, excavating.ai.

13 Nicolas Malevé, *Exhibiting ImageNet*, 2019, documentation online at the Centre for the Study of the Networked Image, London South Bank University, centreforthestudyof.net.

14 See Karen Knorr-Cetina, *Epistemic Cultures: How the Sciences Make Knowledge*, Cambridge, MA: Harvard University Press, 1999.

15 In Britain, this formulation has been offered by the Augur report into higher education funding. *Independent Panel Report to the Review of Post-18 Education and Funding*, London: HMSO, May 2019.

16 Hannah Arendt, *The Origins of Totalitarianism*, New York: Harcourt, Brace Jovanovich, 1973. Rosa Luxemburg, *The Accumulation of Capital: A Contribution to an Economic Explanation of Imperialism*, New York: Monthly Review Press, 1951.

17 See the work of scholars such as Sheila Jasanoff and Brian Wynne working on the public understanding of science for further elaboration of this condition.

18 Noortje Marres, 'How Issues Bring a Public into Being: A Key but Often Forgotten Point of the Lippmann–Dewey Debate', in Bruno Latour and Peter Weibel, eds., *Making Things Public*, Cambridge, MA and Karlsruhe: MIT Press and ZKM, 2005, 208–17.

19 Isabelle Stengers, *Another Science Is Possible: A Manifesto for Slow Science*, trans. Stephen Muecke, Cambridge: Polity, 2018.

20 Eyal Weizman, 'Open Verification', *eflux architecture*, n.d., e-flux.com. 2019.

21 Friedrich Nietzsche, *Writings from the Late Notebooks*, trans. Kate Sturge, Cambridge: Cambridge University Press, 85. This phrase appears in a number of variants in these notebooks.

22 Ibid., 139.

23 Stefan Collini, *Speaking of Universities*, Verso, London, 2017. Rosi Braidotti, *Posthuman Knowledge*, Cambridge: Polity, 2019.

24 Gurminder K. Bhambra, Dalia Gebrial and Kerem Nişancıoğlu, eds., *Decolonising the University*, London: Pluto Press, 2018.

25 Terms we draw from Nietzsche's formation of perspectivism and Donna Haraway's discussion of situated knowledge. Donna Haraway, 'Situated Knowledges: The Science Question in Feminism and the Privilege of Partial Perspective', *Feminist Studies*, Vol. 14, No. 3 (Autumn 1988), 575–99.

26 To pre-empt a potential misunderstanding here, while we are saying that there is an expansion of the domain of aesthetics occuring, we are not proposing that 'all' people who currently consider themselves artists must inexorably be magnetised by these propositions.

1 Aesthetics beyond Perception

1 Jacques Rancière, *Aisthesis: Scenes from the Aesthetic Regime of Art*, trans. Zakir Paul, London: Verso, 2019. For an adoption of Rancière's conception, and for the notion of forensic aesthetics, see Thomas Keenan and Eyal Weizman, *Mengele's Skull: The Advent of a Forensic Aesthetics*, Berlin: Sternberg, 2012.

2 Another source for the notion of aesthetics argued for in this book is to be found in the work of Félix Guattari. See in particular, Félix Guattari, *Chaosmosis, an ethico-aesthetic paradigm*, trans. Paul Bains and Julian Pefanic, Sydney: Power Publications, 1995. Félix Guattari, *The Three Ecologies*, trans. Ian Pindar and Paul Sutton, London: Athlone Press, 2000.

3 See Braidotti, *Posthuman Knowledge*. Matthew Fuller and Rosi Braidotti, eds., *Transversal Posthumanities*, special issue, *Theory, Culture and Society*, Vol. 36, No. 6 (2019).

4 See Bernard Stiegler, 'Individuation et grammatisation: Quand la technique fait sens …', *Documentaliste-sciences de l'information*, Vol. 42 (2005–6), 354–60.

5 Ronald Sukenick, *In Form: Digressions on the Act of Fiction*, Carbondale: Southern Illinois University Press, 1985, 37.

6 For documentation of this project see the page devoted to it at Rhizome's Net Art Anthology site: anthology.rhizome.org.

7 For example, Nicholas de Genova, ed., *The Borders of 'Europe': Autonomy of Migration, Tactics of Bordering*, Durham, NC: Duke University Press, 2017.

8 See for instance, Félix Guattari, *Schizoanalytic Cartographies*, trans. Andrew Goffey, London: Bloomsbury, 2013.

2 Aesthetics

1 Alexander Baumgarten, *Metaphysics. A Critical Translation with Kant's Elucidations, Selected Notes, and Related Materials* trans. and ed. Courtney D. Fugate and John Hymers, London, New York: Bloomsbury, 2013.

2 Immanuel Kant, *Critique of Judgement*, Oxford: Oxford University Press, 2009. For a development of this line see Thierry du Duve, *Aesthetics at Large*, Vol. 1, *Art, Ethics, Politics*, Chicago: The University of Chicago Press, 2018.

3 Fred Moten, *Stolen Life (consent not to be a single being)*, Durham, NC: Duke University Press, 2018.

4 David Lloyd, *Under Representation, The Racial Regime of Aesthetics*, New York: Fordham University Press, 2019.

5 See, for an account of pesticide use, Susanna Rankin Bohme, *Toxic Injustice: A Transnational History of Exposure and Struggle*, Berkeley: University of California Press, 2015.

6 Anthony Trewavas, *Plant Behaviour and Intelligence*, Oxford: Oxford University Press, 2014. Richard Karban, *Plant Sensing and Communication*, Chicago: The University of Chicago Press, 2015.

7 Hannah Meszaros Martin, '"Defoliating the World": Ecocide, Visual Evidence and "Earthly Memory"', in Ros Gray and Shela Sheikh, eds., *Third Text*, Vol. 32, Nos. 2–3 (March–May 2018), *The Wretched Earth: Botanical Conflicts and Artistic Interventions*, 230–53.

8 Ibid., 239.

9 Paolo Tavares, 'In the Forest Ruins', in Beatriz Colomina, Nikolaus Hirsch, Anton Vidokle and Mark Wigley, eds., *Superhumanity: Design of the Self*, Minneapolis: University of Minnesota Press, 2017, 20–35.

10 Francis Hallé, *In Praise of Plants*, trans. David Lee, Portland: Timber Press, 2011.

11 Peter McCoy, *Radical Mycology: A Treatise on Seeing and Working with Fungi*, Portland, OR: Chthaeus Press, 2016; Monica Gagliano, John C. Ryan and Patricia Vieira, eds., *The Language of Plants: Science, Philosophy, Literature*, Minneapolis: University of Minnesota Press, 2017.

12 Eduardo Kuhn, *How Forests Think: Toward an Anthropology beyond the Human*, Berkeley: University of California Press, 2013.

13 Manuel DeLanda, *A Thousand Years of Nonlinear History*, New York: Zone Books, 2000.

14 Danny Kessler, Celia Diezel and Ian T. Baldwin, 'Changing Pollinators as a Means of Escaping Herbivores', *Current Biology*, No. 20 (9 February 2010), 237–42.

15 Matthew Fuller, *How to be a Geek: Essays on the Culture of Software*, Cambridge: Polity, 2018.

3 Hyper-aesthetics

1 Citizen Sense website, citizensense.net.

2 Jennifer Gabrys, *Program Earth: Environmental Sensing Technology and the Making of a Computational Planet*, Minneapolis: University of Minnesota Press, 2016.

3 Jennifer Gabrys, *How to Do Things with Sensors*, Minneapolis: University of Minnesota Press, 2019.

4 Natalie Jeremijenko, *Mussel Choir*, 2015–. Versions installed in New York City and Melbourne.

5 See, for a discussion of plant aesthetics, Matthew Fuller and Olga Goriunova, *Bleak Joys: Aesthetics of Ecology and Impossibility*, Minneapolis: University of Minnesota Press, 2019.

6 See, for example, Otolith Group, *Medium Earth*, 2013, redcat.org/exhibition/otolith-group; otolithgroup.org.

7 Daniel Rosenberg, 'Ingestion/a Manhattan Project: The Libationary Permutations of Hans Peter Luhn's Cocktail Oracle', *Cabinet Magazine*, Spring 2019–Winter 2020, cabinetmagazine.org.

8 Giuseppe Longo, 'Quantifying the World and Its Webs: Mathematical Discrete vs Continua in Knowledge Construction', *Theory Culture and Society*, special issue, *Transversal Posthumanities*, Vol. 36, No. 6 (November 2019), 63–72.

9 Paul N. Edwards, *A Vast Machine: Computer Models, Climate Data, and the Politics of Global Warming*, Cambridge, MA: MIT Press, 2013.

10 Territorial Agency, Oceans in Transformation, Ocean Space exhibition, Venice, 27 August–29 November 2020, ocean-space.org.

11 For further discussion of these terms see the work of cybernetician Heinz von Foerster in, for instance, Albert Müller and Karl H. Müller, eds., *An Unfinished Revolution? Heinz von Foerster and the Biological Computer Laboratory / BCL 1958–1976*, Vienna: Edition Echoraum, 2007.

12 Alfred North Whitehead, *Science and the Modern World*, London: Free Association Books, 1985.

13 Ines Weizman, 'Bauhaus Modernism across the Sykes–Picot Line', in Ines Weizman, ed., *Dust and Data: Traces of the Bauhaus across 100 Years*, Leipzig: Spector Books, 2019, 544–75.

14 Ines Weizman, 'Introduction', in Weizman, *Dust & Data*, 9.

15 Eyal Weizman, *The Least of All Possible Evils: Humanitarian Violence from Arendt to Gaza*, London: Verso, 2012.

16 Ben Grosser, 'What Do Metrics Want? How Quantification Prescribes Social Interaction on Facebook', *Computational Culture*, No. 4 (November 2014), computationalculture.net.

17 Forensic Oceanography, Left to Die Boat, 2012, www.forensic-architecture.org. Charles Heller, Lorenzo Pezzani and Situ Research, 'The Left-to-Die Boat: The Deadly Drift of a Migrants' Boat in the Central Mediterranean' in Forensic Architecture, ed., *Forensis: The Architecture of Public Truth*, Berlin: Sternberg, 2014, 637–56, See also Charles Heller and Lorenzo Pezzani, 'Liquid Traces: Investigating the Deaths of Migrants at the EU's Maritime Frontier,', 657–84.

4 How to Inhabit the Hyper-aesthetic Image

1 Alvar Noë, *Out of Our Heads*, New York: Hill and Wang, 2010. Evan Thompson, Francisco Varela and Eleanor Rosch, *The Embodied*

Mind: Cognitive Science and Human Experience, 2nd ed., Cambridge, MA: MIT Press, 2017.

2 Stamatia Portanova, *Moving without a Body: Digital Philosophy and Choreographic Thoughts*, Cambridge, MA: MIT Press, 2013. Nicolas Salazar Sutil, *Motion and Representation: The Language of Human Movement*, Cambridge, MA: MIT Press, 2015.

3 Brian Eno, *Ambient Paintings*, Venice: Galleria Michela Rizzo, 2020.

4 Eyal Weizman, *Forensic Architecture: Violence at the Threshold of Detectability*, New York: Zone Books, 2017, 85–93. Forensic Architecture, *Torture in Saydnaya*, 2016, forensic-architecture.org.

5 Lawrence Abu Hamdan, cited in 'EarWitness the Saydnaya Prison', 30 August 2016, lawrenceabuhamdan.com.

6 See grenfelltowerinquiry.org.uk.

7 Forensic Architecture, *The Grenfell Tower Fire*, 2018–, forensic-architecture.org.

8 Media archaeology is a diverse field involving a variety of tendencies, and readers are referred to the work of authors such as Ina Blom, Siegfired Zielinski, Jussi Parikka, Anne Friedberg, Eric Kluitenberg, Jonathan Crary, David Link, Wolfgang Ernst, Thomas Elsaesser, Lori Emerson, Erkki Huhtamo, Vivian Sobchack and Jacob Gaboury, and that of artists such as Tamás Waliczky and Garnet Hertz.

9 Paul Virilio, *War and Cinema: The Logistics of Perception*, trans. Patrick Camiller, London: Verso, 1989.

10 Katrina Sluis, 'Authorship, Collaboration, Computation? Into the Realm of Similar Images', in Kamila Kuc and Joanna Zylinska, eds., *Photomediations: A Reader*, London: Open Humanities Press, 2016, 283–9.

11 Walter Benjamin, 'Surrealism', in *Walter Benjamin: Selected Writings*, Vol. 2, ed. Michael W. Jennings, Cambridge, MA: Belknap/Harvard University Press, 1999, 207–21.

12 Susan Schuppli, *Slick Images: The Photogenic Politics of Oil*, Extra City, Antwerp, 2015. See project documentation at susanschuppli. com.

13 Susan Schuppli, 'Dirty Pictures', in Mirna Belina and Arie Altena, eds., *Living Earth Field Notes from the Dark Ecology Project 2014–2016*, Amsterdam: Sonic Acts, 2016, 189–210.

14 An interesting attempt to recompose this problematic is made by the massive recording of a life in the work of Finnish musician, artist and technologist Erkki Kurenniemi. See Jussi Parikka and Joasia Krysa, eds., *Writing and Unwriting (Media) Art History*, Cambridge, MA: MIT Press, 2015. See the documentary directed by Mika Taanila, *Future Is Not What It Used to Be*, Kinotar Oy and Kiasma Museum of Contemporary Art, 2002.

5 Hyperaesthesia

1 Steve Goodman, *Sonic Warfare: Sound, Affect, and the Ecology of Fear*, Cambridge MA: MIT Press, 2012.

2 Susan Schuppli, *Material Witness: Media, Forensics, Evidence*, Cambridge, MA: MIT Press, 2020.

3 Ibid., 62.

4 Guy Debord, *Society of the Spectacle*, trans. Fredy Perlman, Detroit: Black and Red, 1970.

5 Kirill Medvedev, '5', from Kirill Medvedev, *It's No Good*, trans. Cory Merrill and Keith Gessen, London: Fitzcarraldo Editions, 2015, 53.

6 Antonin Artaud, 'To Have Done with the Judgement of God', in Antonin Artaud, *Watchfiends & Rack Screams: Work from the Final Period*, trans. Clayton Eshleman and Bernard Bador, Boston: Exact Change, 2000, 281–307. See also Sylvere Lotringer, *Mad Like Artaud*, trans. Joanna Spinks, Minneapolis: Univocal, 2015.

7 James C. Scott, *Seeing Like a State: How Certain Schemes to Improve the Human Condition Have Failed*, New Haven: Yale University Press, 1998. Manuel DeLanda, *War in the Age of Intelligent Machines*, New York: Zone Books, 1991. Paul Virilio, *The Information Bomb*, trans. Chris Turner, London: Verso, 2000. Simone Brown, *Dark Matters: On the Surveillance of Blackness*, Durham, NC: Duke University Press, 2015.

8 Harlan K. Ullman and James P. Wade, *Shock and Awe: Achieving Rapid Dominance*, Washington DC: National Defense University, Institute for Strategic Studies, 1996.

6 Aesthetic Power

1 This is as much the case for those who took things too seriously, too sincerely – as, for instance, in the story depicted by Andrei Tarkovsky in his portrait of the icon painter *Andrei Rublev*, 1969 – as it is for those who wanted, and those who still aim, to establish an egalitarian mode of the avant-garde.

2 Soroush Vosoughi, Deb Roy and Sinan Aral, 'The Spread of True and False News Online', *Science*, 9 March 2018, 1146–51.

3 The play of difference between the map and the territory is introduced in Alfred Korzybski, *Science and Sanity: An Introduction to Non-Aristotelian Systems and General Semantics*, International Non-Aristotelian Library Publishing Company, 1933.

4 We draw the phrase 'grammars of action' from Philip Agre in his landmark text on the way in which technologies of many kinds structure the behaviours they enable. Philip E. Agre, 'Surveillance and Capture: Two Models of Privacy', *The Information Society*, Vol. 10, No. 2 (1994), 101–27.

5 Diogenes the Cynic, *Sayings and Anecdotes with Other Popular Moralists*, Oxford: Oxford World's Classics, 2012.

6 'Operative' is meant here in the sense used by Haroun Farocki. A term inaugurated in his film *Eye/Machine* (2000), it refers to the ways in which images are used for functional sensing in systems such as weapons targeting epitomised in the Gulf War of 1991, where video cameras were built into cruise missiles.

7 Frantz Fanon, *Black Skin, White Masks*, trans. Charles Lam Markmann, London: Pluto Press, 1986. Judith Butler, *Bodies That Matter: On the Discursive Limits of Sex*, London: Routledge, 2011.

8 Mark Andrejevic uses this term to describe how the incorporation of privatised digital infrastructures into cities, under the rubric of smart cities, creates a digital enclosure. Mark Andrejevic, 'Surveillance in the Digital Enclosure', *The Communication Review*, Vol. 10, No. 4 (2007), 295–317. We also think it fits much of what has happened with the reduction of the Internet to a set of platforms.

9 Marina Vishmidt, *Speculation as a Mode of Production: Forms of Value Subjectivity in Art and Capital*, Leiden: Brill, 2018.

10 Laurie Clarke, 'How the A-Level Results Algorithm Was Fatally Flawed', *The New Statesman*, 14 August 2020. Due to an outcry led by the eighteen- and sixteen-year-olds who were afflicted by this clumsy system, its results were pulled and teachers' predicted grades were used instead.

11 Brian Massumi, *Ontopower: War, Powers, and the State of Perception*, Durham, NC: Duke University Press, 2015.

12 Engin Isin and Evelyn Ruppert, 'The Birth of Sensory Power: How a Pandemic Made It Visible?', *Big Data and Society*, November 2020. https://journals.sagepub.com/home/bds

13 Weizman, *Forensic Architecture*.

14 This return of the techniques has been long observed in the case of the British relation to Ireland, for instance, but also more broadly in what Aimé Césaire called the 'reverse shock' when fascism reimported colonial techniques to Europe. See Aimé Césaire, *Discourse on Colonialism*, New York: Monthly Review Press, 2000. See also Françoise Vergès, 'Postface', in Aimé Césaire, *Resolutely Black: Conversations with Françoise Vergès*, Cambridge: Polity, 2019. This thesis is also present in Arendt's reading of Luxemburg's theory of imperialism, cited above.

15 Fred Moten, transcription of conversation, 'Do Black Lives Matter? Robin D. G. Kelley and Fred Moten in Conversation', moderated by Maisha Quint, Bethany Baptist Church, Oakland, 13 December 2014, vimeo.com.

16 Forensic Architecture, *The Killing of Harith Augustus*, 2019, forensic-architecture.org.

17 Giorgio Agamben, *State of Exception*, trans. Kevin Attell, Chicago:

The University of Chicago Press, 2005. Achille Mbembe, *Necropolitics*, trans. Steve Corcoran, Durham, NC: Duke University Press, 2019.

18 A note on how we have used the term 'translation' here. Much of this book discusses the question of translation in a broad sense, as a term to include the translation of ideas, forces, models, senses, chemicals, structures, representations and so on, as providing points of equivocation or differentiation in which investigation can occur by virtue of the changes and traces they entail in the very event of translation. In this we are indebted to the foundational work of the late Michel Serres; see in particular *Hermes III: La traduction*, Paris: Editions de Minuit, 1974.

8 Secrets

1 This section on secrets has been developed in Eyal Weizman, 'Strike-out: The Material Infrastructure of the Secret', in Edmund Clark and Crofton Black [eds.], *Negative Publicity: Artefacts of Extraordinary Rendition*, London: Aperture, 2016. 300–312

2 See Gillo Pontecorvo, *Battle of Algiers*, 1966.

3 Erving Goffman, *Asylums: Essays on the Social Situation of Mental Patients and Other Inmates*, New York: Anchor Books, 1961.

4 Trevor Paglen and A. C. Thompson, *Torture Taxi: On the Trail of the CIA's Rendition Flights*, New York: Melville House, 2006. Trevor Paglen, *Blank Spots on the Map: The Dark Geography of the Pentagon's Secret World*, New York: Dutton, 2009.

5 International Military Tribunal, *The Trial of German Major War Criminals: Proceedings of the International Military Tribunal Sitting at Nuremberg, Germany*, Vol. 29, Nuremberg, 1948, 110–73.

6 Argentina's last military government waged a 'Dirty War' on its citizens from 1976 to 1983, in which people believed to be political dissidents were routinely 'disappeared': taken to government detention centres where they were tortured and killed. Human rights groups put the figure of *desaparecidos* at 30,000. See Vikki Bell, *The Art of Post-dictatorship: Ethics and Aesthetics in Transitional Argentina*, London: Routledge, 2014.

7 J. Patrice McSherry, *Predatory States: Operation Condor and Covert War in Latin America*, New York: Rowman and Littlefield Publishers, 2005.

8 Forensic Architecture, *The Enforced Disappearance of the Ayotzinapa Students*, 2017, forensic-architecture.org.

9 Forensic Architecture, *Torture and Detention in Cameroon*, 2017, forensic-architecture.org.

10 Sam Raphael, Crofton Black, Ruth Blakeley and Steve Kostas, 'Tracking Rendition Aircraft as a Way to Understand CIA Secret Detention and Torture in Europe', *The International Journal of Human Rights*, Vol. 20, No. 1 (2016), 78–103.

11 Alex Hern, 'Fitness Tracking App Strava Gives Away Location of US Army Bases', *Guardian*, 28 January 2018, theguardian.com.

12 Forensic Architecture, *Chemical Attacks in Douma*, 2018, forensic-architecture.org. Bellingcat has an extensive range of documents on this case at bellingcat.com.

13 Peter Hitchens, 'New Sexed-Up Dossier Furore: Explosive Leaked Email Claims That UN Watchdog's Report into Alleged Poison Gas Attack by Assad Was Doctored – So Was It to Justify British and American Missile Strikes on Syria?', *Mail on Sunday*, 23 November 2019, dailymail.co.uk.

14 Freud remarks on this in *The Interpretation of Dreams* and *Jokes and Their Relation to the Unconscious*.

15 Wikileaks is the publishing network, founded by Julian Assange, which publishes documents considered confidential by other organisations. Edward Snowden leaked classified documents from the US National Security Agency to three journalists in 2013, detailing mass surveillance of private citizens' communications, some of which were then published by newspapers globally.

16 Jonathon Penney, 'Chilling Effects: Online Surveillance and Wikipedia Use', *Berkeley Technology Law Journal*, Vol. 31, No. 1 (2016), 117–83.

17 Bertolt Brecht, 'The Threepenny Lawsuit', in Bertolt Brecht, *Brecht on Film and Radio*, ed. and trans. M. Silberman, London: Methuen, 2000, 164–5.

18 Hans Haacke, *Shapolsky et al. Manhattan Real Estate Holdings: A Real-Time Social System, as of May 1, 1971*, photographs and text, 1971.

19 Clark and Black, *Negative Publicity*.

20 Gregory Bateson, *Steps to an Ecology of Mind: Collected Essays in Anthropology, Psychiatry, Evolution, and Epistemology*, Chicago: The University of Chicago Press, 2000, 465.

9 The Cat and the Angel

1 Metahaven, *Black Transparency: The Right to Know in the Age of Mass Surveillance*, Berlin: Sternberg, 2015.

10 The Ear and the Eye

1 Andrew Roth, 'We Got Really Lucky: How Novichok Suspects Were Revealed', *Guardian*, 27 September 2018, theguardian.com. In a related case, in March 2021 Forensic Architecture was asked to verify whether a particularly gruesome video of a murder described the assasination of Jamal Khashoggoi at the Saudi embassy in Istanbul. The person looked alike in many aspects: same build, balding gray

hair, a goatee. That the structure of the ears were distinctly different, confirmed that it was another victim and a different crime.

2 Carlo Ginzburg, trans., Anna Davin, 'Morelli, Freud and Sherlock Holmes: Clues and Scientific Method', *History Workshop*, No. 9 (Spring 1980), 5–36.

3 Carlo Ginzburg, 'Clues: Roots of an Evidential Paradigm', in Carlo Ginzburg, *Clues, Myth and the Historical Method*, trans. John and Anna C. Tedeschi, Baltimore: Johns Hopkins University Press, 1989.

4 Ginzburg, *Clues*, 91,

5 Marc Bloch, *The Historian's Craft: Reflections on the Nature and Uses of History and the Techniques and Methods of Those Who Write It*, trans. Peter Putnam, New York: Vintage, 1953.

6 Ginzburg, *Clues*, 6.

7 Ibid., 8–9.

8 Carlo Ginzburg, *The Cheese and the Worms: The Cosmos of a Sixteenth-Century Miller*, trans. John and Anne C. Tedeschi, Baltimore: Johns Hopkins University Press, 2013.

9 Adania Shibli, *Minor Detail*, trans. Elisabeth Jaquette, London: Fitzcarraldo Editions, 2020.

10 Ibid., 62.

11 Ibid., 63.

11 The Eye and the Office

1 Roman Polanski, *Chinatown*, 1974.

2 Cristina Vatulescu, *Police Aesthetics: Literature, Film and the Secret Police in Soviet Times*, Stanford: Stanford University Press, 2010.

3 Edgar Allan Poe, *The Murders in the Rue Morgue*, London: Penguin, 2006. China Miéville, *The City and the City*, London: Macmillan, 2009. Chester Himes, *The Harlem Cycle*, Vol. 1, *A Rage in Harlem, The Real Cool Killers, The Crazy Kill*, Edinburgh: Canongate, 1998. Peter Plate, *One Foot off the Gutter*, San Francisco: Seven Stories, 1996.

4 The Intercept's extensive dossier on the Dakota Access Pipeline protests at Standing Rock includes numerous leaked internal documents and reports from Tiger Swan: theintercept.com.

5 Ward Churchill and Jim van der Wall, *The COINTELPRO Papers: Documents from the FBI's Secret Wars against Dissent in the United States*, Boston: South End Press, 1990. Betty Medsger, *The Burglary: The Discovery of J. Edgar Hoover's Secret FBI*, New York: Alfred A. Knopf, 2014. The latter gives an account of the 1971 break-in by a group of war resisters at an FBI office at a town called Media in Pennsylvania which resulted in the leak of over a thousand documents detailing COINTELPRO.

12 Pre-emptive Investigations

1 Brian Massumi, *Ontopower: War, Powers, and the State of Perception*, Durham, NC: Duke University Press, 2015.

2 As a term, 'direct action' has a long history, but is crystallised in a political sense by anarchist Voltairine de Cleyre. See Voltairine de Cleyre, 'Direct Action' (1912), in *The Voltairine De Cleyre Reader*, ed. A. J. Brigati, Oakland: AK Press, 2004, 47–62. As a related concept in what would become ecological thought, it is also present in Peter Kropotkin's elaboration of his work on mutual aid in evolution. See Peter Kropotkin, 'The Direct Action of Environment on Plants', *Nineteenth Century*, Vol. 68 (1910), 58–77; and Peter Kropotkin, 'Direct Action of Environment and Evolution', *Nineteenth Century*, Vol. 85 (1919), 70–89. These texts are available at 'The Anarchy Archives, an online research center on the history and theory of anarchism', at dwardmac. pitzer.edu/anarchist_archives/.

3 Spies for Peace, *Danger! Official Secret, RSG-6*, published by Spies for Peace, no place of publication given, 1963. See also Nicholas Walter, *Damned Fools in Utopia: And Other Writings on Anarchism and War Resistance*, London: PM Press, 2011.

4 Peter Coe and Malcolm Reading, *Lubetkin and Tecton: Architecture and Social Commitment. A Critical Study*, Bristol: University of Bristol Press, 1981.

5 Michel Foucault, 'The Subject and Power', in Herbert Dreyfus and Paul Rabinow, eds., *Beyond Structuralism and Hermeneutics*, Chicago: The University of Chicago Press, 1983, 208–26.

13 Many Logics of Fact

1 Robert Jan van Pelt, *The Case for Auschwitz: Evidence from the Irving Trial*, Bloomington: Indiana University Press, 2002. Weizman, *Forensic Architecture*, op cit, 13–17.

2 Arthur Conan Doyle, *The Sign of Four*, London: Penguin, 2001. (Emphasis in original.)

3 Fernando Zalamea, *Synthetic Philosophy of Contemporary Mathematics*, trans. Zachary Luke Fraser, Falmouth: Urbanomic, 2012.

4 Alexander Grothendieck, *Récoltes et semailles: Réflexions et témoignage sur un passé de Mathématicien*, 1986, pdf, available online at the Wayback Machine. A draft English translation of the preface by Dr Roy Lisker is available online at fermentmagazine.org.

5 Zalamea, *Synthetic Philosophy of Contemporary Mathematics*, 149.

6 For further discussion of this formulation see Weizman, *Forensic Architecture*.

7 Paul Virilio, *Unknown Quantity*, Paris and London: Thames and Hudson and Foundation Cartier, 2003.

8 See tvrain.ru.
9 Weizman, *Forensic Architecture*, 289.

14 Minimal Causation and Field Causality

1 Karl Marx, *Capital*, Vol. 1, trans. Ben Fowkes, London: Penguin, 1989.
2 Mario Tronti, *Workers and Capital*, trans. David Broder, London: Verso, 2019.
3 Kimberlé Crenshaw, 'Mapping the Margins: Intersectionality, Identity Politics, and Violence against Women of Colour', *Stanford Law Review*, Vol. 43 (1995), 1241–99. The Combahee River Collective, 'A Black Feminist Statement', in Linda Nicholson, ed., *The Second Wave: A Reader in Feminist Theory*, London: Routledge, 1997, 63–70. Avtar Brah, *Cartographies of Diaspora: Contesting Identities*, London: Routledge, 1996.
4 Braidotti, *Posthuman Knowledge*.
5 Stuart Hall, Lynne Segal and Peter Osborne, 'Interview: Stuart Hall: Culture and Power,' *Radical Philosophy*, No. 86, 1997, 24–41. radical philosophy.com.
6 Hubert Damisch, *A Theory of /Cloud/: Toward a History of Painting*, trans. Janet Lloyd, Stanford: Stanford University Press, 2002.
7 John Ruskin, *Modern Painters*, New York: John Wiley, 1860, archive. org. Nearly a quarter of a century later, Ruskin would give two remarkable lectures on 'The Storm Cloud of the Nineteenth Century', developing the environmental aspect of his thought further. The text of these lectures are also available at archive.org.
8 David Sylvester, 'Late Klee, Klee I and Klee II', in David Sylvester, *About Modern Art: Critical Essays 1948–1997*, New York: Henry Holt & Company, 1997, 15–47.
9 Ben Highmore, *The Art of Brutalism: Rescuing Hope from Catastrophe in 1950s Britain*, New Haven: Yale University Press, 2017. This book drew our attention to Sylvester's discussion of Klee.
10 For a discussion of the origin of the notion of fields in the work of Michael Faraday and the geometric means of their analysis in that of James Clerk Maxwell, see Peter M. Harman, *The Natural Philosophy of James Clerk Maxwell*, Cambridge: Cambridge University Press, 1998.
11 Christina Varvia and Eyal Weizman, Operative Models, LOG 50: Model Behavior, Fall 2020.
12 Daniel Rosenberg and Anthony Grafton, *Cartographies of Time: A History of the Timeline*, Princeton: Princeton University Press, 2012, 108.
13 Yoha (Graham Harwood and Matsuko Yokokoji) and Matthew Fuller, *Endless War*, three-screen installation, 2011; documentation at yoha. co.uk.

15 Machine Investigations

1 Wendy Hui Kyong Chun, *Programmed Visions: Software and Memory*, Cambridge, MA: MIT Press, 2011.

2 Letanya Sweeney, 'Discrimination in Online Ad Delivery', *Communications of the ACM*, Vol. 56, No. 5 (2013), 44–54.

3 Ruha Benjamin, *Race after Technology: Abolitionist Tools for the New Jim Code*, Cambridge: Polity, 2019.

4 Ronald Coase, 'The Nature of the Firm', *Economica*, Vol. 4, No. 16 (1937), 386–405. For a valuable contemporary discussion in relation to the commons of Free Software see Yochai Benkler, 'Coase's Penguin, or, Linux and "The Nature of the Firm"', *The Yale Law Journal*, Vol. 112, No. 3 (2002), 369–446.

5 Matthew Fuller and Andrew Goffey, *Evil Media*, Cambridge, MA: MIT Press, 2012.

6 Christian Sandvig, Kevin Hamilton, Karrie Karahalios and Cedric Langbort, 'When the Algorithm Itself Is a Racist: Diagnosing Ethical Harm in the Basic Components of Software', *International Journal of Communication*, Vol. 10 (2016), 4972–90. Ezekiel J Dixon-Román, Ama Nyame-Mensah and Allison R. Russell, 'Algorithmic Legal Reasoning as Racializing Assemblage', *Computational Culture*, No. 7 (2018), computationalculture.net. Ramon Amaro, 'As If, towards a Black Technical Object', *e-flux Architecture*, n.d., e-flux.com. Simone Browne, *Dark Matters: On the Surveillance of Blackness*, Durham, NC: Duke University Press, 2015.

7 Michael Tyrrell, 'BAE Systems Predicts Top Manufacturing Job Roles in 2040', *Product Engineering Solutions*, 16 August 2019, pesmedia. com. See also the original press release for this story at baesystems.com.

8 Forensic Architecture, *The Battle of Ilovaisk*, 2019, forensic-architecture.org.

9 Lachlan Kermode, Jan Freyberg, Alican Akturk, Robert Trafford, Denis Kochetkov, Rafael Pardinas, Eyal Weizman and Julien Cornebise, 'Objects of Violence: Synthetic Data for Practical ML in Human Rights Investigations', 1 April 2020, presented at NeurIPS 2019 in the AI for Social Good workshop, arxiv.org.

10 A specific website for the Model Zoo project is at forensic-architecture. org.

11 See forensic-architecture.org.

12 Adrian Mackenzie, *Machine Learners: Archaeology of a Data Practice*, Cambridge, MA: MIT Press, 2017, 36.

13 David Link, *Archaeology of Algorithmic Artefacts*, Minneapolis: Univocal, 2016. Annet Dekker, *Collecting and Conserving Net Art: Moving beyond Conventional Methods*, London: Routledge, 2018. Dennis Tenen, *Plain Text: The Poetics of Computation*, Stanford: Stanford University Press, 2017.

14 See Richard Rogers, 'The Internet Treats Censorship as a Malfunction and Routes around It? A New Media Approach to the Study of State Internet Censorship', in Jussi Parikka and Tony Sampson, eds., *The Spam Book: On Viruses, Porn, and Other Anomalies from the Dark Side of Digital Culture*, Cresskill, NJ: Hampton Press, 2009, 229–47. For a further project mapping the availability of different material according to basic location data, see Aaron Swartz and Taryn Simon, *Image Atlas*, 2012, online at www.imageatlas.org.

16 Investigative Commons

1 Jean-Luc Godard/Dziga Vertov Group, 'What Is to Be Done?/British Sounds', *Afterimage*, No. 1 (April 1970), trans. Mo Teitelbaum, my-blackout.com.

2 Michael Richardson, Dawn Ades, Krzysztof Fijalowski, Steven Harris and Georges Sebbag, eds., *The International Encyclopedia of Surrealism*, London: Bloomsbury, 2020.

3 Kodwo Eshun, *More Brilliant than the Sun: Adventures in Sonic Fiction*, London: Quartet, 1999.

4 Tony Wood, *Russia without Putin*, London: Verso, 2019.

5 Christina Sharpe, *In the Wake: On Blackness and Being*, Durham, NC: Duke University Press, 2016.

6 Baruch Spinoza, 'Ethics', in *The Collected Works of Spinoza*, Vol. 1, ed. and trans. Edwin Curley, Princeton: Princeton University Press, 1985, 408–617. Ludwig Wittgenstein, *Philosophical Investigations*, Oxford: Blackwell, 1958; Paolo Virno, *A Grammar of the Multitude: For an Analysis of Contemporary Forms of Life*, Los Angeles and New York: Semiotext(e).

7 Ludwig Wittgenstein, *Lectures and Conversations on Aesthetics, Psychology, and Religious Belief*, trans. and ed. Yorick Smythies, Rush Rhees and James Taylor, Oxford: Blackwell, 1966.

8 Elinor Ostrom, *Governing the Commons: The Evolution of Institutions for Collective Action*, Cambridge: Cambridge University Press, 1990. See also, for a political and historical reading of commons, Peter Linebaugh, *The Magna Carta Manifesto: Liberties and Commons for All*, Berkeley: University of California Press, 2008.

9 For a sophisticated reading of a wider conception of digital commons, see Raqs Media Collective, *A Concise Lexicon of/for the Digital Commons*, in Monica Narula, Shuddhabrata Sengupta, Jeebesh Bagchi, Ravi Vasudevan, Ravi Sundaram and Geert Lovink, eds., *Sarai Reader 03: Shaping Technologies*, Delhi and Amsterdam: Sarai-CDS and WAAG, 2003, 357–65.

10 See Matthew Fuller and Olga Goriunova, *Bleak Joys, Aesthetics of Ecology and Impossibility*, Minneapolis: University of Minnesota Press, 2019.

11 Eyal Weizman, 'Open Verification', *eflux architecture*, e-flux.com. 2019.

12 Achille Mbembe, 'Decolonizing Knowledge and the Question of the Archive', paper given at Wits Institute for Social and Economic Research (WISER), University of the Witwatersrand in Johannesburg, 2015. See also Boaventura de Souza Santos, *Epistemologies of the South: Justice against Epistemicide*, Abingdon: Paradigm Publishers, 2014; and Boaventura de Souza Santos, *Decolonising the University: The Challenge of Deep Cognitive Justice*, Newcastle upon Tyne: Cambridge Scholars Press, 2017.

13 Mbembe, 'Decolonizing Knowledge and the Question of the Archive'. Bruno Latour, Agency at the Time of the Anthropocene. *New Literary History,* 45(1), 1-18. p. 5, 2014. (Italics in both sources)

14 Ibid.

15 Compare to Ariella Azoulay, *The Social Contract of Photography*, New York: Zone Books, 2008.

17 The Lab and the Studio

1 See, for a political account of this move, Christopher Hill, *Some Intellectual Consequences of the English Revolution*, Madison: University of Wisconsin Press, 1980.

2 Simon Shapin and Simon Schaffer, *Leviathan and the Air-Pump: Hobbes, Boyle and the Experimental Life*, Princeton: Princeton University Press, 1985.

3 Ina Blom, *The Autobiography of Video: The Life and Times of a Memory Technology*, Berlin: Sternberg Press, 2016.

4 Lorraine Daston and Peter Galison, *Objectivity*, New York: Zone Books, 2007.

5 Stengers, *Another Science Is Possible.*

6 Ariella Azoulay, *Potential Histories: Unlearning Imperialism*, London: Verso, 2020.

7 Forensic Architecture and Praxis films, *Triple Chaser*, 2019, forensic-architecture.org.

Index